ART AT OUR DOORSTEP

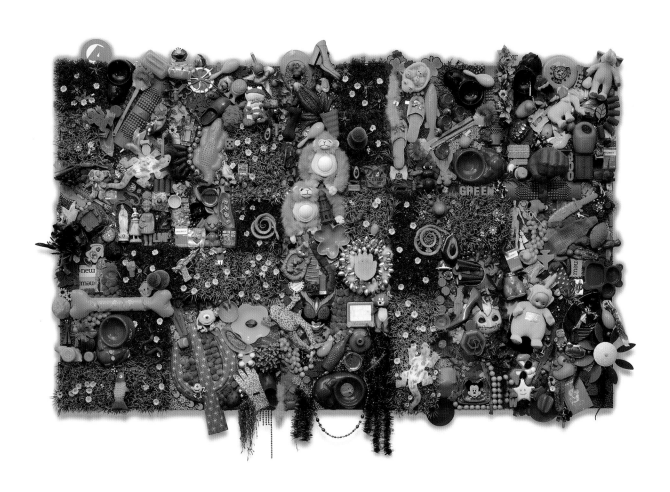

Linda Pace, *Green Peace*, 2003; mixed media on wood, 72 x 120 inches. Private collection.
Courtesy of the Linda Pace Foundation.

ART AT OUR DOORSTEP

SAN ANTONIO WRITERS + ARTISTS

EDITED BY NAN CUBA AND RILEY ROBINSON

TRINITY UNIVERSITY PRESS

SAN ANTONIO

Published by Trinity University Press
San Antonio, Texas 78212

Complete copyright information continues on p. 227.

Designed by Miko McGinty
Typeset by BookMatters, Berkeley
Jacket design by Miko McGinty
Endpapers in hardcover: Alex de Leon, study for *Either
Way There Were Plenty of Loose Ends,* 2004; graphite
on paper, 18 × 22.5 inches. Photo by Ansen Seale.
Cover artwork: Ansen Seale, *Evergreen,* 2001; digital
slitscan photograph, 24 × 56 inches.

Many thanks to the following for photographing art-
work in the book: Bibb Gault, p. 180; Rick Hunter, p. 75;
Todd Johnson, pp. 39, 77, 93, 142, and 163; Richard
Kline, 57; Bryan Rindfuss, p. 51; Michael Salas Design,
p. 186; Ansen Seale, pp. ii, 7, 20, 43, 72, 78, 84, 99, 111,
112, 115, 121, 122, 127, 157, 158, 170, 175, 176, 190, 195,
198, 202–3, 206, and 210; Kathy Vargas, p. x.

Printed in China

12 11 10 09 08 – 5 4 3 2 1

*Trinity University Press would like to thank the
following donors, whose contributions helped to
support this publication.*

CHARLES BUTT

THE EDOUARD FOUNDATION

R. DOUGLAS BRACKENRIDGE
IN MEMORY OF LOIS BOYD

Library of Congress Cataloging-in-Publication Data
Art at our doorstep : San Antonio writers and artists /
edited by Nan Cuba and Riley Robinson
 p. cm.
 Includes bibliographical references.
 SUMMARY: "A gathering of the literary and visual
artists of national and international repute who happen
to live or have lived in San Antonio. Includes full-color
illustrations; poems; and excerpts from essays, fiction,
and creative nonfiction"–Provided by publisher.
 ISBN 978-1-59534-039-9 (hardcover : alk. paper)
 ISBN 978-1-59534-049-8 (pbk. : alk. paper)
1. American literature–Texas–San Antonio.
2. Art, American–Texas–San Antonio.
I. Cuba, Nan, 1947-
II. Robinson, Riley, 1961-
 NX511.S33A78 2008
 700.9764'351–dc22 2007047684

WRITERS

ARTISTS

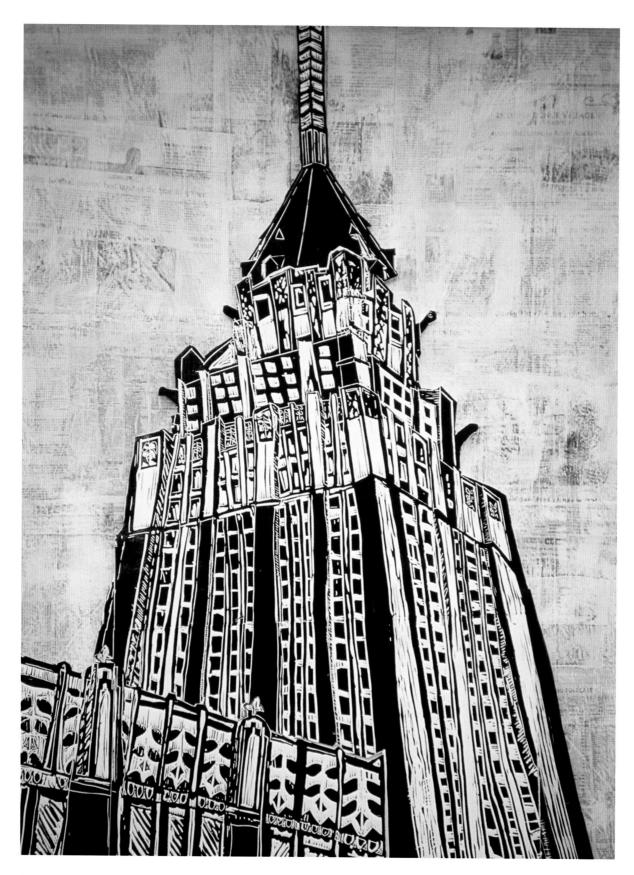

Paula Cox, *Tower-Life Building, 3D*, 2006; linocut, 53 x 36 inches.

ART AT OUR DOORSTEP

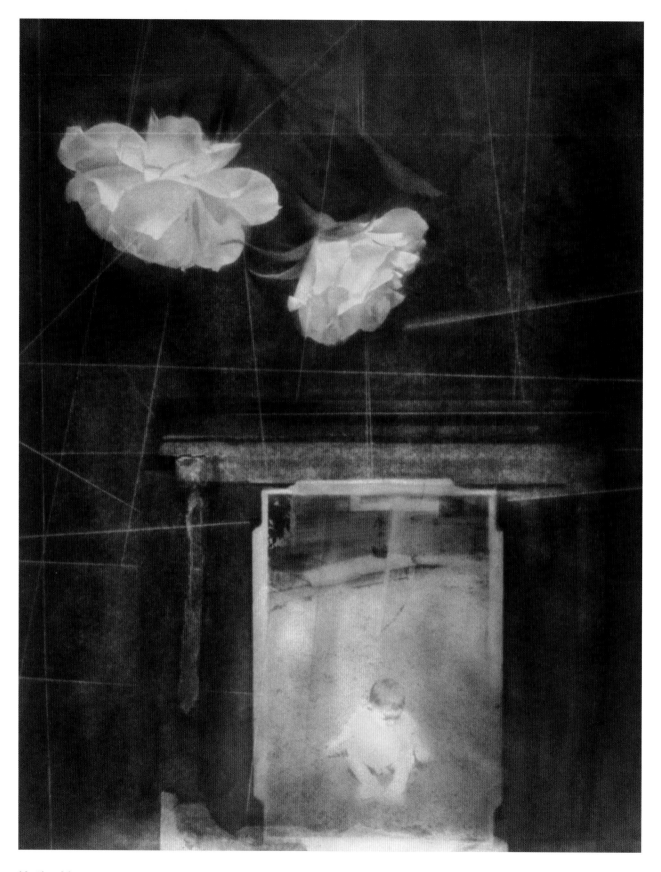

Kathy Vargas, from the *Innocent Age* series, 2006; hand-colored gelatin silver print, 24 x 20 inches.

JOHN PHILLIP SANTOS

From *Places Left Unfinished at the Time of Creation*

I am one of the late twentieth-century Santos, born in *la Tierra de Viejitas,* "the Land of Little Old Ladies," a sun-drenched riverine empire in south Texas reigned over by a dynasty of Mexican *doñas* who held court in shady painted backyard arbors and parlors across the neighborhoods of San Antonio. To the uninitiated, *las Viejitas* might look fragile, with their bundled bluish hair, false teeth, and halting arthritic steps across the front porch. Their names were ciphers from the lost world: Pepa. Tomasa. Leandra. Margarita. Chita. Cuka. Fermina. They were grandmothers, great-aunts, sisters-in-law, and *comadres.*

Their houses smelled of cinnamon tea, marigolds, burning church candles, Maja brand Spanish talcum powder, and Pine-Sol. They tended garden plots of geraniums, squash, tomatoes, cilantro, and chile, decorated with stones that were painted to look like Popeye, Olive Oyl, and Cantinflas. The chickens in their backyards sometimes seemed to cluck to the sound of the polkas coming from the transistor radio left on in the bathroom. They healed children, and animals, with their *remedios,* potions and poultices made with herbs that had names like *el garrabato* and *la gobernadora.* Asking Tía Pepa how she learned the old remedies, cures, and healing arts, she once answered, "It's nothing special – just some little things I heard some people talking about when I was a little girl."

When she was fourteen, Pepa performed her first healing on a woman in her village of Palaú, Coahuila, in north Mexico. The woman was wasting away from a week of stomach cramps and nausea. She was *empachada,* afflicted by some alien spirit that had entered her body to block and torment her guts. Pepa explains how she laid the ailing señora on a large dining room table, rubbing her with freshly squeezed plant oils,

tightly wrapping her in a blanket, "like an enchilada," and praying by her side for hours, petitioning the evil spirit to come out. The cramps subsided and the lady quickly got better.

Many years later, my brothers and I would be left with my grandmother and her old sisters when we were sick with colds. They wrapped hot, wet towels around our clasped hands and had us pray, "to preserve and concentrate the warmth of your body." The heat of the living rooms of *las Viejitas* was moist with the faint, burnt paraffin scent of the gas flames rising along the white-hot porcelain heating fixtures. While I lay dazed with the flu on a sofa, watching *The Andy Griffith Show*, *Let's Make a Deal*, or *The Mike Douglas Show*, they made *huevos rancheros* and *atole de arroz,* read the Bible, planted a new cactus in the backporch garden, and in the afternoon, took a long, tranquil siesta.

On their solo trips to Mexico, we heard how *las Viejitas* rode tough mares and swam in rushing rock-bed arroyos. After being dropped off across the border in Nuevo Laredo or Piedras Negras, they traveled by bus far into the old country to see *sobrinos y comadres* in Monterrey or Nueva Rosita, or deeper into Mexico to collect water from a spring in Querétaro said to have healing powers.

Some traded small parcels of real estate, purchased originally with insurance money from their long-departed husbands. Some loved parades – some wore fur coats in the middle of summer. Others prayed with eyes closed, their hands held to the breast and clasped so tightly the blood ran out. They wore powders and pomades, with small handkerchiefs always modestly folded into their cuffs or bodices.

Effortlessly, they seemed to know exactly what needed to be done. When a violent storm suddenly descended on the city, they pulled the

windows closed and made crosses of lime on small cards, placing them under the beds, chairs, and tables.

They rolled tortillas while cooking beans and *carne guisada* on fiery stoves – and ended most days with a shot of tequila and a little juice glass filled with beer.

Then it was time for the rosary.

That there were no men among *las Viejitas* didn't seem strange at all. They seemed to have died so far in the past that no one ever spoke of them. The pictures of the grandfathers, and the great-grandfathers, were kept in loving regard in living room cabinets and bedroom bureaus – always with the claw mustaches, always un-smiling, stiff-spined in their heavy wool suits. In one old ivory frame, Uela and Abuelo Juan José, my father's parents, were caught in brisk midstride, staring ahead, snapped by a strolling photographer on the downtown sidewalk of Houston Street, under the marquis of the Texas Theater. I marveled at my grandfather's stance, with leg kicked out as if in a march. His expression was tender yet determined. But by the 1950s, most of the men were already distant memories. *Las Viejitas* had made it through without them, even if much of the century had been lonely.

They had raised their tribes – las familias – in *El Norte,* virtually alone. Most of their men fell early in the century, at an epic age's end when the memories and dreams of Old Mexico were reced-ing quickly to the south like a tide falling back into an ancient inland sea, past Zarzamora Street in San Antonio, past the moonlit chalk bluffs of the Nueces River in south Texas, then farther south past the towns of Cotulla, Hondo, Eagle Pass, and the Rio Grande.

After freely moving north and south for gen-erations, the Santos were left on the north bank of this vanishing memory – *naufragios* – shipwrecked beyond the border. No one now remembered when Texas was Mexico, was Nueva España, was wilderness before the Europeans came.

There was revolution in the old country when the family set out for the north in this century. In 1914 they were Mestizo settlers, part Spanish, part Indian, on the edge of the ruins of ancient Mexico and New Spain. Even though these lands had been Mexican for nearly three centuries – Texas had been taken over by los Americanos in 1836 – it was a new world they settled in, less than three hundred miles from home. Mexicanos could easily keep to themselves, but back then, there were some places you just didn't go. Mexicans knew to avoid completely the predominantly German Texas hill country towns of New Braunfels and Fredericksburg, where there had been trouble in the past with *"esa gente con las cabezas quadradas"* – "those people with the square heads" – as Great-uncle Manuel Martinez, Madrina's husband, used to say.

There were outposts of the "pueblo Mexicano" in cities of the north like St. Louis and Chicago, in Detroit and Seattle, but the Mexican Ameri-cans mainly stayed in the lands we knew best, from California to Texas, not too far from *el otro lado,* "the other side," as Mexico was often referred to.

"The apple never falls too far from the tree," Uela used to say. By leaving Mexico, the family had become exiles in what was really our own homeland. But under the all-knowing gazes of these *Viejitas,* we never felt oppressed or downtrodden.

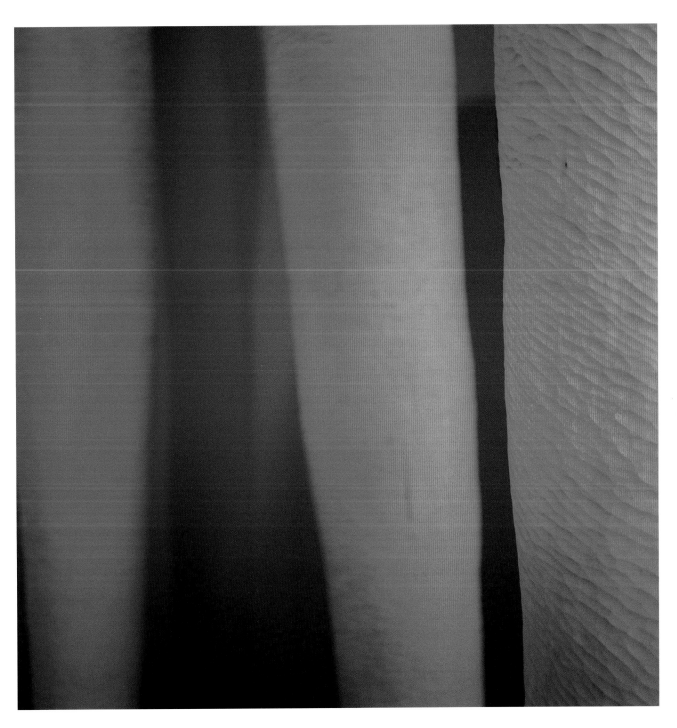

Scott Martin, *Red*, 2001; archival pigment print, 24 x 24 inches.

CATHERINE BOWMAN

Deathwatch Beetle

You are my dog. Your teeth are white. Your tongue
is black. You are my circling sea fish. Behold,
the circling of the planets are nine. Three times
nine the moon comes full

circle. Blind night snake, here in this narrow space
we shed our skin again. Taste the air, it's like
milk. I love this part of the river. We are
two night snakes kissing.

You are my mastiff bat. Your fur is cocoa.
You fly with four long fingers. The fifth,
 the thumb,
is free and clawed. You are my bearded pig. Rain
grubs and roots the swamps.

You lick and eat the ground. Why didn't they tell
me of your filthy habits? Your penis is grooved
and you have two sallow tusks and there are scent
glands in your anus.

You are my sable antelope. Horns like carved
storms, face piebald, ears two blue cloudlets,
 your back
a Niagara of brilliance. Now my desert
woodrat. I find your

stick rooms filled with forgotten objects. My arms
and legs are cut and bruised from chasing over
the cactus. And now you're my deathwatch beetle.
All night you tap, tap,

tap on the window. There's a luminous spot
on your thorax and your nostrils open and
close like fans. You say there's no need to worry
you have an extra

set of eyes for the water, enough air in
your wing case to keep us alive a long time.
Mammoth cumulus trundle the hemisphere,
now as we're churning

in the icy Atlantic, the wind a blue gray
aphrodisiac dug up from the Fire
Island mud. Fever yellow burns on the sky.
Darling, this is our life.

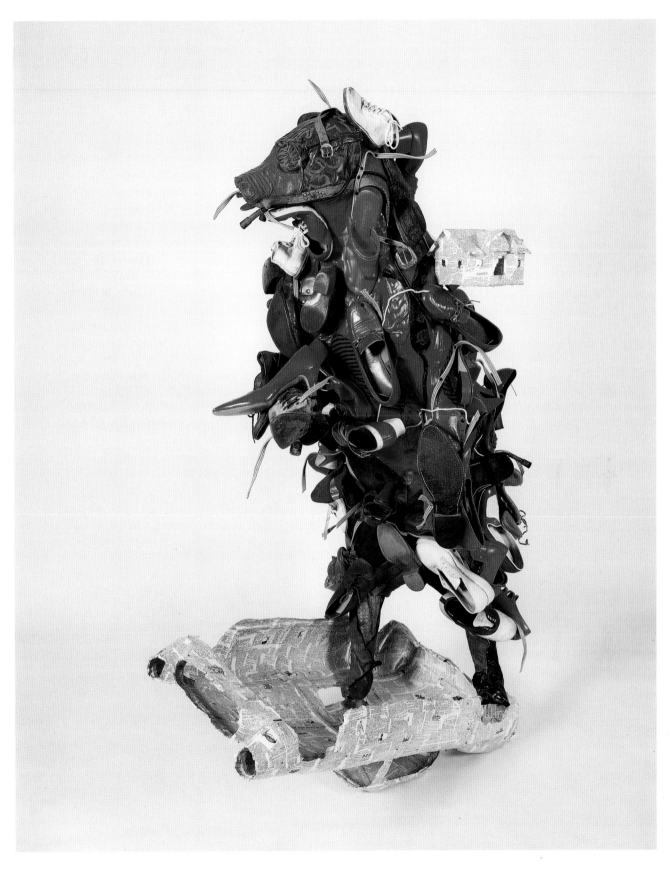

Ken Little, *Burn*, 1985; shoes, bible pages, dictionary pages, and mixed media, 72 x 26 x 46 inches.

NORMA ELIA CANTÚ

Mexican Citizen

In the photo stapled to my official U.S. immigration papers, I am a one-year-old baldy, but the eyes are the same that stare back at me at thirteen when I look in the mirror and ask "Who am I?" and then go and cut my hair standing there in front of the mirror, just like Mia Farrow's in Peyton Place; Papi has a fit. The eyes are the same as the ones on another photo where I am twelve – this one stapled to a document that claims I am a Mexican citizen so I can travel with Mamagrande into Mexico without my parents. We sit for hours waiting at the consulado on Farragut Street until our number is called and the cheery clerk talks to Mamagrande, takes the papers to a mysterious back room to have the cónsul sign, and finally returns. The papers flourishingly signed and decorated with an official stamp – I am declared a Mexican national. I can travel back to Mexico without my parents. I stare into the camera a shy skinny twelve-year-old anxious about body hair and developing breasts that seem to be growing out one larger than the other. Anamaría my best friend confides that that is her fear, too, for as oldest sisters we have been carrying babies almost all our short lives; since December we've been consciously shifting the babies from the right to the left so we won't have one breast larger than the other. We marvel at the bras hung on the line every Monday morning at the Valdezes', Doña Cata must have huge breasts, even bigger than Doña Carmen's, whose bras we've never seen on her line, so we deduce she doesn't wear a bra. We're obsessed by breasts, daily checking our self-perceived asymmetrical protuberances. And talk of when we'll wear bras and how to ask our mothers for bras for next year: how can we go back to eighth grade braless? Such a tragedy! Such a dilemma! But now I'm off to Monterrey with Mamagrande, to her house on Washington Street across from the Alameda. Where my cousins will tease me and call me *pocha* and make me homesick for my U.S. world full of TV – Ed Sullivan and Lucy and Dinah Shore and Lawrence Welk, Bueli's favorite – and Glass Kitchen hamburgers – eight, then six for a dollar on Saturday afternoons. I'm homesick for parents, and siblings, and bingo at San Luis Rey Church with Concha our neighbor. Cousins. Kind and cruel, ask me to say something in English, I recite, "I pledge allegiance to the flag . . . ;" to sing something, and I sing to them silly nursery rhymes and tell them these are great songs: Humpty Dumpty, Jack and Jill, Little Miss Muffet, Old MacDonald. They listen fascinated, awed, but then they laugh when I don't know their games, "A la víbora, víbora de la mar, de la mar," or their hand-clapping games, "Yo no soy bonita ni lo quiero ser, porque las bonitas se echan a perder." And, "Padre e hija fueron a misa, se encontraron un francés . . ." I'm homesick and I don't have a word for it – I cry silently at night asleep in a cot out on the zaguán of the long long house with the colonial windows that face the street, sills close to the floor, cool to the touch, so wide we play jacks on them while the adults sleep their siesta. Cousins. Tina, Lupana, Tati. Scare me with stories of robachicos who steal children and sell them as slaves, or make them beg at the entrance of the cathedral. Cousins. Pita. Chabela. Rey. Teach me to ride a bicycle, to barter with the vendors, and I laugh at their jokes even when I don't understand them. Cousins. I'm sent as chaperone to Tina. She meets Chago, a escondidas. Later, at home, in my innocence I let it out that Chago bought me a paleta – de mango, my favorite – and she really gets it. Papagrande fuming; they don't like Chago because he's not Catholic, in fact he's the son of a Protestant minister. But I don't care. I like his laughing hazel eyes and curly puppy-brown hair. The next day on the way to Felita's to pick up an "encargo" for Mamagrande, Tina explains. I must learn to keep secrets otherwise Papagrande will be angry. I listen and obey, learn the lessons of growing up.

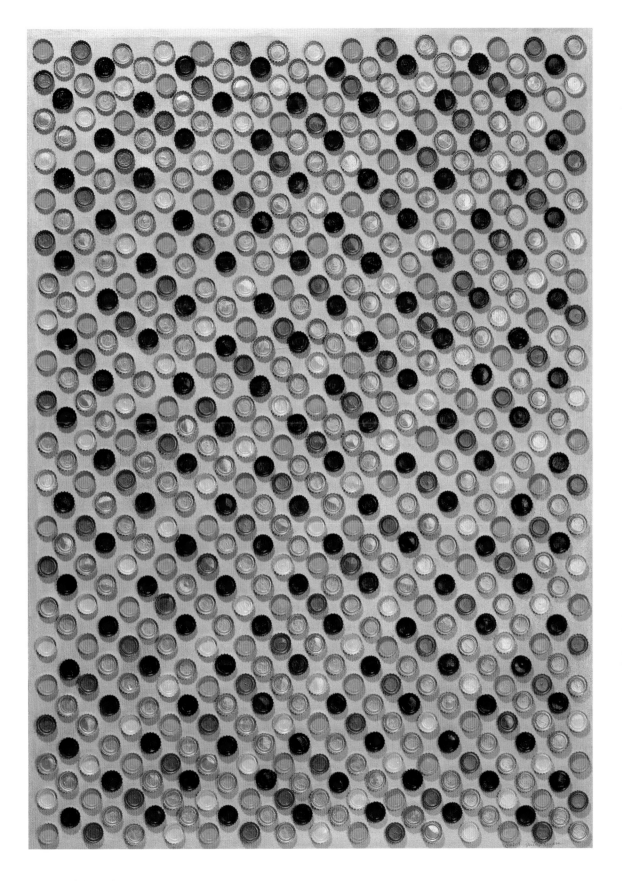

Anita Valencia, *Artifacts #17*, 2007; recycled bottle caps with acrylic on canvas, 42 x 30 x 2 inches.

MARIAN HADDAD

Resurrection

Ascension of bone against bone.
There is something that clatters
like fangs strung together on twine
about my neck. Black sky vapors.
My grandfather's five moons rise
above me. His wife stands clouding
the door of night, blesses me with her once-
fleshy palm, lays it like ivory twigs
upon my head. A holy garment. The chalice
and the cup. She bids me to find blue,
points to the field of night flowers, white
and heavy with damp. I kneel in-between rows
of petals and stems, scent seeping. Camphor
of night. She bids me to immerse myself in water,
past the patch of trees. She prays I will bear
children, that they will swim like truth
around my sphere. She names me
Saturn, and I bow to her presence
in silence, her bones clattering a prayer,
near and around me.

Michael Nye, *Rebecca*, 1998; black and white silver print, 20 x 24 inches.

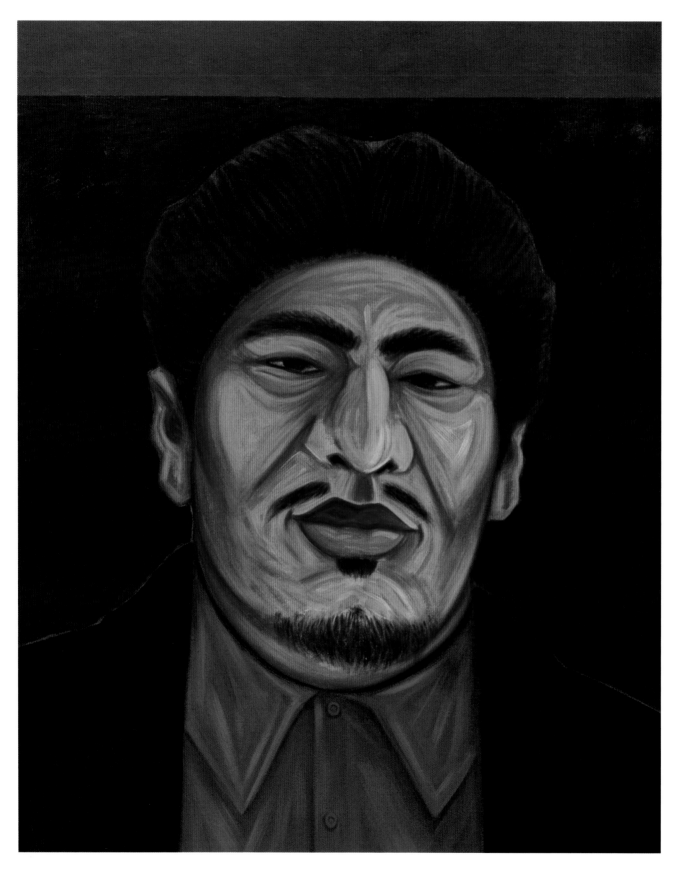

César A. Martínez, *Chevo*, 2006; acrylic on canvas, 54 x 44 inches.

OSCAR CASARES

RG

I saw Bannert at the mall the other day. He was standing near the entrance eating a cone of pistachio ice cream. He pretended he didn't see me, and I returned the favor. This is the same man who used to live across the street from us years ago. Our boys grew up together, played, got into fights. Bannert would wave hello if we happened to pull out of our driveways at the same time. He knows a little bit of Spanish, and sometimes when he came over to the house he tried to say a few words here and there. I appreciated the effort he made. If we saw each other at one of the high school football games, we might shake hands. We were never close friends, but there was a time when we talked in the way neighbors do. That was years ago, though. I couldn't find anything to say to him that day at the mall. And I guess the same goes for him.

Bannert probably thinks I'm crazy. But I'm not. I can tell you exactly when the trouble started— October 3, 1976. I know the date because I keep a record of things. It's nothing fancy, not a diary or anything like that. I just write down what I do every day. It started when I was delivering bread and I had a problem with my supervisor. One day I noticed he was following me on my route, checking to see that I wasn't slacking off. The man had a problem trusting people. He wasn't from around here—maybe that had something to do with it. Either way, I thought writing everything down on paper was a good way to defend myself if he ever said anything against me. I did this at the end of the day, right before I went to bed. Just a few short notes about what I did on my route, the people I spoke to, the mileage on the vehicle, and how long a lunch break I took. Then one night I was writing down all the things I'd done and I realized I hadn't worked that day. This was a Sunday. It had become a habit after so many years, is what I'm trying to say. From then on I

wrote in my notebook every night, even after I quit that job and found a better one.

Don't think that I spend a lot of time writing in it, because I don't. Here's what I wrote last Saturday:

Breakfast at Reyna's Cafe, rotated and balanced tires, bought a new ceiling fan, haircut at Treviño's.

If it's a good haircut I might mention it, but usually it's just a haircut. Sometimes I look back at the end of the year and see what I was doing. Or I'll pull out a notebook and see what I was doing five years ago on that day. I have one for every year back to 1973. They're small spiral notebooks, fifty pages, the same ones the kids use in school. I write the year on the cover.

October 3, 1976—Mowed grass, front and back, trimmed weeds growing next to fence, loaned hammer to Bannert.

So, you see, I have it in writing. I'm not crazy.

My wife said Bannert probably just forgot. I don't know how an honest man forgets for almost four years. I don't know how he wakes up every morning, walks out his front door, looks across the street—straight at my house—and forgets he hasn't returned my hammer.

But she's quick to defend other people, make excuses for them, especially if they happen to have blue eyes. Then they can't go wrong. She thought I was exaggerating the time I told her about my supervisor following me. She claimed that the reason I was so upset was because this supervisor happened to be a gringo. That is her opinion. I've come to expect this from her. You should have seen her when we first moved here. There were only a few Anglo families, but she

thought we were living at the country club. Over the years, most of them have moved across town or passed away, until it's come to be almost all raza that live here. I've lived and worked with gringos my whole life. Gringos, mexicanos, negros, chinos. It makes no difference to me. I've always been more interested in living next to honest people than anything else. After that, they can be any color they want.

My wife actually wanted me to walk over and ask Bannert for the hammer.

"Excuse me, Mr. Bannert, but you know that hammer you borrowed a really long time ago, the one you know and I know is mine, pues, I need it back now."

Something like that. But I said I wasn't the one who did the borrowing, so why should I be the one doing the asking?

I was sitting on the porch steps sharpening the blades on the clippers when Bannert came over that afternoon. He stared like he'd never seen anybody sharpen blades. He stared long enough that he made me uncomfortable, and I finally stood up. I don't like people standing over me when I'm working. He was wearing a white T-shirt and a pair of overalls that had creases. His freckled skin was burning with the sun. Bannert isn't the kind of man who works outside every day. He earns his living selling sofas and beds and whatever else they have in a furniture store. If he had yard work, he usually hired somebody to do it.

"The yard looks good, hombre," he said.

"It could use some rain," I said.

"I guess that's why God made sprinklers." He laughed at this.

"Looks like you're getting ready to do some work, Bannert."

"Yeah, I need to fix a few things around la casa. The dryer needs a new exhaust hose. Plus my wife has me hanging up some curtain rods but, chingado, I can't find my hammer. You think I can borrow yours?"

That's how it happened. That's how I remember it, anyway.

He's not the first person I ever loaned something to. George Fuentes used my weed whacker once or twice. I let Domingo, the man who cleans yards, borrow my machete when the handle on his broke loose. Torres needed a small wrench to fix a toilet. Nobody can say I'm pinche with my tools. But then all those things were returned to me within a day, two days at the most.

Bannert was different. Four days went by y nada. No hammer, no apologies, no "Do you mind if I borrow it for a few more days, hombre?" Nothing. Like they say on the radio: Ni-fu, ni-fa.

So I asked myself, "How long do I wait before I say something?"

It's not like he was a stranger who was going to run off the next day. He lived on the other side of the street, maybe a hundred feet from his front door to mine. If I went over too soon, it was going to look like I was desperate and I didn't believe he'd bring the hammer back on his own, which wasn't so far from the truth.

I can only remember one thing that I ever borrowed from Bannert. It wasn't even for me, really. My wife invited some of her family to go with us to the beach and we needed an extra folding table for all the food. We thought Bannert might have one and he did. I put a plastic covering over the table just in case one of our boys spilled something on it. I didn't want Bannert saying later that those people across the street didn't know how to take care of things. And as soon as we got home, I wiped off the sand and returned the table to him. Bannert looked surprised to see me and asked if one of the legs had busted. The man couldn't understand why I wanted to return the table so quickly.

"Thanks," he said, "but you didn't have to bring it back so fast. I knew you'd stop by when you had a chance."

Right there's the difference between us. Bannert takes everything for granted. Why should I have kept his table one minute longer than I needed it? I was glad that he had a table and was willing to lend it to me in the first place. He thought it was okay to bring back my hammer when it was convenient, when it suited him. I don't work that way.

Time passed: two weeks, three months, seven months, a year, two years.

I understand that most people would've already done something about the hammer, but I'm not most people. I never felt it was my responsibility. Bannert's a grown man. He knew what he was doing. I shouldn't have to go around picking up after him. Just forget about it, my wife said – which was easy to say, since he didn't take something that belonged to her.

During that time, I saw him use my hammer on three different occasions:

May 18, 1977 – Mowed front yard, trimmed grass along the sidewalk, cleaned lawn mower, watched Bannert hammer a new mailbox onto the side of his carport.

November 30, 1979 – Raked leaves in front and backyard, changed oil and filter in car, saw Bannert and his wife nailing Merry Christmas decorations to the front of his house.

July 4, 1980 – Sprayed tree for worms, washed car, drove the boys to fireworks stands, Bannert posted a red, white, and blue sign in his yard: Vote Reagan.

I'm not a political man, not any more than the next Democrat on this block, but I came pretty close to walking over there and grabbing the hammer out of his hand. The problem now was so much time had gone by that saying anything would make it look like I had been hiding my true feelings the past four years. That every morning when he waved and I waved back, I wasn't thinking, "Good morning, Bannert." That instead I was really thinking, "Why the hell hasn't this gringo brought back my hammer?" But the truth is that I didn't think about it all the time. Sometimes months would pass before I remembered again. And when it did come to mind, it was more like a leaky faucet that you forget about until some night when you can't fall asleep and then you hear the *plop . . . plop . . . plop . . . plop . . .* but then you forget about it again the next morning.

I will say that after the first year – when it was clear to me that he wasn't bringing back the hammer – there were fewer and fewer reasons to be friendly. He'd wave and I would nod back, just enough to let him know that I'd seen him. After mowing the yard, I used to sweep the curb and then walk over and sweep his side – I figured the street belonged to the both of us and if his side looked good, my side looked good – but I put an end to that. Christmas Eve we have a tradition of inviting our family and a few neighbors over to the house for tamales. My wife and I were going to sleep after one of these parties and she asked me if I knew why the Bannerts hadn't come. "I guess I forgot to invite them," I said.

I think he got the idea, because he stopped coming around. He stopped being so quick to wave. He stopped bringing fruitcakes around the holidays, which was fine with me because I never touched them anyway. When he threw a big New Year's party and cars were parked up and down the street, we were somehow not on the invitation list. But as far as I was concerned, he could keep his fruitcakes and his invitations, the same way he'd kept my hammer.

13

It's not like I stopped hammering altogether. If I needed to replace some shingles on the house or fix the leg on a table, I used my other hammer. It was an older one that had belonged to my father. The handle was wooden and the head was rusty. I had to wrap duct tape on the handle because the wood was splitting. The head rattled when I used it, and I knew it wouldn't be long before it broke off. My other hammer, the one across the street, was all steel with a black rubber grip. It fit in my palm like a firm handshake. I bought it at Sears.

Maybe I should've written my name on it, my initials: RG. But you wouldn't think you'd have to do that with your own hammer. I wasn't working on some construction job where your tools can get lost. It wasn't a suitcase that somebody might pick up by mistake and walk off with. Your hammer should be your hammer, your property. You never know when you're going to need it.

August 5, 1980—Finished painting the outside trim on the house, cleaned brushes and tray, watched news—weatherman says hurricane headed to the Valley.

We don't get hurricanes every year, but if you lived through Beulah in '67, you know what they can do. It did most of its damage right here and in Matamoros. Trees were ripped out of the ground, phone lines got knocked over, just about every part of the city flooded, the electricity was out for almost a week. All the food and milk in the refrigerator went bad. Forget about clean water. I lost two trees in the backyard. The wind had that poor grapefruit tree twisting around like a pair of underwear hanging on the clothesline. The mesquite split right down the middle. We heard the wood cracking all the way inside the house and I felt a part of me was also being ripped up.

The biggest branch fell on the fence and made it into an accordion. And what happened here is nothing compared to what those poor people went through on the other side of the river. Nobody wanted to have that experience again.

There wasn't anything to do but wait. Wait and pray that it died down or turned some other direction. I watched the news every chance I had. Some people were in the habit of leaving the area, driving north, whenever they heard news like this. I can't say I blame them, but it wasn't something we ever did.

August 9, 1980—Hurricane Allen expected to hit Brownsville-Matamoros tonight, weatherman says winds over 170 mph (his words: "could be stronger than Beulah"), took day off from work, bought boards at De Luna Lumber, boarded up windows, Bannert finally gave me back my hammer.

There's more that I didn't write down in the notebook—there always is.

First of all, let me say that we lived through the hurricane and we're still here today. Me writing in my notebooks, Bannert eating ice cream cones at the mall. The hurricane ended up hitting the coast about forty miles north of here, where there weren't as many people. It still did its damage. It just wasn't as bad as it could have been. A few trees were knocked down on our street and we were without electricity and water for a day, but we survived. Bannert stayed around for a year and then moved to a new subdivision on the north side of town. Four months later another family moved in across from us.

But what sticks out in my mind about the hurricane happened the afternoon before it actually hit. I was waiting in line for almost an hour at De Luna. It looked like half of Brownsville

Victor Pagona, *Menu #14*, 2006–7; photo, 13 x 19 inches.

was there buying lumber. Bannert was towards the back of the line, but neither of us made an effort to say hello. The other men were talking about what they'd been through with the last big hurricane. An older man with a cane told everybody how he'd lost a sister in Matamoros when she drowned in her front yard. He said the two boys with him were her children but that he had raised them as if they were his own.

As I stood in line, I could see a policeman directing traffic on International because the lights had gone out. People tried to get in and out of the Lopez Supermarket on that side of the street. My wife was inside there buying all the food and candles she could fit into a shopping cart. The parking lot was full of women loading their cars with enough groceries to wait out the worst of the storm.

I was sliding the last board onto the bed of my truck when I noticed Bannert and one of the De Luna workers unloading a cart stacked with boards. Anybody could tell they weren't going to be able to fit all that lumber in the trunk of Bannert's car, and if they did, he was going to cause an accident. Some other day they might have delivered the boards to his house, but there was a line of men still waiting to buy lumber.

"Looks like you could use some help getting that back to the house, Bannert," I said.

"You have room in your truck?" he asked.

"I think I can fit a few more boards."

We each grabbed an end of the first board and started loading, one by one, neither one of us saying a word. We hadn't talked in almost four years—why start now? He drove out of the parking lot first, and I followed him back to the neighborhood. On the way there, I saw him keeping an eye on me in the rearview mirror like I might forget where he lived. When we were at his house, I backed my truck into the driveway. Again, we grabbed the boards one by one until we had them all leaning against the carport.

"Now I just have to get them up there," he said and laughed.

"Maybe one of your boys can help you."

"Nah, they're still too young. They'd only get in the way."

I thought about his situation and what I should do. He was right about his boys getting in the way. Mine wouldn't be any help, either, but at least I knew I could board up my house without any help. I remember looking at Bannert's overalls, a little faded now, but still with the creases.

"Two can work faster than one," I finally said. "Why don't I help you get started with some of these windows?"

I had my old hammer in the toolbox in my truck. Bannert brought out a stepladder so I could reach the top of the windows. He held the boards against the house and I hammered the nails in. I could hear the sound of banging hammers and the grinding of electric saws coming from every direction. I stopped a couple of times just to listen. I wanted to believe the hammers were somehow sending messages all over the neighborhood. Messages saying what we didn't have words to say ourselves. Regardless of what had happened between us, I didn't mind helping Bannert this one afternoon. His family lived in this neighborhood, just like mine. If I could lend a hand, why not give it? And I had the sense that if he had been in a position to help me with something that he wouldn't have hesitated. That's what I believed. But I also knew we would've never talked if the situation hadn't turned out the way it did. And after this work was done, we would stop talking again. We'd go back to ignoring each other, and that's just the way life would be around here. I knew it even back then.

I ended up doing most of the work that afternoon, but when we were at the last window I thought he might want to do one.

"You want to knock a few in?"

"You bet," he said.

We switched places. I held the board against the window, and Bannert climbed the stepladder. He took a couple of practice swings with the hammer and then hit his first nail. He had two good swings before he hit to the left and the nail bent sideways. It took a couple of taps to straighten it out and start again. The next few nails went the same way.

"Be sure you hit the center of the head and put some more weight behind your swing."

He nodded okay and banged the nail a couple of times. On the next swing he missed the nail altogether and the hammer pounded the side of the house. That was what finally made the head crack off the wooden handle. The head flopped over like a chicken with a broken neck.

"Sorry." He stayed looking at the broken hammer.

What could I say? He'd borrowed my good hammer and never returned it, and now he'd broken my old one.

"It's my fault," he said.

I didn't argue with him. He climbed down from the stepladder and turned towards me.

"I'm going to give you my hammer," he said.

Then he reached into a brown shoe box he had in the carport and pulled out my hammer. There it was, after four years. It didn't look any different from the day he had borrowed it. I held the hammer again and it felt like a missing finger that had been reattached to my hand. So, yes, maybe he really had forgotten that it was my hammer. That didn't excuse the past four years, but at least it explained to me how a mistake could've happened.

"Go ahead, it's yours now," he said. "I owe you one, hombre."

I guess he thought I might refuse his offer to take the hammer. He looked me in the eye, and I wanted to believe that the man was telling me the truth about having forgotten. I mean, there were things I forgot now and then. Sometimes I had to look in my notebook just to remember what I was doing two days earlier. It was possible that his memory could've failed him. Anything's possible.

"Thanks, Bannert."

It felt strange to be thanking him for giving me something that was really mine, but those were the only words that came to me. I wanted to say more and set things straight with him, explain the misunderstanding, and see if maybe there was some way to put this behind us. It was just a hammer that had caused this. Maybe we could even laugh about the whole thing. I would've said something right then, but I could feel the temperature had already dropped a couple of degrees and the wind was beginning to shift. I only had a few hours left to board up my own house.

ANGELA DE HOYOS

La Vie: I Never Said It Was Simple

for Alicia Z. Galván—3/27/96

She reminds me of that painting by
Velázquez: *La Infanta Margarita*,
in a pink and silver gown . . .

except that here, she is sentadita muy
atenta, listening to my incantations,
listening as I command the heavens,
cutting the clouds con mi cuchillito;

eyes round with hope in breathless
expectation, she wants simple clear-cut
answers to her square-root questions;

little does she know I can barely—just
barely—hew my own antidotal sword
from the selfsame tree that grows the
nightmare dragons. (. . . Ay, if only I had
the wisdom of Sor Juana!)

. . . An oracle? Listen, I am nowhere *near*
Delphi. Ni soy curandera, con polvitos y
milagros, con monitos de aserrín

. . . not a wonder-woman-shaman who
paints a mystic mandala, who wraps up the
world in a huge tortilla de maíz, with a
 Here it is, take it, it's all yours.

. . . She is, let us say, a captive voyeur
witnessing the secret dragline of my
voice. My voice that comes and goes like
the wail of La Llorona . . . Llora que llora

La Llorona . . . ¿Por sus hijos? . . . Ay, no . . .
Llora porque *nunca* tuvo hijos. Pobrecita,
es yerma. Qué pena. So she cries and cries.
Llora que llora La Llorona por los callejones
de San Cuilmas. Finally, por fin, she comes
to her favorite stomping ground: the river.
She finds her spic & span spot on a rock,
sits down and dries her eyes con una pata.

A sigh, and she twists her thorax to the right,
reaches down to open the tiny silver door of
her spinneret. Out comes the moonlight magic.
The magic moonlight thread. The moonlight
thread with which she weaves her stories. Her
brain-children. Her bambinos. Los muñecos y
las monadas:
 *Míos. Re-te-míos. Re-que-te-míos! Just
think! Such beautiful 8-legged people. . . .*

And she thinks and thinks and thinks about it,
until she imagines they are in truth her very
own. (The people, that is—and well yes, the
stories too. . . . Why, everyone knows she puts
them to bed every night, singing a soft
 Coo-coo-roo-coo-coo paloma
. . . all dressed up in pink & blue & yellow
pajamas. Pink for girls. Blue for boys. And yellow
for those undecided.)

. . . But let's not talk about chiquilladas. Let's talk
instead about that sword—yeah, sure, why not—
that Huitzilopochtli sword of lightning. If we
follow the *HOW-TO* instructions carefully, I'm
sure we can construct one. . . . Oh, yes, of course,
someone is *bound* to discover our upstart
"Wishing Well" machinations. Our Mad Hatter;
our Crazy Coyotl notions. . . .

But by then, it will be too late. I will have given
you the sword. You will have given it to the Queen.
The Queen has called a meeting of the deck. The
deck has counted the ayes and the nays. Meeting
adjourned!!! The order has been submitted in
triplicate. Sealed and delivered by hand. At 10 A.M.,
the Queen accepts and *HO!* . . . A deft swing, a
ringing whoooooosh . . . and there!!! She has klopt
off the eeny meany, what a greedy Medusa head. . . .

¿Ya ves? Like I said, it's not simple . . .

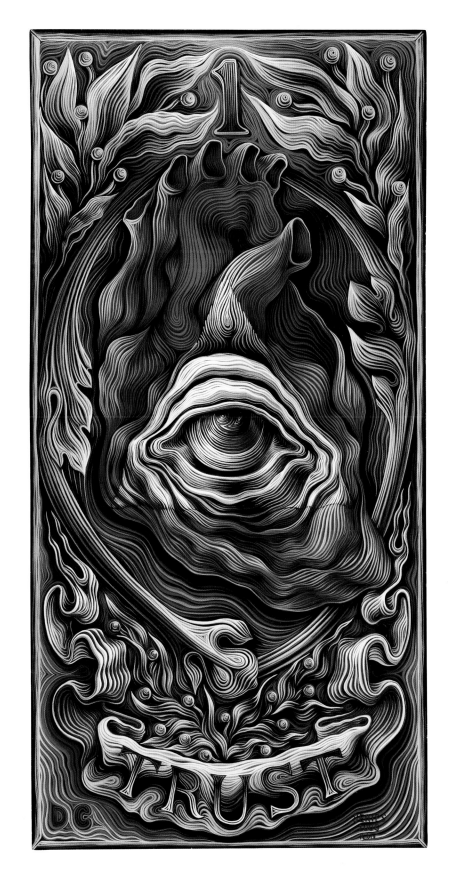

Alex Rubio, *Trust*, 2007; acrylic on canvas, 48 x 30 inches.

Penelope Speier, *Mantra*, 2000; oil on canvas with glass beads, 8 x 10 inches.

JERALD WINAKUR

From What Are We Going to Do with Dad?

My father is eighty-six years old. He was never a big man, except perhaps to me when I was his little boy. At most he was five feet, eight inches tall and weighed 160 pounds. Today he weighs barely 120. Maybe he is five feet two. He teeters on spindly legs, a parched blade of grass in the wind, refusing the walker his doctor recommends or the arm extended in support by those of us who love him. He doesn't know what day it is. He sleeps most of the time, barely eats. Shaving exhausts him. His clothes hang like a scarecrow's. Getting him in for a haircut is a major ordeal. He is very deaf but won't wear his hearing aids or loses them as often as a kid might misplace his marbles. He drives my mother – five years younger – crazy to tears.

My only sibling, the architect, asks me every time we are together (which is often because we all live in the same town) and every time we speak on the phone (which is almost every day because we are a close family now in crisis): "What are we going to do with Dad?" As if there must be a definitive answer, some fix – say, putting a grab bar in the bathroom or increasing the width of the doorways. Something that is according to code.

He asks me this question not just out of fear and frustration, not only out of a realization that it is time for the adult children of a progressively demented elderly parent to act, but because he figures that his older brother who has been practicing medicine for almost thirty years should know the answer. I do not know the answer. I do not have a pat solution for my father or yours – neither as a son, a man past middle age with grown children of his own; nor as a doctor, a specialist in geriatrics, and a credentialed long-term care medical director. [. . .]

Thirty years ago I became a physician. My father, a first-generation American born of immigrant Russian Jews, was then the age I am now. He never completed high school. He was a sensitive man who helped his fatherless family eke out a living through the Depression and then served five years in the Army Air Corps – a member of the "Greatest Generation." He ended up a man who was neither secure nor successful, even in this country's most optimistic years. But he was proud of me, a college boy, a medical school graduate.

In my family there was no more honorable profession than medicine, and the highest calling to my generation of physicians was the discipline of internal medicine – to follow in the footsteps of Sir William Osler, an empathic bedside clinician, a skilled diagnostician of the first order. To become a physician who derives great joy from shepherding his practice, his flock of inter-connected families and friends through their medical lives, available for those frightening calls in the night, those tense moments in the ER, those difficult days in the intensive care unit (ICU). The one who is trusted to help make the tough choices, the final decisions. The one true patient advocate with broad knowledge, com-passion, and unbiased judgment. [. . .]

Three years ago my father, a longtime heart patient, had trouble breathing and complained of chest pain. He was admitted into the hospital with congestive heart failure. This is the hospital in which I have made rounds almost every day for the past three decades. Many of the nurses and therapists and I call each other by our first names. The CEO is my friend and patient. My father's physician is one of my young associates, well-trained and eager. I was confident that my father would receive the best medical care he could get in America today. Yet I would not leave him alone in his hospital room. During the day, if I or my brother or mother could not be there, I had a hired sitter by his bed.

It's rarely talked about, but acute hospitalizations are the most dangerous times for the elderly. Even if they have never before manifested any signs of confusion or disorientation, it is in the hospital – in a new and strange and threatening environment, under the influence of anesthetics, pain pills, antiemetics, and soporifics – that the elderly (competent or not) will meet their match. Add to this the iatrogenic mishaps (caused by the "normally expected" side effects and complications of standard medical procedures) and the human errors (mistakes in drug dosing, the right medication given to the wrong patient) – now multiplying in our modern hospitals like germs in a Petri dish – and it is almost a miracle that any elderly patient gets out of the hospital today relatively unscathed.

I stayed with my father every night; I slept in the reclining chair by his bed. I got up when he did; ran interference with bedrails, side tables, and IV poles; guarded his every move to the bathroom; looked at every medication that was handed to him and every fluid-filled bag plugged into his arm. I was not afraid to question the nurse or even call his physician. Each day my father descended deeper and deeper into paranoid confusion. He couldn't rest, he was intermittently unsure of who I was. At first I could calm him with my voice, talking about the old days, reminding him of our fishing trips on the Chesapeake Bay when I was young. Then he needed the physical reassurance of my hand on his arm or shoulder at all times. Finally, so that he could get some rest, I got in the bed with him and held him, comforting him as he once – in a long-ago life – did for me.

After four days and nights in the hospital, I knew I had to get my father out of there. His doctor came by and told me that his heart failure was better and that his dementia evaluation did not show a treatable or reversible cause. But he didn't like the way my father looked – he was agitated and sleep-deprived and deconditioned, a perfect candidate for some time in the skilled nursing unit. And, after all, here I was, his senior associate, the medical director of the SNU. Surely my dad would get good care there.

I took my father home. I knew if I didn't get him home at that moment, he would never come home again. The SNU for my dad would have been only a way station to a custodial nursing home. I arranged for a home health agency to come to my parents' house and provide my father with physical therapy to aid in his reconditioning and to assist with his bathing and dressing and grooming – something Medicare covers, but for only a limited period. I went to the pharmacy and filled the eight prescriptions he left the hospital with, and I went back again to buy the blue plastic container divided into daily dosing compartments when I realized that my mother was having trouble reading the labels on the bottles and following the instructions. How long had this been going on? [. . .]

From my years as a geriatrician and now as the son of an "old, old" man, I recognize that there is but one inescapable truth: Our parents will become our children if they live long enough. Perhaps if we looked on our elderly in this way, we would be kinder to them. They will become dependent on us, our stronger arms, our acts of gentleness and caring. We will arrange for their meals, pay their bills, take them to their doctor visits, sit by their bedsides at the hospital and in the nursing home.

I don't know what else to do for Dad at this moment, but I know what is likely to happen to him if he does not die in his sleep, a heaven-sent coup de grace that from long experience I recognize is unlikely to occur. There is almost always a great struggle in the end. One day I will get a

frantic call from my mother that he is on the floor and she cannot get him up and he is crying out in terrible pain. Wherever I am, I will drop what I am doing and race over there and find that one of his legs is shortened and externally rotated. His hip is broken. From the wall phone in my parents' kitchen, I will call my brother and I will tell him all the reasons why we should not send him to the hospital: He might not recover from the surgery – indeed, might die on the table given his bad heart. But even if he does survive, he will spend days in the ICU, probably on a respirator, until his heart is stable. And then he will be constantly confused and agitated. I don't see him ever being able to cooperate with physical therapy. At best he will end up in a nursing home, bedridden and at the mercy of overworked, underpaid aides. He will descend deeper and deeper into disorientation and delusion, require medications to keep him from harming himself, and die anyway in a few months – or perhaps even a year or two if he is unfortunate and the care is better than average.

My brother will hear my mother crying and my father hollering in the background. He will feel guilty that he is not in the house with me at that moment. He will remember the time our father took us on a summer vacation to the White Face Mountains and we all huddled together on the swinging bridge in the mist, as the Ausable River tumbled and roared through High Falls Gorge. Then he will say, "Maybe it won't be as bad as you think. Maybe we can set up a hospital bed in his room – I think the door is wide enough – and it

won't take much to alter the shower to accommodate a wheelchair." There will be a moment of silence. "I don't know," he'll say. "You're the doctor. What do you think we should do?"

I do not tell him that I often, in fitful sleep, dream that when the time comes I go to my father's bedside, quietly fill a syringe with morphine, and stroke his arm as I place the tourniquet. I tell him over and over again how much I love him and what a good father he has been to me as I slip the needle into his antecubital vein. Then I say how much I will miss him and goodbye, Dad, goodbye, as I push the contents into his bloodstream. In this dream I tell my mother and my brother that he has gone peacefully in his sleep.

Yet I have not until now given voice to this dream because I know for certain that in the end, I could never do this. Not to my poor, demented, suffering father. Not to anyone. I know there are some who disagree with me, and perhaps this is one way our society will ultimately deal with its flood of elders in this age of limits. I will by then, I hope, be old and no longer on the front lines. When my time comes – before it comes – I will choose for myself. But for now, as long as I have the will and the strength to practice, I am a physician deeply steeped and firmly rooted in the art and tradition of healing, of comforting.

For my father, on that day, I will tell my brother that I will handle it and hang up the phone. Then I'll pick it up again and dial 911.

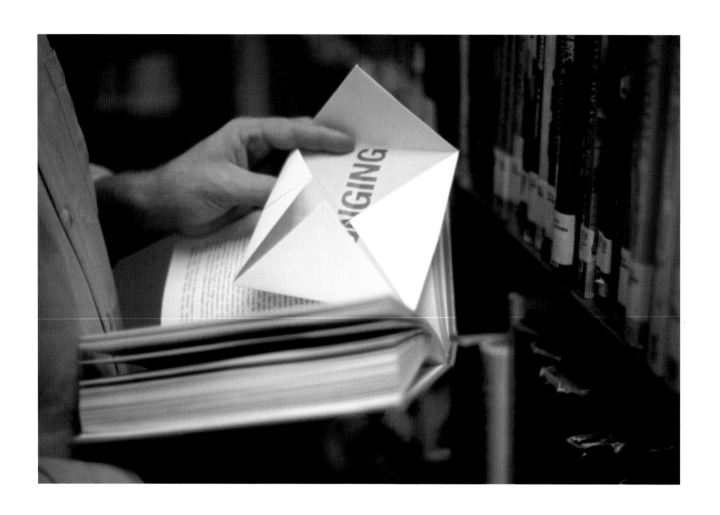

Andréa Caillouet, *Fortune*, 2004; offset prints with the words "LongingBelonging" hand-folded into the shape of fortune tellers (the ancient child's game still played today in countries all over the world); 1,000 pieces were randomly inserted into books at the downtown San Antonio Public Library and another 1,000 in the Martin Luther King Jr. Library in Washington, D.C.

ROLANDO HINOJOSA-SMITH

Rafe Buenrostro

Delineations for a first portrait with sketches and photographs (individually and severally)

Chano Ortega, born and raised in Klail City, died of abdominal wounds received in June, 1944, during the invasion of France. A quarter of a century later, his mother, Tina Ruiz de Ortega, walks the streets of Klail with no idea what it was her son was doing, as she says, "in those Europes over there."

What follows is for them and for a select few.

Miss Moy, our first grade teacher, a mass of red hair and freckles, hated it at First Ward School; she was forever washing and soaking her hands in alcohol and then drying them off with disposable napkins. Somehow she managed to teach me to read.

The next year we were transferred to Miss Bunn's room where quiet and sullen inactivity were the order of the day, and with every day's routine being the same. One day, she decided to ask Lucy Ramírez what it was she had for breakfast that morning; and Lucy, trying to please, lied:

"Orange juice, Miss Bunn, with buttered toast and jelly, and two scrambled eggs." I looked at the free book covers they gave us: she was reading What Every Young Child Should Eat for Breakfast. Poor thing.

"Thank you, Lucy. And you, Leo? Did you have the same?"

Leo Pumarejo looked at Lucy and then smiled at Miss Bunn: "No, Miss Bunn, what I ate for breakfast was one flour tortilla WITH PLENTY OF PEANUT BUTTER!"

Hilario Borrego, he lived in another section of Klail City, either bumped or pushed me, and when I got up I bloodied his nose for him. It happened during recess when Leo and I had taken over the slide. If you came from our neighbor-hood, up you went; if you weren't, you were out of luck. It was a short, one-punch fight, but some-one told his mother; the next day, during recess again, she walked across the yard and slapped me flush in the face.

I was seven then, and I remember that I cried for a long time. But it was a personal affair: I didn't say a word at home. The rest of the year, though, I went after Hilario while Leo kept an eye out for the old hag.

Times were hard and things were bad.

When a city employee came to the Ponce household to shut their water lines, several families came to see what that was all about. The city employee tried to smile his way through, and looking at doña Trini Ponce, he blurted out three or four words in some very broken Spanish. Doña Trini wasn't having any, and looking straight at him, she recommended he gargle with a glass full of bird droppings.

Life is fairly cheap in Flora, and if you're a Texas mexicano, it's even cheaper that that: Van Meers shot young Ambrosio Mora on a bright, cloudless afternoon, and in front of no less than fifteen witnesses.

It took the People of the State of Texas some five years to prepare the case against him, and when it did, the State witnesses spoke on behalf of Van Meers and against the victim.

In the Valley, the few Lebanese who live there are called "arabs" for want of a better name. One of these arabs had a fruit stand, and every night he'd pick a few of us to move some 200 bushels of fresh fruit away from the sidewalk and into his store. And you know how he paid us? With rotten fruit, that's how.

The man was a son-of-a-bitch, of course, but what made it worse was that damfools that we were, we never complained.

In Edgerton, a man armed with a knife lunged at my father and me; we had no idea who he was, but my father then shot at the man. On the way to Klail City long after statements and etc., my father told me not to say anything about the incident right away; the news would get known at home soon enough.

We arrived, and I didn't say a word; trouble was that it wasn't long before I developed a stammer and, soon after, I came up with a very high fever. Had it not been for Auntie Panchita and her prayers, I might have never recovered.

Tacha was a very old woman who lived in the alley behind our home; when she died, my cousin Jehú and I went to see her. There was no one in attendance when we got there, and we could see and smell the cotton swabs in her ears, mouth, and nostrils.

Jehú said he was brave enough to touch her, and he did. Standing there, he reached into his back pocket, and pulled out an old Indian head penny. He held it between his thumb and index finger and made the sign of the cross across her body; it's a good luck penny now, he said.

Pius V Reyes was buried in the mexicano Protestant cemetery just east of Bascom. I can't recall why my father took me with him, but he did; and it was cold, too cold for October in the Valley, I thought. We drove back to Bascom, and he took me to a house owned by some relatives I'd never met; I was served flank steak, flour tortillas, and my very first cup of coffee. Ranch style, they said: instead of sugar, they used Karo syrup and no cream.

As I sat there on a straight chair, the women present took turns placing the palms of their hands on my face to ward off, they said, *el mal de ojo,* the eye of evilness.

I didn't believe in the curse of the evil eye, but ever since Aunt Panchita had cured me of fright and dread, I went along . . . I didn't know *what* to believe.

Aside from a public library and a stopped-up swimming pool, there were two cafés on Ruffing's main street along with some beat up buildings. One of the cafés didn't allow Texas mexicanos in while the other one did; now, it could be that the first would allow us entry but no service which comes to the very same thing. My father and I were in the second one when I spotted a black family, man and wife, and two boys just about or a little over my own age. Dad turned to me and said that black folks would only be served in the kitchen, if there. I didn't understand that part of it, and he repeated once and then again.

On the way home, I wondered how the black man had first explained it to his own kids when they entered the kitchen for service.

One afternoon, after school, Jehú and I were so very busy talking and listening to one another that neither one of us noticed a man walking the white line in the middle of the street; he was carrying a twenty-four pound sack of wheat flour. As we came up, he stopped, wheeled around, ran, and then threw the sack at us. Later on we learned that apart from being drunk, the man had been smoking marihuana cigars and cigarettes all afternoon.

Along those lines, a neighborhood boy, older, but not much older than either Jehú or me, became insane. The family owned a printing shop and, during the day, kept him inside their home,

in the rear of the shop. He escaped by breaking a window, and I happened to run into him on my way back from a grocery errand; I was carrying a milk bottle, and when I saw him, I dropped the bottle and ran so hard and so fast, I ran past my own house. For a long while after that, I'd go out of my way to do all of the house chores, and I'd even invent some; anything. Anything but run errands to the grocery store.

In Monon, Indiana, on the left-hand side of Route 421 going north, there's a roadside place called Myrtle's, about two and a half blocks from a Shell station; we always stopped there to gas up on the way to Benton Harbor during the cherry picking season. When we stopped at the Shell station, Dad and I would then walk from there to Myrtle's for some doughnuts. Once, while the woman waited on us, she told my dad that I was getting to be a little man now. Back in the truck once again, Dad turned to me and said, "This makes the sixth time you've made the trip to Michigan, son."

About a year after my father was killed, we received a formal *esquela*, a printed death notice; it was a woman who had died in Ruffing. I was going on eleven at the time, and I had no idea who she was. My two brothers and I went to the funeral, and although Ma didn't attend, she said *we* had to; an obligation, she said. On the way to Ruffing, my brother Israel, looking straight ahead, said that the dead woman was a half-sister of ours; our father's daughter by another woman.

I didn't know what to say; I looked at Aarón and then at Israel. Nothing. Knowing Dad as well as I did or had, and knowing Ma, too, I realized that, somehow or other, I had lived some ten years among strangers. And, when we arrived at the wake, the people there walked the length of the room, shook our hands individually as we each said and repeated the formulaic phrase of condolence, again individually; this done, we were given their chairs on the front row for the remainder of the wake.

Get some ice, hurry! Quickly now – on the forehead; yes. There, that should help stop the bleeding. No, no, you're going to have to tilt his head back a bit more, but be careful he doesn't choke, now. And you? What are you doing just standing there? Don't you see the shape your little brother is in? I was right all along, I remember telling your father that you were much too young for a driver's license. You go straight home, young man, and wait for us there.

Up front, ladies! Front! Here come the first customers of the day, two young American gentlemen to see us.

Gentlemen? Americans? Shoot, it was just Monche Rivera and me, and we were going on sixteen at the time; the one I got – or the other way round – wore a light cotton dress you could see through; this was my first visit there, and I was game but scared.

In Korea, out in the field anyway, powdered rations came in two flavors; after twelve straight days out there, Cayo Díaz, mess kit in hand, walked over from his tank to ours and said: "We get powdered eggs and potatoes for early chow; we get powdered potatoes and eggs for mid-chow, and, then, for late chow, we get a choice of eggs or potatoes. But I got me a plan. Listen to this: Tomorrow, I'm not going to eat this shit. No, sir. This boy isn't going to clean his plate. And you want to know what's going to happen if I don't clean my plate? It means some Chink'll starve to death, at least that's what they used to say at home all the time. Well, I figure that if I keep this up long enough, why, I can win the goddam war all by myself."

Cayo Díaz and a kid named Balderas and I went on our first Rest and Recuperation to Japan; the southern guys in the outfit called them I and I for intercourse and intoxication . . . At that time, our recon unit was attached to the Triple Nickle, 555 Field Artillery Bn (Major Oscar Warren, Commanding), but we always hung around together.

We started drinking in Tokyo and somehow wound up in Kobe a couple of days later. At the Kobe Station we looked like hell, and a man approached us and gave us a card with an address; we followed him, and it turned out to be a geisha house. The man was a World War II vet, and he wore the light khaki uniform with billed cap; his prosthetic leg was made of aluminum or tin, and he played an old Hohner accordion.

Before we walked into the place, we passed him forty dollars and told a woman there to tell him to come back the next day.

We had some Asahi beer, opened up the barracks bags and had our stuff washed. We had some more beer, bathed, and each got an "only" for company.

We spent a week there, and before it was all over, I wound up singing an old Mexican standard about strangers in an alien land.

In the Valley, there are families from around Klail, Flora, and Bascom who have known each other for some six-seven-eight generations, and many are blood related, as well. In spite of this, when a young man from Klail, say, makes plans to marry a girl from Flora, a commission is charged to ask for the girl's hand. They become serious and solemn; the about-to-be-engaged couple is nervous: he sweats, and she fans herself.

Obdulio Yáñez, a relative of mine, lives in Relámpago; those who know him for what he is call him *La caballona* – the he-mare. There's no such thing, of course; still, he answers to that when called for breakfast, lunch, and dinner. The words "shiftless" and "lazy" used to describe him merely reveal the poverty of the English language in his case.

Sitting on a backless bench, cue in hand, looking out the window and waiting his turn, he asks for some chalk. Someone has just reminded him that Paula, his latest fiancée, has gone to bed with almost every man in Relámpago.

He chalks up, and says: "Relámpago isn't that big a town, you know . . ." He walks around the table. "Two bits says I make the nine ball in the middle pocket."

When Young Murillo told don Víctor Solís he wanted to test Estefanita prior to the marriage ceremony, don Víctor replied that he didn't raise his daughter to be no goddam watermelon.

This happened a long time ago, and Young Murillo still considers himself quite a card, as they used to say; trouble with that is that at this late date, he still has no idea how many times he's been fitted for antlers.

One fine October day, Pancho *la burra* gathered every penny, nickel, dime, and dollar bet on the seventh (and deciding) game of the World Series and left for Jonesville-on-the-Río. The people from Bascom swore (up and down) that he'd get his if he ever showed that rat-chewed nose of his in this town. Again.

Three months later, there he was: mounted on a thin-tire, royal blue Schwinn with hand brakes, horn, twin baskets, etc., and ready to raffle off a radio or a chance on a bus trip to the shrine of Our Lady of San Juan.

As the Argentine once said: Really, now, one can always rely on people not to do anything.

Janet Lennie Flohr, *Adrift*, 2003; four-plate mezzotint intaglio, 6.25 x 9.25 inches.

In Bascom, people walk softly and carry no stick at all; they go about saying things on the order of: 1. Behave yourself; 2. Keep it down; 3. Don't do anything that'll draw the Anglo Texans' attention; 4. Etc.

The bald truth is that our fellow Texans across the tracks could hardly care about what we think, say, or do.

Here's something of what the A.T.s usually say: "Oh, it's nothing, really; just one of your usual Mexican cantina fan-dan-goes, 's all. They drink a little beer, they play them rancheras on the juke box, don't you know; and then one o' them lets out a big squeal, and the first thing you know, why, they's having theirselves a fight."

See what I mean?

When the man at the bank shot himself, just about everybody from both sides of the tracks knew the reasons why. His family was provided for by way of trusts and such.

Now, when Chale Villalón, in his junior year, stole – and that's the word – stole a jersey *and* a football, everyone from both sides of the tracks learned of it in short order.

Our splendid Board of Education instructed a constable to arrest Chale, make him surrender the items, and teach him a thing or two about respecting other people's property.

"Rafe, if old Echevarría shows up, don't let him have any more beer, 'kay? I'll be out in back."

"Has he been drinking?"

"Most of the day, now, and you know how he gets after a while."

"What shall I tell him?"

"Try and see if . . . well, try and get him to stop, okay?"

Echevarría opens one of the swinging doors, looks about, and makes for the bar.

"Rafe, how's about a Buddy Watson?"

"Sorry, don Esteban, but we're out of Budweiser."

"You got any Hamm's left? Hamm's is a good beer, too, you know."

"Yes, it is, but we're fresh out."

"And what about that there Lonestor beer, y' got any o' that?"

"Lone Star? No, we're out of that, too."

"Mmmmmmmmmmmm . . . And Yax?"

"Nope."

"Betcha got Flag! At least the one, right?"

"No, no Falstaff either."

"Well, what *do* you have?"

"All we got's Pearl."

"Pearl, huh? Well. . . . Bring her on out."

"Quart-sized Pearl, Echevarría."

"Well, that's a break! They last longer, you know."

"But they haven't been iced, yet."

"It's my lucky day, Rafe; why, a man can catch a cold with iced-down beer."

A voice from out back:

"Jesus Christ! Let him have his goddam beer!"

No sooner did Tome Fonseca conk Robe Cantú with the red and white No. three ball at Pérez Pool Hall than the guys baptized him anew; this time, they named him *Three,* and in English, too. So, in less than a month, he answered to Three. To tell the truth, the conking was a boon to Robe; face it, it's difficult as hell to rise above the crowd when one answers to Shit-pants.

"Sit on *this!*"

"Your sister loves it!"

"Yeah? Well up your nose with a limber hose!"

"Why don't you take a bite!"

And on and on it went, and it was all talk; neither one really wanted to fight. Now, if someone had laughed out loud or said something like,

"Why don't you two just go to bed together," there would have been blood, and lots of it, probably. But they were lucky no one did, and they were let off easy.

At other times, though, some bystander's wise-ass remark has cost a life or two; these two were just lucky, that's all.

Ma's burial day. That's the third time I've been able to cry. In my life.

The man in charge of the Draft Board in Klail during Korea moved on to become the V.A. adviser; he was given an office in the County Courthouse basement. He advised me to sign up for a two-year course in boat-building; after that, he said, I could then use the remainder of my GI Bill in another form of carpentry: cabinet making.

He'd done right well – his words – without college, and it was his honest opinion I'd waste my time there.

Some adviser; some advice.

Leaving the Valley for a while; I've registered at the University up in Austin. It'll be a new town for me. Will it be a new life?

We'll see.

JENNY BROWNE

Native Grasses

Strange to dig this shallow
and expect anything
to grow. What we scatter
is said to have roots
that know the way.

To slide a spade
in at this flat angle, nearly flush
with a plan to welcome
the from-here-low-
maintenance-grow-to-
thigh-high varieties.

Not to dig really but to lift
the surface, untangle
bottom knots of always green.
We do it for the promise
in the picture, for the sound
of their sparking names, Little Bluestem,
Sandoat Grama. For the predictable
line of shovel pressing a steady
refrain through the waffled
rubber sole.

We do it for an excuse
to loosen the work talk that rises
like water to the red palm, tender bubbles,
silent filling like sunrise to stinging
release until you me the dirt
the hands all stand
skinned and blinking
in one small spot that remembers.

Rolando Briseño, *At the Proton Table*, 1991; acrylic on wood, 48 x 83.5 inches.

Diana Rodríguez Gíl, *Maria . . . Memoria a Gloria*, 1989; multimedia performance.

NAN CUBA

From *Body and Bread*

1972

Most of my days at the Ciudad Universitaria were spent at the Central Library. Walking across its volcanic rock pathway, past its iconic walls of O'Gorman murals, I realized I was happy. When the librarian set out the accordion-folded pages of the Codex Fejérváry Mayer, I knew I'd become what my brother Sam had intended: a truth scavenger unearthing the past. Now my life's work would be the study of cultures that first appeared in 20,000 B.C. in the Valley of Mexico, a natural basin a mile and a half high in the heart of Mesoamerica.

As a professional collecting and analyzing data, I accepted my role as an outsider examining cultures like specimens clamped to graticule slides. But the pitfalls were obvious, especially since, in this case, the scientist was a middle-class, Anglo American female. I attempted to move beyond my high school fetishism toward a psychological connection to these ancients in two ways. First, I learned Nahuatl; then I interpreted documents like the Aztec codices, their ceremonial scenes illustrated alongside pictographic systems of glyphs. Gradually, I came to recognize and appreciate, in spite of our temporal and corporeal distance, the people's surprisingly modern beliefs. Although they did not recognize an interior life, and their rituals were grisly and well documented (but in most cases misunderstood), the ceremonial design and intent were impressively complex. Costumes and movements consciously joined opposites – warriors and fertility, female and male, sky and earth – disrupting the familiar, reminding participants that society's attempt to bring order was futile. I confess I also liked each group's flamboyancy. They outpomped the pompous courts of glorious Europe.

So I traipsed from class to library, declining most invitations, knowing my intensity was excessive, that others thought I took myself too seriously. The truth, however, was that I felt ridiculous (I'd become a *character*!) and believed I was no more significant than a beefsteak tomato. Organically homegrown, maybe, but a common herb, nonetheless, of the nightshade family. The seed of this newfound self was a protected secret: my brother had drowned himself.

Six months before I'd arrived, a heavy rain had produced a major discovery thirty-three miles northeast of Mexico City, in Teotihuacán. At its peak in A.D. 500, this metropolis had covered eight square miles with a population of 200,000, making it larger than its contemporary, imperial Rome. Sometime between the birth of Christ and A.D. 150, the Pyramid of the Sun and the Pyramid of the Moon had been built, and the city's main axis, the Avenue of the Dead, had been extended to three miles. Teotihuacán's huge public compounds and numerous temples comprised an area so vast that the buildings at one end of the avenue could not be seen from the other. The 1971 discovery, however, occurred at the base of the largest structure. The Pyramid of the Sun, which required thirty-five million cubic feet of sun-dried bricks and rubble, was 738 feet square and twenty stories high, but the downpour caused a depression that got men busy digging.

My anthropology professor, who'd been part of the original team, later invited me along with two other students to crawl through the man-made entrance they'd uncovered. Standing at the foot of that truncated monument, he explained that the first-century A.D. opening pointed toward the setting sun on the days of the equinox. Just inside, the cramped enclosure required the lights from our spelunking helmets.

We crawled down an ancient stairway as though rappelling a mountain, the steep stone steps cut into the walls of a shaft twenty-three feet deep. Although each ledge held, my foot barely had space to balance; every dusty surface felt on the verge of disintegration. At the bottom, we found a tunnel that turned out to be 112 yards long. Our professor, his helmet's light probing, his voice soaking into rock and mud, said that archeologists called it the Volcano Tube.

I stayed as close to him as possible while we crawled through the damp darkness, my back a clamp, my knees throbbing, my mind picturing long-tailed shrews, albino salamanders. The air thinned – we could've been, instead, on a mountaintop – and I grew dizzy, gulping, my lungs filling but not getting enough oxygen. I curled against the tunnel wall, refusing to move. Patiently, the professor, his ray of light aimed at my feet, guided me through a regulation of my breathing, all the while conversing lightheartedly with the other students. During his team's initial investigation, he explained, they'd found a series of twenty-nine masonry walls blocking the way, each plainly built by someone who could've only been working outward.

My breathing restored, my heartbeat settled, we crawled for another fifteen minutes, the professor's light beam roving crags ahead. When he finally stood, his head disappearing as he rose, my heart lurched; then we joined him.

The cavern, he said, his voice echoing, had been formed by an enormous bubble of gas in lava that streamed from deep within the earth. Dark as a blank, and humid, it was huge, our lights illumi-nating its regions. A path of stones, originating from what had been a spring, had once served as a channel for water. Attached to the floor were ceramic pieces that surrounded a flagstone, situated directly underneath the pyramid's center. When light from the monument's narrow entrance had flickered across this arrangement, shamans, perhaps the city's founding fathers, held elaborate rituals. I wondered how their ceremony compared to the Huichol sacred peyote practice at the White Shaman site in the Lower Pecos. Years before, I'd run when an amorphous shape appeared there, but now I hoped it would reappear here. Our voices ricocheted; our lights streaked across walls slick as obsidian and a ceiling covered in what looked like fossilized toucan tongues.

The cave ended in a four-petal flower shape, the chambers resembling those mentioned in Tolteca-Chichimeca history. Inside, skull carvings and jaguar sculptures, symbols of death, had waited centuries to be found. A greenstone figurine with inlaid pyrite eyes had also lain undisturbed, alongside basalt bifacially flaked blades and a conch shell.

The Teotihuacanos believed that while the cave's spring originated from the underworld where the dead journeyed, the cave was also the womb from which the sun and moon first arose. When the pyramid was built over this holy place, the structure became an *altepetl*, or "hill of water," around which the community settled. In other words, the pyramid became the center of the universe.

As we squatted inside a flower-petal chamber, the professor described a self-taught archeologist's first attempts in the early 1900s to excavate the pyramid, which had been covered for centuries by debris. "At its highest level," he said, "skulls of children, none older than eight, were found at each corner." The victims' tears had been shed for Tlaloc, the god of water.

I gathered a fistful of groundcover and sniffed: dust, alkali, metal. So, I thought, this is time, its

dark elements, and I'm like Jonah inside the whale's belly, like the mouse Sam once found in a fish.

He'd said that courage was being able to see yourself as something else, and now I did. The amorphous shape would not appear in the cave, I realized, because it was inside me. I had become an *ixiptla*, a demigod's agent. Not because I'd committed a moral sin, but because a metaphysical impurity had arisen from an unspeakable transgression. My transformation was going to realign me with the spiritual world. Sam would present aspects of himself through me.

STERLING HOUSTON

From *The Secret Oral Teachings of the Sacred Walking Blues*

The Ice House, which really did sell ice, but mostly sold ice-cold beer, cigarettes, and soda water, was situated on a wedge of ground formed by the "x" of two dirt roads pretentiously called Hedges Street and Gevers Boulevard. This Ice House was not an actual house of ice but a tin shed cobbled together from the salvaged pressed tin ceiling panels of the Good Samaritan Colored Hospital torn down in 1948.

These were big tabletop-sized pieces of tin embossed with olive branch borders surrounding a central thistle bloom. Many of them were decorated with big cloudy stains caused when long-ago storms leaked through. These panels had been banged together on a skeleton of two-by-fours, and were decorated by colorful tin and porcelain advertising signs for Nehi, grapes, Lone Star, Pearl, and Chesterfield Kings.

The resulting shed was topped by a roof of rusty corrugated tin, which hung out over the front by several feet. This overhang was supported at its corners by stout posts made from sawed-off telephone poles. It gave the front of the place the look of a funky trading post, which in a way, it was.

Behind the little building and beside the outside toilet (which was not an outhouse, but a cabinet made of plywood packing crates built around a single, seatless commode) there grew an ancient mesquite tree. Although most mesquites grow squat and spread out like gnarled and signifying hands, this one had tapped into a deep spring, which fed it till it had grown twice the normal height. It had grown tall and twisty like a monster bonsai slanting lazily to shade the little shed from the furnace blast of midday midyear midcentury San Antonio Texas afternoons.

At times, groups of men gathered here to play cards, or loudly click dominoes and shout. Other times a lone man and his guitar and Kindhearted Woman and Have You Ever Been Mistreated and sometimes all of this at once plus me nine years old drinking Nehi grape and pineapple Hippo soda water. That time year day hour had frozen in amber suspended in the murmur of guitar strings trembling forever unresolved. Yeah. Secret. [. . .]

Prologue & Innuendo, San Antonio, Texas

When you are a child, everything is perfect. But any young queen-in-waiting born to the manner will find something to complain about. It's a gay DNA thing. I couldn't help but notice that, in the summertime, the morning sunlight here has too much gold in it. I admit, this seems a minor flaw in the great scheme of things. Everything that light shines on looks warm and gilded as if suspended in the clearest honey. That sunny honey light fades quickly or rather brightens into silver-white before disappearing altogether to become ordinary illumination noticed only in its absence. Whether dripping gold from leaves or bouncing off your face, matching you glow for glow, that goldish light puts later lights to shade. Your skin, like your guitar, is antique mahogany streaked and polished by tears. It's the salt they say, that gives that shine. But that's not all it is. You, my father, are the keeper of secrets, this one and others. I will look for you until I find you, somewhere, here or there. There are secrets kept because they are not worth the telling. Secrets told because they are not worth keeping and one other kind known by those who know. The secret of the sacred Walking Blues. That secret is not just some nugget of perfect understanding, but closer to unexpected bliss. A secret, like a cliché hiding out in plain sight, delivered in code and unheard by all but the coolest ears. You didn't call it rag, you didn't call it blues, or jazz or be-bop or hip-hop hippity hop shoo bop, did you Daddy? You did not call it anything but yours, and you commenced to walking it, didn't you? The walking blues, the worried blues, and then I guess you gave it up so I could walk them too.

Mark Hogensen, *Pretty Please with a Cherry on Top,* 2005; acrylic on wood, 48 x 60 inches. Collection of the University of Texas at San Antonio.

DAVID RAY VANCE

Regarding Conservation of Matter and Energy

In part, in parting, as if sunlight constant
as if it never wavered

not here where we perceive but objectively
 measured beyond atmosphere

not over centuries but daily, by the hour
by the tenth-of-a-second

as if emotion, but another vigorous force
 might steady us

when not even breathing, when no star
when not the ocean's level

when neither the number nor variety
 of species

nor this moment just elapsed

so that we ask not *when* but *how long?*
and answer together

 Soon. Not now. Likely never.

Chris Sauter, *Mind and Body*, 2005; drywall, variable size; telescope, 48 x 36 x 36 inches.

MARIE BRENNER

From *Great Dames: What I Learned from Older Women*

"Attention shoppers! Attention shoppers!" My father is speaking on the PA system in the downtown Solo-Serve in the summer of 1966. I was spending my summer before 11th grade bagging dresses in the store. We were busy that day. I remember Dad walking the floors greeting customers by name. A Sale of Progress promotion was going on, the lines at the cashier were ten deep. My father's office was behind a glass wall on the second floor. I could see him sometimes during the day swiveling in his green leather chair. He kept a glass wall plaque on view: SELL AND REPENT. That day, in the afternoon, I looked up to see him as he walked to the microphone. "Shoppers," he said, in his deep Texas drawl, a puckish smile on his broad features, "there is a celebrity in our midst! The famous Leonard Lauder, the son of the great Estee Lauder of *Noo* York has flown all the way to San Antonio to try to find out how we can sell our Estee Lauder cosmetics at such a tremendous discount! He is here to see how Solo-Serve undersells Frost Brothers and Neiman Marcus! And he is right now in our cosmetics department checking out our merchandise! I want y'all to walk over to the cosmetics department and shake hands with Mr. Leonard Lauder of New York!" I recall my father's pleasure that night at dinner, his head thrown back laughing; *he had shown him!* "I bet that son of a bitch went right back to New York," he said.

My father was convinced of the rightness of his battles, no matter that it meant he would later be isolated socially within the intimate confines of the community. He took on crooked local mayors; he offered large cash rewards for whistleblowers. In the midst of one of his campaigns there was excitement around him, a feeling of possibility. He was just secure enough to stick his finger in the eyes of the authorities and not fear that any harm could come to him. I think my parents' best moments were when he was riding a hobbyhorse and she could listen as he worked the phones. The largeness of his personality defused her anxieties that they would be shunned; in fact, she never was. She seemed then particularly girlish, appreciative of his spirit.

But sometimes I would find her wandering in the hallway in the middle of the night, distracted and melancholy. "What is it, Mother?" I would ask. "Oh, nothing. Everything is fine," she would say, unconvincingly. She refused to lift the curtain and let us see what was in the darkness. I understand now that she was adrift in a marriage which had given her security and fidelity, but that wasn't enough. Mother was a woman of smoke and mirrors; she deflected us by explaining that she was worried about how she was perceived. Sensitive to slights of all kinds, she would puzzle over ambiguous remarks. What did this mean? Why did someone say this to her?

Oddities of behavior would play out as hypochondria – she kept files of clippings on nitrates in processed meats, carcinogenic substances, contagions found on toilet seats. It feels to me now that she was looking for a catch-all for her anxieties, but her coping mechanism was motion, a trait she has passed on to me. Sleeping late was unheard of in our house. She set the standard – up at sunrise in full maquillage, ready to set off on her day. The silver Buick would zoom down Contour Drive heading for the University of Texas seminars, tennis games, conversations about Martin Buber, assignments to teach the history of the Holocaust in the local schools. She began to quote Abraham Maslow on the "fear of nonbeing" and put up signs in my room with telling remarks from Hannah Arendt: "We must think about what we are doing." In parentheses, she had added, "In case you are interested, that comes from *The Muses Flee Hitler*,

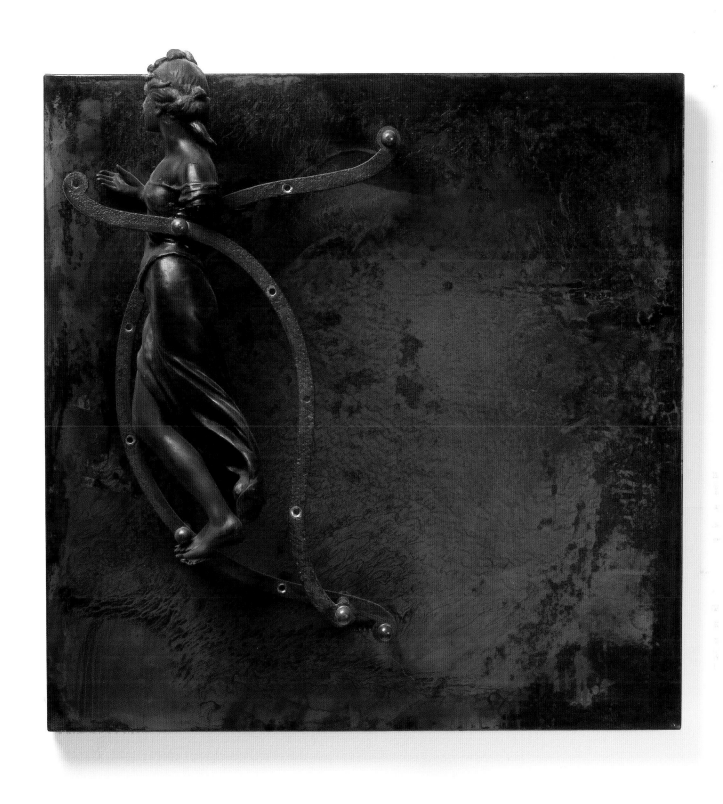

Henry Stein, *It Was in Her Imagination*, 2006; metal and found object, 24 x 24 x 5 inches. Collection of Raphael and Sandra Guerra.

page 132." She went back to college and earned one degree and then another in psychology, but she had a fear of analysis of any kind. "I know more than these shrinks do," she told me, and later was contemptuous of my belief in the beneficial quality of psychoanalysis. "Do hope you are seeing results from the 6 to 9 month period you have been going–not that I am as intolerant as Fritz Perls (the Gestaltist) who thinks that talking to a psychoanalyst in free association is a schizoid exercise by its very nature and does not impart authentic insight." Perls was concerned, she wrote, that in psychoanalysis, "Something must be wrong if it takes many years and decades to get nowhere."

At night she read from the dictionary, quizzing me with words–"tautology," "hegemony," "loquacious." She mastered French and often used phrases: "*Ma vie!*" "*Il faut que nous partions!*" That coping mechanism had a flair. "It's good that you too are taking French," she wrote. "As Pascal said, 'When all else is gone, knowledge remains.'"

Mother's attraction to that sentiment was real. She had her first cancer at forty-six. She lost a breast, but she was on the tennis court two weeks after surgery. That first performance must have been excruciating for her. She confided that if she lost ten pounds, finished her master's degree in psychology, or perhaps had a spectacular party, her marriage could be "transformed," but she spent many nights believing that the cancer had come back and she would die.

Soon there were fewer visits from the flutey ladies. Mother began to see the futility in idle conversation and trying to penetrate my father's isolation. She used the expression "climbing up a glass wall" and he would stare at her blankly, impervious to insult. She continued to serve my father dinners that would often feature myriad uses of Stouffer's frozen spinach soufflé. He never once got up or learned to cook or help himself. I found that disturbing too. "Why can't he serve himself?" I would snap. She never had an answer. Mother would eat only dry-roasted peanuts. Later she discovered they were laden with the carcinogens she was so terrified of.

It could not be coincidence that she became obsessed with the rights of victims of all kinds. She underlined Hannah Arendt with a shocking pink marking pen. The shelves in the game room filled with new books, Elie Wiesel and William Shirer, memoirs of survivors. It was crucial, she believed, to know every fact, every date, and she started to teach the history of the Holocaust to high school students. They were mostly Hispanic and there were those who could hardly read. What did they care about Treblinka? "I must teach them the perils of demagogues," she said as I drove with her to hear her speak. We passed the Delicious Tamale Factory on South Zarzamora Street. The air suddenly was filled with the smell of chiles and frying corn and beans. In her zeal that day, she got all tangled up on the dates of Treblinka and Bergen-Belsen. She was upset on the way home in the car, as if she had let them down. On Zarzamora Street again, I was desperate for those bean tamales, but my mother was too agitated to stop. "You don't need all that grease," she said.

She began to feel she had limited time to accomplish something important in her life. Mother saw oppression and darkness around her; she spent hours counseling child victims of "sick and perverted" families, a phrase she often used in her work as an advocate for CASA, the volunteers who took on child welfare cases in family court. I found it hard to listen to her descriptions of the children's lives.

This was a difficult time. I was in my twenties, and Mother came to believe I was her doppel-

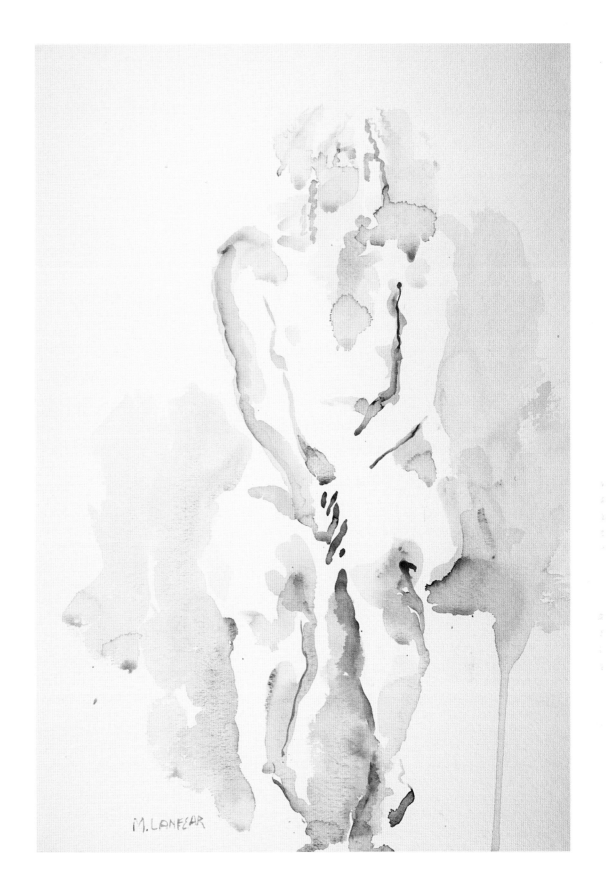

Marilyn Lanfear, Untitled (Nude), 1972; watercolor on rag paper, 30 x 22 inches.

ganger, perhaps because she was finally alone in her marriage. My father would rarely travel or go to parties with her. They lived separate lives, but they were loyal to each other. She persisted in trying to crack his code. It was clear to her friends that this yearning was the essence of her life. She more and more talked about her carefree days in wartime Washington where she had been surrounded by beaux at the OSS. Mother would describe being bused to dances somewhere near Langley, Virginia, the curtains drawn for security reasons. She wrote odd and melancholy letters to me. "There is no one role we are destined for but we act as the situation demands. That is why we can never know who we are. We are not just a mother or wife or artist or sweetheart or teacher or friend or competitive sports player or business-woman – but a person with versatility. The best thing we can do for ourselves is to act with fair play and integrity in all we do – remembering Kant's Categorical Imperative. . . . When we affirm what is good in ourselves (and in others), we lose the habit of self-pity, which can keep us everlastingly sick and neurotic."

She believed, however, that a deal was a deal. Once at a dinner in San Antonio, an acquaintance of my new husband insulted my father. "You married the Brenner girl? The daughter of that impossible man?" "We have to think of a way to respond to these people," my mother said the next morning when we told her what had happened. "How about this! The next time someone insults Milton to you, just look them straight in the eye and say, 'A peasant never understands an aristocrat.' That is a line of Diderot."

I see myself with my mother in the summer of 1967. I am soon to leave San Antonio to attend college in the East. I will never live in South Texas again, but I don't know that yet. I am at the beginning of the beginning of a long journey. I am gathering clothes to take in my trunk to Penn. I tie pastel yarns in my new fall, the thick hair-piece that was a Texas wardrobe necessity. I have matching Pappagallo loafers in pink and green. For this summer, I wear white shoes, lime green miniskirts. My mother has convinced me that the sky is the limit: I have picked up her interior panic but I keep it hidden underneath an odious teenage superiority.

I know everything. I will never have her life of bourgeois convention, I tell her and myself. Your friends are phonies, I tell her, although I truly love the women who gather around her and luxuriate in a warm bath of classic Texas female hyperbole. *You look good. I don't. Ewe look good.* You've lost some weight. I haven't. Well, I love your hair. Who is doing it? Your skin! The texture is like a pearl.

They were smart women with college degrees; they had opinions on events and organized against the Vietnam War in a claque called San Antonio Mothers for Peace. That summer, when Robert McNamara came to San Antonio to lecture, they forced their way into his room at the St. Anthony Hotel. He was on the telephone, my mother told me, and he was baffled by this cluster of society matrons in their linen suits and color-coordinated shoes. Everyone knew them at the hotel – their husbands were powerful men – so the bellman had let them up.

It was difficult for me to see how serious she was, determined to keep the game going, no matter what. She often stayed up past midnight typing papers for her college courses. At the breakfast table, she would read them to us: "Two Philosophical Concepts in 'La Vida Es Sueño' by Calderón de la Barca." She wrote toadying notes to her professors: "Dear Dr. Benavides: All the work done on this paper has been original, based on thoughtful reading of the text combined with

lecture notes which have enriched my analysis. Have a nice summer vacation! As usual, I have enjoyed and benefited from being in your class and am looking forward to seeing you in the fall."

She was an anomaly, a housewife among the nineteen-year-old students, and could annoy her professors with her high-flown phrases and opinions, culled from my father's tirades and the *New York Times.* I recall that in 1963 she was asked to leave her economics class at San Antonio College. Something about a fight that had to do with price-fixing on General Electric's discounting appliances. I'm sure my father was the ventriloquist, and delighted in making a fool of the teacher, oblivious to how he was harming her. My mother wrote a furious six-page letter and copied it to the dean.

> *You are not doing the student justice when you teach a negative approach to capitalism . . . I believe that the core of our problem revolved around the fact that you did not like my frankly liberal-capitalistic approach and that I was not afraid to question your socialist slant on our economic system. Certainly, if I had agreed with your notions, you would not be in the position of having axed me. . . . On the contrary, it would have occurred to you what a delightful person Mrs. Brenner is: You might have thought, "She doesn't talk up enough."*

My last summer living at home I belittled her for trading recipes for King Ranch casseroles and mango mold. I did a mean imitation of her conversations with her friend Louise: "That mold will never gel unless you go to the *mercado* and get the Jacques Clementes canned mangos that come from Mexico." "I add sour cream," Louise said. "What an interesting idea. Do you use apricot or lemon Jell-O as your base?" I was merciless, determined to cut the ties. The more petulant I became, the less she seemed to notice. She would make a joke about it. "I'm counting the days!" she said. She became ferocious about my virginity. I parked my car by the local boys' school and made out with my boyfriend for hours. My mother knew where to find me. She would drive up in her silver Buick and shout at the fogged windows of my red Opal Cadet: "You are acting like a whore! Remember who you are!" I drank Black Russians and whiskey sours until I was woozy and smuggled vodka bottles into the dorms for my beau at the Texas Military Institute.

Did she intuit I was taking off for the world? She appeared desperate for me to finish my education. She saved her best lesson for the day I was leaving. "Remember, always ask anyone you meet fifteen questions in the first fifteen minutes you meet them. Fifteen questions. They will like you better and the answers might teach you things."

Liz Ward, *Fading Shore*, 2001; watercolor on paper, 18 x 72 inches. Private collection.

JACINTO JESÚS CARDONA
Back in '57

I was just another Latin American boy
deep into khaki pants, steam-iron pleats, gaudy cufflinks,
impressed by the passive parking meters on Main Street,
mesmerized by the chrome spokes of customized wheels.

And yes, I would laugh and laugh at how I took my black shellac,
celebrating the edges of my orange Stacy's, my dancing shoes
anxious to shake loose the alkaline kiss
of caliche down my unpaved streets.

Caught in the vortex of oil wells and taco shells,
Spanish was my first, English was my second,
but Star-Spangled Spanglish became my middle name.
So was I Tex or was I Mex,

part-time Aztec, or was I your classic borderline case?
Biped and bilingual, I even wore bifocals,
but my biceps remained monolingual.
Back in '57 I could care less and less

because I could always laugh
with Cantiflas at the Ranch Drive-In.

Bill FitzGibbons, *Light Channels*, 2007; LEDs and aluminum.

Robert Tiemann, Untitled, 2006; mixed media, 4 x 8 feet.

JAY BRANDON

The Grip

Medieval lawyers invented a very reliable method for preserving the records of land boundaries in living memories. They would round up a batch of neighborhood children and take them out to the site where the land was being sold. The children were marched around the property in question, and at each turning or corner of the land, a lawyer (or more likely a good sturdy bailiff) would select one of the children and beat the stuffings out of him, preferably leaving him scarred for life. This had a wonderfully focusing effect on the child's memory. Even after he got to be an old man, he'd be able to point out to interested surveyors the exact spot where he'd been beaten.

This story from property law reminds me of my grandfather, who raised me. He was a kindly man, at least to me, and as far back as I remember, he was already the oldest man I'd ever seen. After my mother died from complications following my birth (grief was said to be one of the complications, embarrassment another), her father brought me up. Grandfather always took a lively interest in me, and he was a physically affectionate man, often patting my head or resting a hand on my shoulder. The only times I can remember him hurting me were those few occasions when a full-lipped, thin-cheeked man with black, curly hair came to see us. The first time I remember seeing the black-haired man was when I was perhaps four years old. Grandfather and I were walking on the lawn when the man suddenly appeared. He was dressed in what I now know to be the moddest of fab clothes – striped bell-bottoms and a polkadot shirt with a white collar tall enough to brush the bottoms of his bushy sideburns – but at the time, I thought he was a clown. The redness of his cheeks solidified this impression.

My grandfather's hand was on my shoulder, and when he saw the dark man, his grip tightened as if from a convulsion. Throughout the brief interview, his grip did not let up. It was so painful I wanted to cry out, but I didn't like to disturb the conversation of the grown-ups. My grandfather had pushed me half behind him, but I stared at the face of the black-haired man as I gritted my teeth to keep from groaning. It was an affable face with bright eyes and a long nose, but it gradually darkened until he turned and stomped away. Only then did the pain in my shoulder subside. Watching the man's retreat, I rubbed my shoulder.

We lived in Olmos Park, a tiny city surrounded by San Antonio, Texas. My grandfather's brick house was large, the grounds extensive, but I never felt isolated, or as if I were raised in a lonely, echoing mansion. I ran through the house, I ran out its doors, to friends' nearby houses. This was at a time when children were given the freedom of their neighborhoods. Nor was our house inaccessible. The mailman came to our front door, and so could anyone else. I sometimes looked up suddenly from my play, thinking the black-haired man's shadow had fallen across me again, but when I looked around, I couldn't see him.

The next time we did see the man with black, curly hair, it was by appointment. I was only present for the first few minutes, after which my grandfather asked me to leave. It was a relief to do so, because from the moment the dark-haired man walked into the room, my grandfather was pinching my shoulder quite painfully.

"Do whatever you like," my grandfather meanwhile was saying to the man. "You can't hurt me, and if you try to hurt the boy, I'll put a stop to you."

It was odd that he spoke of putting an end to my hurt, because as he said it, he was hurting me himself. The black-haired man seemed solicitous by comparison. He looked directly at me as he said, "I would never do that."

He knelt to my level, and I opened my mouth to reply but only grimaced instead, because with a final pinch my grandfather sent me out of the room. I looked back a last time. The black-haired man's curls were gone that time; he was wearing his hair very close-cropped, which went with the combat fatigues and boots he was wearing. Whether he was actually serving in the military I have no idea, though he certainly had a soldier-of-fortune air about him.

He was an adventurer, no doubt. I didn't know what was passing between him and my grandfather, but the black-haired man sightings were so rare that I always remembered all the details of his visits. That time, when I was perhaps six or seven, I understood little except that the grown-ups were arguing, but I remembered what my grandfather had said to him. Years later, I realized that the black-haired man must have known the circumstances of my birth and was trying to blackmail my grandfather with the information. He didn't know what a hard target he'd chosen.

There were a few other meetings, not many, with the black-haired man before I was grown, and each time my grandfather was present and sent tendrils of pain through my shoulder. I didn't blame my grandfather for this; I knew him to be my protector. I always associated the strong-fingered pinches with the black-haired man. Like those medieval children, I remembered well the spot where I'd suffered pain. My spot was wherever the black-haired man was.

My grandfather tried hard to spare me the effects of his wealth while remaining the strongest influence in my life, and he succeeded at both. I didn't go into my grandfather's profession – land grabbing – but I did develop a strong interest in the ways he used his holdings, an interest that led me into property law. I was in my last year of law school when Grandfather died.

We tend to forget that inheritance can pass both up and down. My grandfather had seemed capable of outliving me, and if he had, and I had left neither will nor wife nor child, my small estate would have passed into the higher branches of the family tree, perhaps to my grandfather. Grandfather himself had taken no chances on letting his money wander untended after he was gone; his will went on for pages and pages. I was worth a paragraph or so. That made me the principal individual beneficiary, but my grandfather believed charity should make only a small beginning at home. He left me a trust to see my education finished, and a nice chunk of money to set me up in professional life, and another trust to my children – if any, if ever – but the vast bulk of his estate went to various charities, as I had known it would. His name can still be seen on a few plaques around the city. I did not hold his generosity to others at my expense against him. My grandfather believed, as I've come to agree, that there is no greater stumbling block to character than early fortune. (I hold this principle so firmly that I plan, as soon as I have children of my own, to do my very best to steal their trust funds from them.)

One of the last times I saw the black-haired man was immediately after the reading of my grandfather's will, an event at which the black-haired man had been neither present nor mentioned. Nonetheless, he seemed generally familiar with the will's pronouncements. I flinched when I saw him, but he came up to me, greeted me by name, and shook my hand, congratulating me in a very friendly way on my inheritance. Now that I think of it, perhaps he didn't know so well the terms of the will and assumed that because I was the main individual beneficiary, I had come into most of the money. At any rate, he was very friendly and seemed as bright-eyed as ever, though there were gray hairs scattered among

his black. He promised we would meet again soon. I was in a strange way glad to see him. The black-haired man had always fascinated me, with his air of travel and adventure; I'd always wanted to learn more about his connection to my grandfather. I felt nothing to fear from him myself, since any attempt to blackmail me would be a dismal failure. First, I didn't have the money to pay. Second, I wouldn't have; the rumors of my scandalous birth, the few that faintly persisted, gave me the only intrigue I possessed.

Nonetheless, I didn't prolong the conversation with the black-haired man, because it was a relief to see him turn away. My shoulder throbbed all the time he was talking to me, as if I felt the grip of a dead hand.

During the following year, I had much more to think about than the man with black, curly hair. I finished law school and took a job with a largish firm that was happy to have me because they suspected I had contacts among the old money in town. I took up the practice of property law. My upbringing had instilled in me more firmly than most the idea that all our lives are shaped by property – by money, to put it more vulgarly – or the lack thereof. Nothing in my practice discouraged this idea. Clients came to me because they wanted to loosen what we trust and estate lawyers call the grip of the dead hand – to shake off the encumbrances of instructions that had come with inherited property. Others, older, more experienced, having lived long enough to grow enmities, came to me to establish such a grip, to dictate the courses their money would take long after their demises. I was sympathetic to both kinds, being very familiar with the grip of a dead hand.

I wasn't obsessed with work. Well, maybe I was for a while, but then I met a girl, decided after some contemplation that I was in love with her, and then actually did fall in love with her, which was such a different experience from intellectual devotion that it startled me right into engagement. Her family, who had some no-longer-young money of their own, were familiar with my name – it was the same as my grandfather's, perhaps my best legacy from the old man – and, like so many others, they assumed I had come into most of my grandfather's money. Jennie, who knew my true situation, let her parents think what made them happy.

The wedding date we set was not far off. I am a traditionalist, and that last week before the wedding, I went around in a traditional lovestruck daze. I broke things, I mislaid keys, I talked to people for long minutes without later remembering the conversations. One afternoon, I even tried to joust with a speeding car.

This was 1990. The economic boom that had crested and died in other Texas cities had bypassed San Antonio altogether. Though it had almost three-fourths of a million people, San Antonio retained a small-town feeling. I was always running into people, mere acquaintances, who knew my marital plans and other details of my life. Even people who don't know each other in San Antonio appear to; a stranger would think we're all friends from the way we greet each other on the streets. It was lucky for me that I lived in such a friendly city. In other places I've been, bystanders would only have watched interestedly as I stepped off the curb and was broken down into my component parts, but in San Antonio the stranger beside me grabbed my arm and pulled me back. The car hurtled out of sight as I pumped the stranger's hand and explained what a favor he'd done me, because I was getting married Saturday. He refused a reward but accepted my invitation to the reception.

Jennie and her mother left me out of all the wedding preparations, which was a sensible and terrible thing to do, because it left me at very loose ends for most of the week. Once her father had me to his club for a rollicking hour of anecdotes about the futures market, and old friends called to invite me out for drinks, but no evening was so diverting as the one on which I opened my door to find the man with black, curly hair smiling at me.

"Well. Hello," I said, putting my hand on my shoulder and then having to lower the hand to shake his.

"This is a surprise," he said, which was going to be my next line and so threw me silent. It didn't take much, that week, to make me lose the thread of a conversation.

"That is what you were going to say, isn't it?" he asked heartily. I nodded. "But why should it be?" he went on. "I read the paper, I know what's happening in San Antonio. You're probably thinking that we never see each other, but then there's very seldom an occasion as happy as this one, is there?"

I nodded again. It was nice of him to carry on both sides of the conversation, lessening the strain on both of us.

"I've seen the bride-to-be." He twisted his head so that he was staring at me with one merry blue eye, which winked. "You're a lucky boy."

"Thank you," I said formally, before I remembered my manners. "Won't you come in?"

"I was hoping you'd come out with me instead. You can't be a host the week before your wedding, you have to let me buy you a drink."

While I was trying to think of a believable excuse, my careless tongue was accepting his invitation. He stepped inside and closed the door while I went off to find a jacket. I had a nice apartment, five rooms in a half-renovated block of downtown, and my guest surveyed the living room appreciatively. When I came back, he was fingering some trinket of my grandfather's as if he recognized it.

"Ready?" He smiled.

I suggested we go down to the Riverwalk, just below my windows, but he dismissed that idea with a single word, "Tourists," and said he knew some places of his own.

The second thing I saw when we got down to the sidewalk was my car parked at the curb. The first was the monster between me and the car. He was a carelessly bred dog larger than an average-sized Doberman, and with a head the size of a Great Dane's, enormous; a brown patch on his forehead was the size of my fist. He was a black, somewhat ungainly looking animal, but frightening. I was glad to see that his leash was tied to a lamppost, and I hoped it was secure. I wondered how we could get around him to the car, but my crazy companion walked right up to the beast.

"What are you doing? Don't untie him!"

But the black-haired man already had the leash in his hand and was scratching the dog's ears.

"Somebody probably had him tied up for a reason," I said nervously.

"Because I didn't want to bring him up to your apartment," the dark man said, and grinned again. "Can we take your car?"

That wasn't my idea of a good idea, but as they both stood there patiently, I felt compelled to acquiesce. "Yours?" I asked about the dog, stalling.

"I'm keeping him for a friend. He's really very gentle."

In truth, the dog looked very mild and lazy. "What's his name?" I asked.

My friend smiled. "Chester."

That settled it. It was hard to fear a dog named Chester. I unlocked the car doors, and Chester

Bernice B. Appelin-Williams, *Mirror Mirror, Who Is the . . . ?*, 2007; mixed media collage, 31.5 x 29.5 x 1.5 inches.

climbed slowly into the backseat. "He really prefers to ride in the front, but this will do fine," the black-haired man informed me, "as long as he doesn't get carsick." I kept glancing over my shoulder as I drove, but Chester just lay on the seat, completely relaxed.

The black-haired man did know some places of his own, places I'd never heard of at all. He directed me northward to a club that looked like a shack from the street but was surprisingly pleasant inside, well but discreetly lighted, with a high grade of fake leather in the padded booths and more plants than I've been able to keep alive in my apartment. Chester came in with us. For my upholstery's sake, I was glad, but I expected his presence in the club to provoke discussion. He lay docilely at the black-haired man's feet, like the statue of a dog, or perhaps of a small horse.

The bartender, who looked as if he served as bouncer as well, walked toward us, frowning. "Chester," the black-haired man said in a low, sharp voice. Chester seemed to become only a trifle more alert, but he turned his head toward the approaching bartender.

"The dog's gotta go," was the first thing the bartender said. He was a beefy man, his stomach preceding him with hands as big as Chester's head.

"Oh, I'm terribly sorry," the black-haired man said. "Would you just do me the favor of taking him outside? He'll stay wherever you leave him."

The bartender-bouncer glared as if he were being challenged, but my companion just turned to me and asked what I'd have. I kept an eye on the bartender. He reached aggressively for Chester's collar, stooping to get at it. And Chester—yawned. It seemed mere coincidence that the yawn opened Chester's enormous jaws around the bartender's hand. Chester held that

pose, not biting the hand, just engulfing it. I had been wrong about the size of the bartender's hand. It was a dainty little thing.

The bartender grunted, straightened, and the dog wasn't mentioned again. I waited until the bartender had returned to his post before laughing. The black-haired man patted Chester's head affectionately. "Dogs have been good friends to me," he said, with such earnestness that the simple statement opened vistas of a life lived mostly alone.

"To your marriage," he said when the drinks came. "May it be as long and as happy as Queen Victoria's reign. Drink it all down at once," he advised me, "so the toast will come true."

So I did, and managed not to cough. My host beamed at me. I soon began beaming myself. My companion had been all over the world and knew a great many toasts. Most of them required the same ritual. I soon realized that downing the drinks at one gulp was a duty I owed to Jennie, to ensure our happy union. I was very conscientious.

"Are you married?" I asked.

"Once," he said with a distant smile, "for a few blissful weeks," an answer that deterred further questioning on the subject.

"I had worked for him, briefly," he said later in response to a different question, about how he had known my grandfather.

"In the house?" I asked. "Or for one of his companies?"

He gave me a quick, sharp look, as if I had pried, then smiled his open, engaging smile. "There at the house. He had me wrong, you know. All I ever wanted from him was another job—one I was well qualified for. Or his backing on one project or another. I brought him good, solid ideas, I had the experience. The oilfields in Venezuela, ranching in Australia. I have a sheep ranch near Brisbane now, a big operation."

I had my doubts about that. His clothes fit him well, but they hadn't been bought this year, or last. One cuff was turned under to hide fraying. But there's no shame in failure. I couldn't deny what he was implying about my grandfather's hardness.

"Yet you kept coming back here," I said.

"This was my home. This was where I wanted to have my life." Another sad-eyed smile.

I was enjoying the black-haired man's company, but perhaps I have inherited something of my grandfather's suspicious nature, too. I couldn't help questioning him again. "If they were good projects, why didn't you take them to someone other than Grandfather?"

He smiled at my naïveté. "I guess you don't know the influence your grandfather had in this town. This was when you were just a boy, things were much tighter in San Antonio, all the money knew each other. Once your grandfather's opposition to something – or someone – was known, it was doomed."

I had a twinge of empathy that felt like guilt. Grandfather had taken me in when he needn't have. That decision had given me my life. But his enmity, just as randomly fallen, had given the black-haired man an entirely different life, one used up in forced travels and failed "projects." His life could as easily have been mine, mine his.

"It's a shame we haven't had more evenings like this," I said some time later.

"I'm glad to hear you say so."

We were in yet another bar my friend knew. This one, if I hadn't been in such a cheerful frame of mind, I would have described as a low place. It was in a small old stone building south of downtown, off one of those narrow ways that seem to deposit the unwary tourist in Mexico. The room was narrow and darkened, its occupants absorbed in their own concerns. The place was such that no one had bothered about, or even seemed to notice, Chester. The black-haired man and I sat on kitchen chairs at a scarred table drinking beer chasers after shots of something from a bottle with a worm in it, the worm's thin body moving in the currents of the liquor like a languid dancer on a distant stage.

"That grandfather of yours," my companion went on. "Well, he was only being protective. But it must have been a strange life for you."

"I wouldn't know, since it's the only one I've had."

We talked about other things after that, ocean voyages and Montana, sheep ranching, European marriage customs. We talked almost exclusively of things I had never seen or done, and they sounded wonderful. I began genuinely to regret that I hadn't gotten to know the black-haired man better when I was younger. That was a lapse we vowed to correct.

After one more toast to my bride, my companion asked, "What's the matter? That one go down the wrong way?"

"I just need a little air, I think. Will you – ?"

I stumbled outside while he stayed to pay the check. A lamppost at the curb stayed my progress, and I clung to it, taking deep breaths. If I'd been more alert, I would have been concerned about where I was, for the street was narrow and dark, pocked with doorways out of which any number of hard-eyed men could emerge in an instant. But the god of drunks protected me while I breathed deeply. The world had settled down a little by the time my companion rejoined me. "Beautiful night," he observed, and looked more closely at me. "Time to go home?"

I nodded. I was only a trifle unsteady as I bent to unlock the passenger door of the car for him. When I straightened, he had stepped back to the sidewalk.

Alberto Mijangos, *Surrounded by Sound*, 1988; oil, acrylic, and mixed media on canvas, 80 x 80 inches. San Antonio Museum of Art, gift of Geary and Priscilla Atherton. 88.103.

"I think I'll just stay here for a while," he said. "Would you do me a favor, though? Keep Chester tonight? I'm staying at a hotel, and they really –"

I looked at the dog, who looked at me. Why not? He'd been so quiet, I had forgotten he was along. If he'd be no more trouble than that at my apartment, I could certainly tolerate his company for one night.

"He's housebroken?" I inquired first.

"Oh, yes," said the black-haired man. "He's very well trained."

I shrugged and held the door wider. At a word from my companion, Chester climbed elaborately into the front passenger seat, and I shut the door behind him.

My host followed me around the car and caught my shoulder after I'd opened my own door. I winced slightly, turning the wince into a smile for the benefit of the black-haired man, who looked rather perturbed by my expression. "It's been fun," he said. "I'll call tomorrow to get Chester."

"And be sure to be at the wedding Saturday," I reminded him.

He nodded. "I'm very happy for you," he said, smiling. I smiled back and climbed inside the car. I was sure I needed my seat belt but took some time with it, tangling the lap belts and shoulder straps in great loops around the front seat.

"Are you sure you can drive?" the black-haired man asked. I nodded, and he closed my door and stepped away.

Before starting the car, I turned back to look at him and saw that he was calling. I opened the window a crack to hear him.

"Chester!" he said sharply. So it wasn't me he was calling. Last words of admonition to his pet, I thought. The dog's head came around ponderously until it was at my shoulder. He blinked at the man outside.

"Chester!" the black-haired man said again, and then: "Kill!"

Beside me, the dog suffered an abrupt personality change. He snarled, his lips pulled back from his huge teeth, and his head was coming toward me before I even had time to turn in that direction. I felt his breath, though. Instinctively, I threw up my right forearm as my left hand groped frantically for the handle of the door. Chester's teeth closed on my elbow, and we both howled. When he opened his jaws to try for a better grip, I jerked free for an instant. But then I made the mistake of trying to push him away, which took my hand away from the door handle, so I was still trapped with the dog.

Chester was a big dog, but he was smaller than a grown man; he had more room to maneuver than I did. I couldn't escape him in the confines of the front seat. He lunged at me, pinning me under his paws, and his mouth opened to enormous size. The awful teeth came toward my throat.

I kicked, but it was an awkward, twisted kick that only made Chester miss his first lunge, and not by much. His teeth grazed my ear. I screamed. He growled in response.

I pushed him again, got my hand on the door handle, and finally pulled it, my heart opening with relief, until nothing happened. The door didn't move. I remained trapped. I turned my head and saw the black-haired man leaning against the door, holding it closed. He had the most amazing look of awful expectancy on his face, so that I thought I could have talked him out of his purpose if I'd had a moment – if he could have heard me. But I didn't have a moment.

Chester's teeth weren't his only weapons. His paws were as big as my hands, and carried claws. He planted one on my leg, and when he scrambled for position, the fabric ripped, and I felt blood

trickle down my thigh. Again his jaws closed on my arm, and blood spurted there as well.

The twin springs of blood energized me. I thrust upward, banging the dog's head against the ceiling. When he released me, I pushed backward and fell back over the seat. I managed to reach the door handle on the opposite side of the car from the door the black-haired man was holding closed, pulled, and fell out onto the sidewalk.

There was no salvation in that. My back was on the ground, my feet still entangled in the car. Chester turned his huge neck, growling horribly, gathered his paws beneath him, and sprang.

And the seat belt I'd looped loosely around his neck when he first got in the car pulled tight, choking him and stopping his lunge. He turned, snarling, and when he had slack, he managed to jerk his head free. But by that time, I'd rolled completely out of the car and slammed the door in his face.

My danger wasn't over. I leaped, suddenly strong as Chester himself, onto the roof of my car and over it. The black-haired man was moving slowly, looking dazed himself. Otherwise, I might not have reached him in time. He was just opening the door when I came over its top, butted him with my head, and closed the door again as I fell down past it. I scrambled to my feet, found my car keys still in my pocket, and locked the door, which in my wonderful Volvo locked all four doors.

When I turned back to the black-haired man, I heard the click of a knife. He held it at his chest, the blade displayed before his face.

"Go ahead," I said, standing straight and ready. He didn't move. "You don't have the nerve, do you?" I said. "You'd rather use a dog, or a car."

That was a stab in the dark – I hadn't seen the driver of the car that had almost hit me earlier in the week – but I thought I saw it register on his face.

The street was unnaturally quiet. It was the kind of block where people resolutely refused to be witnesses to trouble. The black-haired man and I stared at each other until growling mixed with whining drew my attention back to the interior of my car. Chester was possessed. Spittle flew as he bit and snapped at the glass, then at the steering wheel, the seat, and everything else within his reach. He still seemed capable of coming right through the glass and metal of the door to get at me. The mild dog of earlier in the evening was completely gone, devoured by this monster.

The black-haired man came up beside me, looking contemplatively at Chester. I turned to face him so that I was between him and the door handle.

"He won't be happy until he's obeyed the command," the black-haired man said musingly.

I grabbed his arm, pulling him away from the car, remembering too late the knife. My hand closed on it, cutting my palm and all my fingers, but I was so full of adrenaline that I snatched it away from him. His resistance was only slight. What I'd said of him was true, he hadn't the nerve. But, of course, the same was true of me. He made an empty-handed gesture at me, and I simply threw the knife as far down the street as I could. We heard it clatter in the darkness.

I looked at him for a long moment, fear and fury and pity so mingled I felt like throwing up. "What a wasted life," I finally said.

His head came up with a measure of pride that erased some of the sudden aging he'd done in the last few minutes. "Not many men get that close to such a fortune so young," he said, eyes flashing.

I was breathing deeply, and I realized my fists were clenched, still ready for attack. The black-haired man, though, seemed entirely stripped of purpose. He looked at me strangely, not with anger, not smiling as he'd done throughout the

evening. His closed mouth made his jawline firmer. I saw how handsome he must have been years ago when he'd worked in my grandfather's house.

"I'm going straight to the police," I said tightly.

The threat didn't seem to concern him. "They'll find it hard to believe," he said, looking into the car.

"I just want them to have the report. Besides," I added, "after Saturday, it won't matter, will it?"

He nodded sadly at the logic of that. My subconscious mind must have been working furiously as I'd fended off Chester's attack, and I'd emerged from the car understanding everything. Why the black-haired man hadn't tried to blackmail me, and what his only possible motive could have been for trying to kill me. I had been his only conduit to my grandfather's money, and my impending wedding hadn't given him much time. I watched him resign himself to having lost his last chance at fortune, something that must have been a lifelong quest with him. I almost felt sorry for him. But when he reached toward me, I pulled back. He had only been reaching to squeeze my arm with his own twisted version of affection, but when he saw my reaction, he smiled and turned away. I never saw him again.

It was my grandfather who had saved my life. Much as I'd grown to like the black-haired man during the course of the evening, I was uncomfortable every moment I was with him. That had made me take precautions like surreptitiously putting the seat belt around the dog's neck. I had felt the grip of my grandfather's dead hand, its message written in the nerves of my shoulder: this man means you harm. I still felt that pain every time I saw the black-haired man. In the end, that was of more significance – to either of us, apparently – than the fact that the black-haired man was my father.

EVANGELINA VIGIL-PIÑÓN

Sudden Storm

I hear the delightful clitter clatter of hail
one of those unannounced storms
which at the most unexpected hour
invades San Antonio

the skies darken in an instant
like heaven's light out
and the strong, masculine wind
with its tempestuous gusts
dances to the sea
its final song of vigor and passion
reaped from waters vast

and your window frames wind, rain
and crashing thunder
and you remember the whole day's wash
left hanging on the lines
all the linen
and the old man's calzoncillos –
"ni modo"
you mumble to yourself;
and so you delight in the storm
and its crashing passion
and you picture in your mind's eye
wood-gray jacales en el westside
being drenched by pouring waters
and your imagination spins into one- and
 two-room habitats
where you catch glimpses of viejitos y viejitas
shuffling before their make-shift altars
prendiéndoles a sus santitos
sus velitas

yo ya tenía las mías prendidas desde muy
 temprano

Mark Schlesinger, *Cancún Monsoon*, 2006; acrylic, vinyl, and wood, 36 x 30 inches.

Stuart Allen, Untitled, 2003; sailcloth, fiberglass tubing, Dacron string, 8 x 2 x 100 feet each (including bridles).

JAN JARBOE RUSSELL

Into the Woods

"What's this?" said my fifteen-year-old son, Tyler, as he pointed to a crawdad squirming on the edge of Double Lake, one of my favorite childhood haunts near my hometown of Cleveland, in East Texas. "It's gross."

My grandfather Dock Jarboe had once brought me to this very spot in the Big Thicket. Surrounded by the great stands of pine trees and hardwoods, he had entertained me with stories about how old-timers had hunted in this forest for bears, panthers, and wolves. Now here was my only male child standing on the edge of the lake on a July afternoon, unable to identify a simple crawdad.

Tyler planted his size 12 Nikes in the boggy soil–first the left shoe, then the right. His feet made a sucking sound on the wet earth. "Hear that, Mom?" he said. "The land sounds like it's farting."

We walked on without speaking, watching fishermen cast their lines into the lake and listening to the absurd sound of Tyler's nervous march. Then he asked if he could borrow my cell phone. I explained that he would get no reception here. The woods are too dense.

"That's okay. I just want to take a picture," he said as he aimed my cell phone's camera toward the spot where he'd seen the crawdad. "I just want to try and get a shot of this attack fish." He not only got the shot but also entered it as the new wallpaper on my cell phone. Thus my two worlds– the old, rural Texas of my childhood and the new, urban Texas of my present–collided in a single image.

Tyler and I had gone back to Cleveland so that I could show him the kinds of things I used to do in the summer when I was his age. Swim in Double Lake. Climb the Liberty Hill fire tower. Run a mile around the track at the high school. Have a piece of cherry icebox pie at the Liberty Cafe. Shell peas. Make deviled eggs. Hike through the forest.

The Cleveland I remember was a timber town, poor and isolated, slow moving and inward. I haven't lived there since 1969, when I gladly struck out on Highway 59 for the University of Texas, thinking I would leave behind the xenophobia simply by leaving the woods. Over the years, I returned for holidays and to mark certain milestones. I used to come back in the spring when the dogwoods first bloomed. When my children were young, we made regular visits to my parents.

After my mother died, in the fall of 1993, I discovered that some of the same feelings I felt for her I also felt for Cleveland: a strong sense of belonging, a disabling dependence, and deeply buried anguish. I decided to cut all ties to Cleveland, to stop thinking of it as home. By then I had lived more years of my life in my adopted home of San Antonio–where there are no pine trees and I have a clear, liberating view of the horizon–than in Cleveland. Cleveland felt finished for me, the curtain of the forest closed.

It's my children who regularly remind me that no matter where I am, some part of me mentally inhabits Cleveland. My daughter, Maury, who is nineteen, says that my worldview is warped by Cleveland's smallness and limited options. Once, when we were at a San Antonio Spurs game, for example, I remarked that there were three times as many people in the SBC Center as in my entire hometown. "Poor you," Maury said dryly. Last season, when the Spurs faced the Los Angeles Lakers in the playoffs, Tyler told me that several boys at Alamo Heights High School wore Lakers T-shirts to class. I couldn't believe it, because I have a small-town, be-true-to-your-team mind-set. "It's a big world, Mom," Tyler said. "Room for both the Spurs and the Lakers."

My parents and I were separated by a generation gap, divided by conflicting ideas about race, politics, and religion. The Cleveland of my childhood was segregated, conservative, and dominated by fundamentalist Christianity. It was a deeply southern place where generations came and went yet nothing seemed to change. I defined myself by a determination to change. I embraced civil rights. I left fundamentalism behind. I moved to a city that is, in every way, Cleveland's opposite: predominantly Mexican American and Catholic and, for the most part, free of southern obsessions.

And now, all these years later, my children and I have a geographic gap, separated by more quotidian matters, like food. When I was growing up, we almost never ate in a restaurant, except on Sundays after church. I associate mealtime with eating at home – at a table, with all family members present. My kitchen, like my inner compass, spins between two places. Most days I operate a San Antonio kitchen. There is homemade salsa in the refrigerator and a pot of beans on the stove. However, Maury and Tyler can tell when my mood has turned dark and sad, toward Cleveland. They come home to find black-eyed peas, cornbread, and mustard greens on the table, served with a main dish of overcooked roast beef. Inevitably, one or the other child moans: "Oh, no, not mustard greens. Mom's on Planet Cleveland again."

Then the ritual begins. They make fun of my East Texas twang (sometimes I forget and that word spills out of my mouth as "forgit"). They can't believe that my family had one telephone and shared a party line with our neighbors. They ridicule the fact that my view of the world is fundamentally agrarian while theirs is fundamentally technological. I live in real time on real landscapes. They live in virtual time and space. But

it's not all bad: At least they know how to work the DVD player.

On the morning we left for Cleveland, Tyler packed our Suburban with a small TV and a suitcase full of video games, and I made sure that we both had plenty of insect repellent. It had been raining for days in East Texas. I knew the mosquitoes would be big and hungry, not as easily vanquished as the virtual enemies in Tyler's games.

On the long drive, I tried to tell Tyler about the remembered world of my childhood: the old men in khakis smoking on the front porches of wood-frame churches and the women harvesting watermelons from the red dirt, and how I would explore the forests around Cleveland, places of fantastic diversity where cacti grow alongside camellias.

"Are there snakes?" Tyler asked.

"Not only snakes," I replied, "but quicksand too."

Tyler shuddered and turned the conversation to Britney Spears and Paris Hilton. He told me his favorite song is one called "Hot Mama." I chose not to brood on the relationship between quicksand and a fifteen-year-old boy's preoccupation with dangerous women.

These days, Cleveland has lost its sense of place. When I lived there, the population was about five thousand and the distance to Houston seemed vast. Now Cleveland's population has swelled to more than seven thousand, and Houston has sprawled out on Highway 59 to meet its edge. The suburbanization has been in progress for decades, but when Tyler and I were there in July, the transformation seemed complete. The town where I grew up no longer exists.

As we drove around, I called out the changes. We would not be having cherry icebox pie at the

Liberty Cafe. It isn't there anymore. I drove by all the schools – Southside Elementary, where my mother taught for years, my old junior high, the high school. All of them had vanished, replaced by newer versions. Years ago, the Twin Ranch Drive-Inn, which was owned by my best friend Margaret's parents, shut down. The Drive-Inn had been the center of my social life. Margaret and I spent hours there, telling each other stories, stargazing, dreaming of true love, planning our escape from Cleveland. A boy named Butch gave me my first kiss at the Drive-Inn when I was fifteen, just Tyler's age. "Yuck," said Tyler when we passed what was left of the Drive-Inn. "There's nothing here." He was right – nothing but memories.

We proceeded to Circle Drive, and I pointed out the house where I used to live. Tyler had his own memories of the house. He was four when my mother died and had last seen her there. "She hugged me hard on the back porch," he said. "It was nice."

After Mom died, my father sold the house and moved to nearby Coldspring, a smaller town that has held on to its sense of place. We drove to Dad's new home, where Tyler hooked up his video games and spent the evening on familiar terrain. It was raining again. I sat outside under the carport, listening to a choir of frogs sing their full-throated song, suddenly aware of how removed from nature I am in San Antonio.

The next morning, I told Tyler that he was in for a treat. I was taking him to my secret place, a place I had visited often both as a child and as an adult. We drove out FM 2025 toward Cleveland, then made our way to the Big Creek Scenic Area. The narrow, red-dirt road was lined on either side by tall pines. As we drove deeper and deeper into the forest, I traveled back in time. I was in my

native habitat, a cloistered, sacred universe. Tyler woke me from the trance. "Mom," he said, "do you know the way out of here?"

We continued on for several miles, then pulled over to a four-mile hiking trail. I wanted Tyler to get an eyeful of what's left of the Big Thicket, what little has been spared from logging. I have hiked this trail hundreds of times, usually by myself. It's where I've made the big decisions of my life, where I came to celebrate after both of my children were born, where I grieved when Mom died. Tyler and I slathered insect repellent on our arms and necks, and he grabbed a giant stick. Snakes and quicksand weighed heavy on his mind.

We walked along in silence for a while. The trees made cracking noises as limbs fell from on high. Water dripped from the leaves of the giant hardwoods, making a percussive sound that emptied my head of all thoughts. We crossed several creeks and heard animals stirring. "What's that?" Tyler asked with every noise. "Natural sounds," I said. The vegetation was lush and the air thick with humidity.

Near the end of the hike, Tyler began to settle into the rhythm of walking in the woods. His breathing became more relaxed. The nervous chatter stopped. On that sylvan path, sheltered by pines, we walked where my grandfather and I had walked. I felt serene, more at home and less self-conscious than I had in years. I showed him the things I love – old stumps from felled trees, toadstools with fat caps living in the humus of those stumps, lacy spider webs.

For a moment, I thought Tyler felt at home too. But when we were back in the car, he said, "That was creepy, Mom. Can we go home now?"

"Sure," I said, turning the Suburban westward – away from Cleveland, toward San Antonio.

BRYCE MILLIGAN

Copano, 1834

Aransas was stormy,
the channel churning and full of muck;
it lifted the *Wild Cat* to the south,
the *Sea Lion* to the north,
set down the two schooners
 gently
one in sand, one in mud,
and left them there to rot.

Two ships full of Irish
escaping, escaping
in the black dull days
between the ninety-eight
 and the famine,
escaping to Texas
and more honorable deaths.

The sea receded, placid,
calmly accepting its toll
as the cholera took them
 one by one
until the bay was littered
and the sands of San Jose
became putrid.

The survivors passed on
as survivors do
to the Alamo,
San Jacinto,
and
Comanche moons;
glad to have escaped Eire,
gladder still
to forget.

Larry Graeber, *Yellow Clearing*, 2006; oil on canvas, 50 x 80 inches.

Kate Ritson, *Knotted Jar #2*, 2002; mixed media, 15.5 x 9 inches.

ROBERT RIVARD

From *Trail of Feathers: Searching for Philip True*

On the morning of November 27, 1998, Philip True, the Mexico City correspondent for the *San Antonio Express-News*, walked out his front door to a waiting taxi summoned from the corner *sitio*. Martha, his Mexican-born wife, was four months pregnant with their first child and not yet showing. She stood by and watched as her husband and the driver wrestled True's heavy backpack into the car's small trunk for the ride to the airport and his flight to Guadalajara.

It was the Friday after Thanksgiving Day. The American holiday is not celebrated in Mexico, but True had scrounged through Mexico City's open-air markets, tracking down everything he needed to prepare an elaborate farewell feast of roast goose with all the trimmings. Before every great trip, Philip always told Martha, a great meal.

At 50, True had a rugged, weathered face but was boyishly lean and fit, an outdoors devotee bound for a long awaited ten-day trek into the remote canyon country of western Mexico. True's outing would be both wilderness quest and jour-nalistic exploration of the reclusive Huichol (wee-chole) Indians, whose small villages and outlying ranches were spread along the deep folds of the Sierra Madre Occidental.

True gave his wife one last kiss and climbed into the taxi. "If I'm not back in ten days, come looking for me," he said, then waved goodbye through the open window as the taxi disappeared from view up the steep, winding street.

No one who knew True ever saw him alive again.

True was my reporter. I was his editor. We were not close friends, but we had much in com-mon: difficult home lives we fled as teenagers, years of blue-collar work as directionless young men, and a backdoor entrée into newspaper reporting that gave each of us a new start in life.

The many intersections of our two lives began long before we met.

We came from distant corners of the United States yet somehow made our way to the same small daily newspaper in the same small city on the Texas–Mexico border. More than a decade separated our arrival in Brownsville. But it was there, where the muddy waters of the Rio Grande flow downstream and empty into the Gulf of Mexico, that each of us began to pursue a reporter's life working south of the border. Our paths crossed for the first time in San Antonio in 1992; soon afterward, True and I found ourselves working together at the same South Texas news-paper. My own rise from reporter to senior editor positioned me to send True to live and work south of the border, just as I had once lived and worked south of the border. Years later, fate led me south once more, this time not on assignment, but in search of my lost reporter.

Philip True was a journalist with working-class roots and no known family other than Martha; he had little to say about his own past life. He was openly skeptical of anyone in power, in govern-ment, and even at his own newspaper. He wrote with great craft and empathy about the poor and the powerless. It was his keen appreciation for the redeeming qualities of people living on the margins that made his best stories so memorable.

Only after his disappearance did I learn that True was a devoted walker, in the wilderness definition of the word. He savored every oppor-tunity to leave behind his everyday existence to venture into the unknown, sometimes with a friend or girlfriend but usually alone. Retracing his life much later, I figured that True had spent an entire year sleeping outdoors on treks, camp-ing and cycling trips, and hitch-hiking adven-tures. He never stopped.

"Walking in the wilderness," True told his Mexico City therapist, Sara Delano Rojas, in one particularly revealing remark, "helps me put back together the pieces of my broken soul."

News of True's long-planned trek caught me by surprise when I learned he was missing. I had covered civil wars and repression in Central America in the 1980s, so his disappearance was deeply unsettling news. I knew what could befall a reporter traveling alone in the lawless backcountry. I wondered why True had set out without a companion.

As Martha and the newspaper launched a search, I realized I could not stay in San Antonio while others went into the mountains. So I went looking for True, fearing the worst, hoping for the best. Only one thing was certain: we were going to find him, no matter what.

Jennifer Agricola, Untitled, 2003; wood and acrylic, 18 x 22 inches.

ROSEMARY CATACALOS

From Home

for Bernardino Verástique

Desde tu tierra te dicen:
The *chicharras* are beginning to die again
and it is the end of summer fruit.
The peaches and melons are coming in
bruised and bitter and thin
to the point where the shooters
selling from the backs of their trucks
try to pawn them off as change.
And the *chicharras, ayyyy, the chicharras*
are giving out with loud choruses
building one voice on another until
the trees shake with a noise
that pounds the heart and eyes.
There is no escape.
They are dying and pulling
the heat into the ground after them.
The mornings become brittle and cool
without their sound. *Camarada,*
the moon is on the rise,
dogs howl through the night,
and it is September.
Grass is starting to grow
where you planted it in July.
It will die with the first frost,
come back again in the spring.

Camarada, in Greece there are grandmothers
who insist on being photographed as they
rummage behind the church among the dead
for the skulls of their former rivals,
finally cupping the empty bone for the camera
with the proud half-smile
of an accidentally longer life,
the eyes rheumy,
the pieces of embroidery fewer these days,
the shroud already woven.
I only tell you these things
because war has broken out in the lands
where the oldest angels
have always known it would come to this.
I only tell you because
Mr. and Mrs. Ozdabeano Maldonado
keep whirling their eternal polka
across my walls.
I only tell you
that somewhere in France
and perhaps elsewhere,
at this very moment
the dead are trying
to walk out into the air
without their stones.

Bettie Ward, *optimism holding the purse strings in a topsey turvey world*, 2006; embroidery, 14 x 19.75 inches.

Dario Robleto, *No One Has a Monopoly Over Sorrow*, 2005; men's wedding ring finger bones coated in melted bullet lead from various American wars, men's wedding bands excavated from American battlefields, melted shrapnel, wax dipped preserved bridal bouquets of roses and white calla lilies from various eras, dried chrysanthemums, male hair flowers braided by a Civil War widow, fragments from a mourning dress, cold cast brass, bronze, zinc, and silver, rust, mahogany, glass. 10 x 8 x 11 inches. Collection of Julie and John Thornton.

ANDREW PORTER
Hole

The hole was at the end of Tal Walker's driveway. It's paved over now. But twelve summers ago Tal climbed into it and never came up again. Weeks afterward, my mother would hug me for no reason, pulling me tight against her each time I left the house and later, at night, before I went to bed, she'd run her fingers through the bristles of my crew cut and lean close to me, whispering my name.

Tal was ten when this happened, and I was eleven. The backs of our yards touched through a row of forsythia bushes, and we had been neighbors and best friends since my parents had moved to Virginia three years before. We rode the bus together, sat next to each other in school, even slept at each other's houses, except in the summer when we slept out in the plywood fort we'd built under the Chinese elm in Tal's backyard.

Tal liked having the hole on his property. It was something no one else in the neighborhood had and he liked to talk about it when we camped out in the fort. The opening was a manhole that Tal's dad had illegally pried open, and it led to an abandoned sewer underneath their driveway. Rather than collecting their grass clippings and weeds in plastic bags as everyone else on the street did, the Walkers would lift the steel lid and dump theirs into the hole. It seemed like a secret, something illicit. We never actually knew what was in there. It was just a large empty space, so murky you could not see the bottom. Sometimes Tal would try to convince me that a family of lizard creatures lived there, just like the ones he swore he'd seen late at night by the swamp – six-foot-tall lizard people that could live on just about anything, twigs or grass, and had a special vision that enabled them to see in the dark.

That was twelve years ago. My family no longer lives in Virginia and Tal is no longer alive. But this is what I tell my girlfriend when I wake at night and imagine Tal talking to me again:

It is mid-July, twelve summers ago, and Tal is yelling to me over the roar of the lawn mower less than an hour before his death. His mouth is moving but I can't hear him. Tal is ten years old and should not be mowing the lawn, but there he is. His parents are away for the day on a fishing trip at Eagle Lake and Kyle, his older brother, has offered him fifty cents to finish the backyard for him. Tal and I are at the age when responsibility is an attractive thing, and Kyle has been nice enough on a few occasions to let us try out the mower, the same way my father has let us sit on his lap and drive his truck.

It's drought season in Virginia. No rain in two weeks and the temperature is in triple digits, predicted to top out at 105 by evening. The late afternoon air is gauzy, so thick you can feel yourself moving through it and when I squint, I can actually see the heat rising in ripples above the macadam driveway.

Tal is hurrying to finish, struggling through the shaggy grass, taking the old rusted mower in long sweeping ovals around the yard. The back of his T-shirt is soaked with sweat and from time to time a cloud of dust billows behind him as he runs over an anthill or mud wasps' nest. It is the last hour of his life, but he doesn't know that. He is smiling. The mower chokes and spits and sometimes stalls and Tal kicks at it with his bare feet. In the shade of the Walkers' back porch, I am listening to the Top 40 countdown on the radio, already wearing my bathing suit, waiting for Tal to empty the final bag of clippings into the hole so we can go swimming at the Bradshaws' pool.

The Bradshaws are the last of the rich families in our neighborhood. Their children have all grown up and moved away, and this summer they are letting Tal and me use their pool two or three

times a week. They don't mind that we curse and make a lot of noise or that we come over in just our underwear sometimes. They stay in their large, air-conditioned house, glancing out the windows from time to time to wave. We swim there naked all the time and they never know.

It's strange. Even now, I sometimes picture Tal at the end of the driveway just after he has let the mowing bag slip into the hole. He is crying and this time I tell him not to worry about it.

"Let it slide," I say. "Who cares."

And sometimes he listens to me and we start walking down the street to the Bradshaws'. But when we reach their house, he is gone. And when I turn I realize he has started back toward the hole and it is too late.

In the retelling, the story always changes. Sometimes it's the heat of the driveway on Tal's bare feet that causes him to let the bag slip. Other times it's anxiousness – he is already thinking how the icy water is going to feel on his skin as he cannonballs off the Bradshaws' diving board. But even now, twelve years later, I am not sure about these things. And I am not sure why the bag becomes so important to him at that moment.

It is said that when you are older you can remember events that occurred years before more vividly than you could even a day or two after you experienced them. It seems true. I can no longer remember the exact moment I started writing this. But I can remember, in precise detail, the expression on Tal's face the moment he lost the mowing bag. It was partially a look of frustration, but mostly fear. Perhaps he was worried that his father would find out and take it out on him or Kyle as he'd done before, or maybe he was scared because Kyle had told him not to screw up and he'd let him down, proven he could not be trusted.

In the newspaper article, the hole is only twelve feet deep; they'd had it measured afterward. But in my memory it is deeper. The bag is at the very bottom, we know that, but even on our bellies Tal and I cannot make out its shape in the darkness. Warm fumes leak from the hole, making us a little dizzy and our eyes water, a dank odor, the scent of black syrupy grass that has been decomposing for more than a decade. Tal has a flashlight and I am holding the ladder we've carried from his garage. If Tal is nervous or even hesitant as we slide the ladder into the hole, he does not show it – he is not thinking about the lizard creatures from the swamp or anything else that might be down there. Perhaps he imagines there is nothing below but ten summers' worth of grass, waiting like a soft bed of hay.

We both stare into the hole for a moment, then Tal mounts the ladder carefully, the flashlight clamped between his teeth, and just before his mop of blond hair disappears, he glances at me and smiles – almost like he knows what is going to happen next.

A few seconds later I hear him say, "It smells like shit down here!" He says something else and laughs, but I can't hear what it is.

The flashlight never goes on. Not after I yell to him. Not after I throw sticks and tiny stones into the hole and tell him to stop fooling around. Not even after I stand in the light of the opening and threaten to take a whiz on him – even pull down my bathing suit to show him I am serious – not even then does it go on.

Later, in the tenth grade, a few years after my family had moved to Pennsylvania, I received a letter from Kyle Walker. He was living and working in Raleigh since high school. In the letter, he said he wanted to know what had happened that day. He'd always meant to ask me, but could never

bring himself to do it. There was no one else who had actually been there, and it would help him out if he knew the details.

A few days later I wrote him a long letter in which I described everything in detail. I even included my own thoughts and a little bit about the dreams I had. At the end I said I would like to see him sometime if he ever made it to Pennsylvania. The letter sat on my bureau for a few weeks, but I never mailed it. I just looked at it as I went in and out of my room. After a month I put it back in my desk drawer.

Two firemen die in the attempt to rescue Tal. Two others end up with severe brain damage before the fire chief decides that they are looking at some *seriously* toxic fumes and are going to have to use oxygen masks and dig their way in from the sides. Later the local newspaper will say that Tal and the two firemen had probably lived about half an hour down there, that the carbon dioxide had only knocked them out at first, but that the suffocation had probably been gradual.

There is a crowd of people watching by the time the young firemen carry out Tal's body and strap it onto the stretcher. He no longer seems like someone I know. The skin on his face is a grayish blue color, and his eyes are closed like he's taking a nap. Seeing Tal this way sends Kyle into the small patch of woods on the other side of the house. Later that night Kyle will have to tell his parents, just back from their fishing trip at Eagle Lake, what has happened. There will be some screaming on the back porch and then Kyle will go into his room and not come out. For years everyone will talk about how hard it must have been on him, having to carry that type of weight so early in life.

When the last of the ambulances leave, my mother takes me home and I don't cry until late that night after everyone has gone to sleep, and then it doesn't stop. Tal's parents never speak to me again. Not even at the funeral. If they had, I might have told them what I sometimes know to be the truth in my dream: that it was me, and not Tal, who let the mowing bag slip into the hole. Or other times, that I pushed him in. Or once: that I forced him down on a dare.

That is the real story, I might say to them. But I will not tell them about the other part of my dream. The part where I go into the hole, and Tal lives.

LEE ROBINSON

The Rules of Evidence

What you want to say most
is inadmissible.
Say it anyway.
Say it again.
What they tell you is irrelevant
can't be denied and will
eventually be heard.
Every question
is a leading question.
Ask it anyway, then expect
what you won't get.
There is no such thing
as the original
so you'll have to make do
with a reasonable facsimile.
The history of the world
is hearsay. Hear it.
The whole truth
is unspeakable
and nothing but the truth
is a lie.
I swear this.
My oath is a kiss.
I swear
by everything
incredible.

Danville Chadbourne, *The Myth of Inherent Values*, 2005; acrylic on earthenware, 19 x 6 x 4 inches.

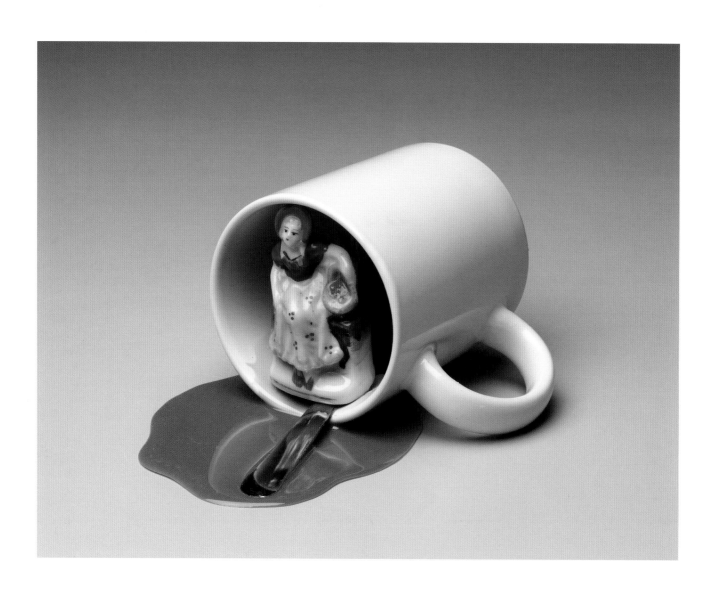

Franco Mondini-Ruiz, *The Coffee House*, 2007; mixed media, 5 x 5 inches.

CARMEN TAFOLLA

Chencho's Cow

It all began when Chencho's cow kicked over a pot of beans. The very pot of beans that Chencho had so painstakingly prepared the night before for the Amados' baby's celebration, selecting the beans with care, cooking them on a low fire for hours, with salt, chile, and bacon, then putting in the *tomate*, cilantro, onions, and more bacon near the end, with, of course, the crowning touch – a can of beer – to make them *frijoles borrachos*, little drunk beans that he would ladle up into small cups that people would down like chocolate syrup, only better, not leaving even a teaspoonful of juice at the bottom, and always going back for more.

It was a special occasion. Elena and Javier Amado had given birth to a round-cheeked boy whom they named Carlos Javier, after both their fathers, and Chencho, their neighbor, was invited to the gathering at the house after the baptism. In fact, he was on the way to the party with the aromatic pot of beans cradled in potholders when he heard the cow moo loudly and decided to make certain she still had enough water, since he didn't know how late the party would keep him.

It was for being in a rush (as problems usually are) that he laid the pot down so close to her, thinking just to run the hose a minute and continue on his way. But the smell of those delicious drunk beans must have made the cow more energetic than usual, and when Chencho turned around to pick up the hose, she followed him, kicking over the beans and all their *jugo* onto the thirsty dirt. Chencho found himself in a true quandary. He wanted to go to the party, but he wanted to take a pot of beans with him. He thought about making up some quick *papa con huevo*, or squeezing some juice into a large *galón* bottle, but that wasn't what he wanted to take. He wanted to take a pot of beans. Worse than that (the truth had to be told), he wanted

to take *that* pot of beans – the very pot he had made with young Carlos Javier Amado in mind, and that now lay flavoring the red, sandy dirt. He stared at it, he *wished* it back into the pot, he even thought about scooping up what he could, but one look at the cow (and one smell) changed his mind. There was simply nothing that could be done.

The party was as pleasurable as imagined. The townspeople were happy to congratulate (and toast) the young child. Everyone understood about the beans, and they all agreed with Chencho that it was a terrible shame. Chencho took his accordion and played for the party, and even promised the young couple a replacement pot of beans for the next Sunday round of visitors. Everyone went home feeling good. Everyone except Chencho.

Every day for a week, he would go out into the barn and stare at the floor, jealously remembering that pot of beans. It got to the point where he began to neglect his fields, and he even shouted angrily at his cow one day. He apologized to her, but still it bothered him – it even bothered him that it bothered him.

One morning, as Chencho was standing in the barn heaving one of his now-customary sighs, someone said, "It doesn't have to happen that way, y'know." Behind him stood an *avena*-faced Anglo, a man dressed formally and all in black, like one of those *Protestante* ministers, hat coolly in hand. The man pointed to where Chencho's beans had by now (Chencho was sure) fertilized and strengthened the ground with their nutrients. "Such a waste and all for no necessary reason," said the stranger.

Chencho was startled a bit and also a little embarrassed, as if someone had caught him without his clothes on. "My beans?" Chencho verified, his discomfort not permitting any more

eloquent a response than that. "Mm-hm," the stranger nodded, and looked coolly at the rim of his hat.

"You heard about my beans?" Chencho asked.

"Mm-hm."

A moment of silence passed between them, their wandering eyes missing each other's intentionally.

"Hate to see you feelin' so bad, m'friend."

Funny the way the gringos, especially this kind that traveled through and appeared from nowhere, leaving also into nowhere, liked to call you "my friend," even though they had never laid eyes on you before and you didn't even know their name. He felt so irritated and embarrassed that this stranger should know so much about him. He tried to retract from that intimacy, awkwardly, but in a definite retreat.

"I'm alright." His embarrassment and the mutual silence belied his attempt. Chencho took a few steps to the side, and then – thinking better – to the front. The gringo looked away politely.

"It's just that they were for a very special fiesta . . . in the home of my young neighbors . . . the baby boy was named after his two grandfathers – very fine men, very well respected . . ." Chencho realized he was rambling and stopped.

"Sure, nothin' the matter with that. Just bein' proper. Anyone could understand that." Chencho relaxed. The man continued, cautiously, "All the same, it do prove a bother, given everythin'." Chencho's brows came together as he studied the talkative gringo. "An' the most bothersome part comes down to just one thing –" Chencho was caught. No one had talked to him about it with such concern since the day after the party, as if everyone else had forgotten or worn out the interesting part of it, and Chencho had only himself to talk it over with. "Just one thing, m'friend, at the root of it all – causing you this heartache –" the gringo held the moment, letting Chencho hunger for an answer, " – Passion! Jus' plain passion!"

¡Gringo entremetido! Chencho thought, I knew he was sticking too far into my private feelings!

"Now don't go backin' off, m'friend. This is a problem common to the majority of human bein's that inhabit this planet! An' to darn near all of the animals! Why that cow of yours just got so excited by the smell o' those beans that she jus' had to kick up her heels an' dance across the floor behind you, kickin' over those special beans o' yours. You'd a thought she would've stepped over logically, or waited till you got the water filled an' was out o' the way, but she jus' got so filled up with passion." Chencho was listening again. "Passion's what did it! Why, people go near all their lives gettin' their feelings hurt or broodin' over things, cause o' the trouble that passion causes'm . . ."

By the time he cleared the dishes off the lunch table, Chencho was feelin' pretty good. The gringo had brought in a couple of bottles of elixir from behind the panels of his truck (to cleanse the body after eating, he said) and Chencho was feeling more relaxed than he'd been in a week, with the drone of the gringo's voice putting him just a little (but not too much) to sleep. It never occurred to him to ask what could be done about it; it just somehow made more sense for this whole incident to have had some reason. But the gringo was on his way to some special road: "If only they didn't have their hearts gettin' in the way all the time, so much could be accomplished . . ."

Chencho didn't remember having really thought about it a lot. In fact, he didn't really remember how it all happened. But his cow seemed to be doing fine, and the gringo reassured him that she

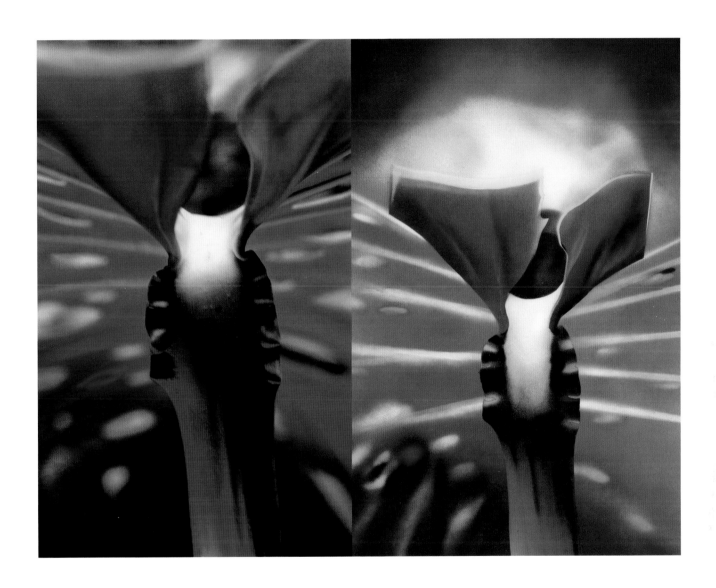

Robert Ziebell, *Robert/Roberto (Palm)*, 2005; paint on paper, 16 x 20 inches.

was actually doing better than she ever had before. Even the scar where her heart had been taken out didn't seem to bother her. And the gringo was sure to point out that she would never again moo at him crossly when Chencho was late to feed or milk her. In fact, she would never again moo at him at all. There was simply no reason to do so.

There was still the matter of Chencho staring at that special spot in the barn and savoring the memory of not only the beans, but of the whole *celebración* as he had envisioned it, but the gringo had an idea that he said would take care of that, too. It wasn't that Chencho had so much confidence in the gringo – he was a curious sort that did too much talking and not enough waiting – but it was just that the man had a way of getting him to agree without asking his opinion.

"Passion! M'friend, without our hearts, we could get so much more done, and with so much less pain. Now, I wouldn't recommend this to ya' if I didn't happen to have seen it work so many times. If we weren't so emotional, we'd have lots more space for being logical. Why the proof o' that's women, ain't it? Get so emotional they don't have an ounce o' logic in'm. Now that's one that a good man like you can really understand, can't ya?" he said, laughing and elbowing Chencho. Chencho didn't, but he laughed anyway, from the mouth outward, as they say in Spanish, but enough to keep from looking too unmasculine to the gringo.

This time, Chencho insisted on taking the night to think about it. He would have put it off much longer, but the gringo said he had appointments to keep in another town and would have to leave this town "sooner than I'd like, m'friend." Chencho talked about it plenty with his neighbors, and some of the things Nilo said got him

so upset that he spent the whole night struggling with his pillow, and by morning was ready to give it a try, just to get rid of this problem. He went out to the barn, where the cow was standing, looking very peaceful and unconcerned. "You'd be considered quite a man to have that kind of calm and strength in every situation." Chencho turned to look at the gringo, and something about the man's absoluteness, stark black and white against the brown of the barn, made Chencho want to trust him, want to really make his "m'friend" expression a reality. He was a little nervous about the cutting part, but the gringo explained that the reason the wound had healed so rapidly on the cow (in fact, it was not even like a wound at all) was that nothing really biological had been removed, only the emotional mass, the heart itself, and without the bother of this too-emotional muscle in its chest, the body could proceed with even greater health, allowing the brain to take over the functions previously so poorly supervised by the heart.

Maybe it was Marta's grandfather, the one with the weak heart, that did it first, after Chencho, or maybe it was *la rica*, the one who was always so scared of someone stealing the blue tile birdbath that she'd bought in Mexico and placed so precisely in the perfect shady spot in her garden. No one seemed to remember how it had all happened, but they did recall that there were long lines in front of Chencho's house and that everyone went in very envious and excited and admiring how well Chencho and the others seemed to be doing, and came out looking very happy, or maybe it was strong, or in control, they weren't certain which. At any rate, by the time three suns had set, there wasn't a normal-brained person over the age of ten that hadn't had their heart removed by the kind gringo who brought them the science of

"depassionization," as he called it. Chencho's mother had been one of the last to agree, and most of those three days she ranted and raved (quite passionately, proving the gringo's point) against the whole idea, saying that if God had meant people not to struggle for anything, he would have given women "labor thoughts" instead of labor pains. The strangest thing of all was that the reason she probably gave in and had it done was because of passion itself! She just couldn't stand to see everyone else in such a predicament and her not right in there with them, with her hands in the *masa*, so to speak.

Chencho's mother had made certain, before placing herself defiantly in that line, however, that her retarded niece, Eva, would not be touched. The gringo agreed emphatically, stating that it really wouldn't work well on the mentally unfit or on children under ten because, with as little as they'd accumulated up top, they wouldn't have anything left to lean on.

It wasn't until weeks after the gringo left that they realized something was missing. At first, they thought they were just forgetting things, making a mistake or two, or having a dull day. But the pattern was noticeably repeated. Their thinking no longer seemed as sharp, and the reasons for thinking things out were not known. Many things left a taste of not having been tasted. Chencho discovered that he no longer remembered how to make beans. This was the case with numerous things: they had to look elsewhere to find what had once been inside of them. Chencho contacted a cousin in a neighboring city and made clear the level of his need: The necessary papers were sent promptly. Chencho would focus all of his attention, following the directions with great care. Each step was outlined elaborately. Cleaning the beans required spreading them on the table, removing the stones, removing the beans that were shriveled more than twice as much as the majority, eliminating those that had a very dark color – correction, those that had an unnaturally dark color. (He had wondered what was unnatural, and had been told to remove those that looked burnt and reddish, while leaving those that were dark in the same shade as the dark spots on the light beans.) It seemed so complex. He had first learned to clean the beans as a child, but he had not learned with his head. He had learned with his heart, while watching his grandmother do that which had later become integrated into his view of life. Now it was integrated into nothing more than the piece of paper he studied so thoroughly, stumbling through the applications.

"Wrinkles that come with life, wrinkles from rubbing against other beans, wrinkles from wilting under the sun – all right. Wrinkles of petrified stone – no." He worked at it repeatedly, adding precisely measured amounts of ingredients at precisely timed stages. Chencho found that every time he cooked beans, he needed to follow the written instructions again. It was as if there was some ingredient missing, but he had no idea what to add.

Chencho and the others would sit in the evenings, trying to piece together those things that their hearts could no longer provide. Eva, the retarded thirty-five-year-old, began to play a special role. She was the one they turned to for lessons in how to cuddle babies and how to help the older children play. They listened carefully as she and the little children laughed, trying to imitate the sound.

They tried to make lists of what it was they had lost, had had, and had been said in those days of the gringo's visit. They tried to piece together old conversations, but, somehow, every conversation had something important missing between the lines. The eight- and nine-year-olds were brought

in to listen and respond, but even their responses were difficult to comprehend. The teenagers just took notes. Chencho's mother proposed they go over every event and every conversation from the day of the gringo's arrival to the day of his departure. Chencho remembered him climbing into the truck with some salutation, what was it? The children offered possible expressions until the right one was found. "Goodbye, my friend," the gringo had said, as he folded the worn dollar bills into his pocket. "And then what?" asked Jorge, as the Amados' baby began to cry and the adults turned to stare at him. "He wants his bottle," said a bright-eyed seven-year-old.

Chencho thought carefully, and found the information as best he could through his passionless brain. "And then he told me how fortunate we would be – to be able to work longer days in the sun, without feeling upset, and to bring home paychecks of any amount at all, without wanting to cry." "What?" asked Elena, thoroughly confused. "Without wanting to cry?" "Yes, that's what he said." "Is that all?" asked his mother, whom people somehow sensed should be regarded as a leader, although they were not certain why. "No," said Chencho slowly. "There was something more . . . something . . . like that, like what that child just did." "He laughed?" asked the seven-year-old. "Yes, that was it. He laughed. He laughed," Chencho verified, "and then he drove off."

In the distance, Chencho's cow could be heard moving around the barn, her bell dangling against the trough as she searched for food, but everyone knew that she would never again bother to moo.

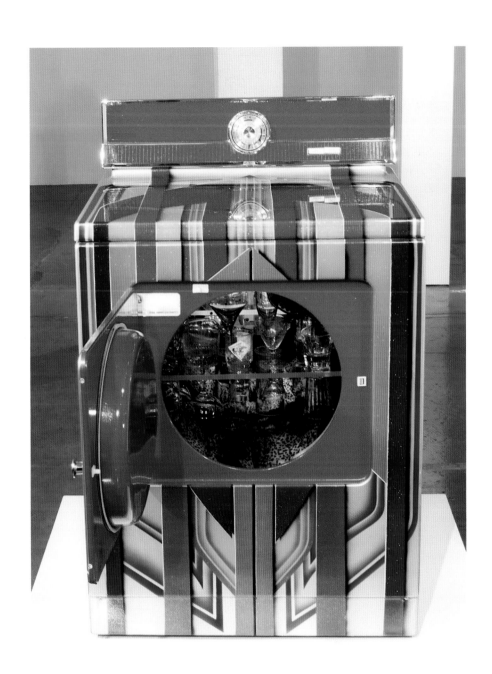

Katie Pell, *Candy Dryer*, 2006; Maytag dryer, paints, upholstery, assorted materials, c. 34 x 30 x 30 inches. Collection of Guillermo Nicolas.

PETER STRECKFUS

After Words

Here is a wall. The strange empty space above the wall . . . what is it for? Here, a little boat, a canopy of silver plastic rattling above it.

Listen to the babe-scare cry of the wind. You are in the unsteady boat and this poem is a lake.

It's too late now. You are in the boat my little skipperoo, my kitzie koodle. Look. In the other boat, your son. All the rest, the other sons, the boy you blinded and the daughter you maimed, the weapons and the armor, is film, a thin and punctured membrane, a fictitious hymen.

There's no place for that weapon here. Come on now, you have no choice. Trust me.

I'll speak nonsense. You speak truth. We'll see what comes of it.

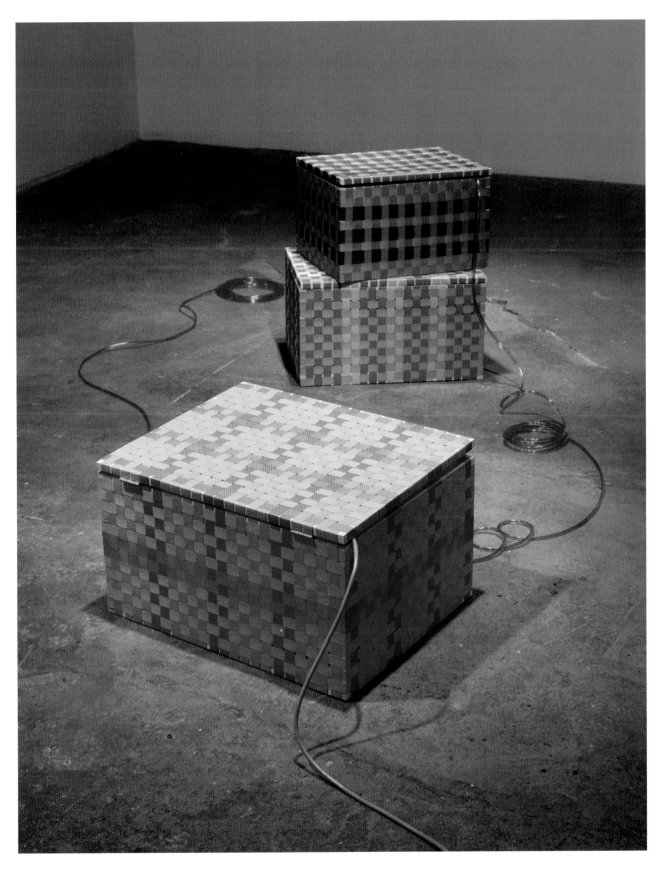

Jessica Halonen, *Picnic Baskets: Relationship 1 (Indispensable)*, 2003; grosgrain ribbon, wood, clear vinyl tubing, water, dye, recirculating pump; three pieces, range 13 x 18 x 12 inches to 15 x 25 x 20 inches.

Ron Binks, *Nueva West,* 2003; color photo, variable size.

ROBERT FLYNN

Truth and Beauty

To be a writer in Texas is to know truth and beauty. A friend and I were standing in the cotton field one day. It was one of those hundred degree north Texas days when the hot wind blows – and the wind always blows – and it always blows either hot or cold. And the only thing there is to move is sand. And the sand moves every time the wind blows. We were leaning on our hoes, and way off in the distance we could see a pickup truck going down a county road and dragging a cloud of dust behind it. We must have stood there, transfixed, for ten or fifteen minutes, just admiring that cloud of dust on the horizon. My friend said, "Ain't that the prettiest thing you ever saw?" It was my introduction to beauty.

My introduction to truth was not so dramatic. My grandmother was born in Vermont in 1842. That was the year the Webster-Ashburton Treaty was signed between the United States and England settling the boundary of Canada west of Lake Superior. She married my grandfather who was an Irish immigrant and followed him to Texas where he helped build the Fort Worth and Denver Railroad. Grandmother bore him three sons, all born at a constantly moving end of the track. Near Chillicothe my grandfather bought a piece of land. A few years later, 1897, he was murdered. Grandmother hung on to that piece of land and she doomed her children to do the same.

Every day both going and coming from the two-room country school I attended, I had to cross over the railroad tracks my grandfather helped to lay. And in both directions the tracks ran as far as the eye could see. A few miles to the east and we would have been in an oil field. A few miles west and we would have been on land good for nothing but running cows and chasing jack-rabbits. Slowly the truth appeared on the horizon. My grandfather had been tricked into buying the only place in twenty miles that would grow cotton.

The cotton field is one of the great classrooms of life. Put a young man in a cotton field, place a sack on his back or a hoe in his hand and right away his thoughts will turn to truth and beauty. A far-off look will come into his eye. Put a young man in a cotton field and he will take up prayer. "Lord, if you will just get me out of this, I will never again as long as I live look at the women's underwear in the Sears catalog."

It was in the cotton field that I first learned the power of the English language. I had a girl friend who chopped cotton with me. She was called a hoe hand. I know because my mother told me. As I stood there all alone in the cotton field – my girl friend had been sent home because I used the wrong word – it came to me like a flash of light that if the wrong word like hoer had the power to move my mother to such action, just think what using the right word like hoe hand could accomplish.

That was when I first got the notion of being a writer. I knew it wasn't going to be easy. We didn't go in much for writing at the country school I attended. Writing was something that was done by fairies and other New Yorkers. Real men studied penmanship. We made little push-pull lines all over the page. And row after row of spirals. It was called the Palmer Method and was invented during the Spanish Inquisition as a means of turning boys from writers to pray-ers. "Lord, if you will just get me out of this I will never touch another pencil. And I will never again drop my eraser and try to look up Myrtle Bailey's dress."

But we knew what a writer was. A writer was somebody who was dead. And if he was any good he had been dead a long time. If he was real good, people killed him. They killed him with hemlock. Hemlock was the Greek word for Freshman Composition.

The country school I attended was closed and we were bused to Chillicothe. Chillicothe had a teacher who had seen England. From a boat. She had discovered truth and beauty from eight miles offshore and had come to Chillicothe to share her vision with picturesque rustics. With some timidity I confessed that I too hankered after truth and beauty.

Chillicothe is small. Chillicothe is so small there's only one Baptist Church. Chillicothe is so small you have to go to Quanah to have a coincidence. For a good coincidence you have to go to Vernon. Chillicothe was fairly bursting with truth and beauty and my teacher encouraged me to write about it.

I decided to write about my father. My father, the youngest of three sons, was born in a box car at the end of the track that has since come to be called Chillicothe, Texas, being the first child born in my home town. The box car served as the station house for the railroad, and was, with the exception of a dugout that served as a store, the only building in town. I wrote that my father was born in the finest house in Chillicothe. My teacher told me to write something that had an epiphany. For an epiphany you had to go all the way to Wichita Falls.

I wrote about Delmer Lance's pet heifer, Snuggles. Snuggles was raised on a bottle and was as friendly as you'd want a heifer to be. Until Delmer locked her in the barn with his range bull. The next morning, Snuggles was gone. Also the barn door. The top rail off the fence.

Delmer chased that cow all over the county but Snuggles went wild as a new rope. One night Delmer was driving down the highway and ran over Snuggles. Delmer said he recognized her when she passed over the windshield by the puzzled look on her face. That was an epiphany.

I spent half my life thinking I could recognize a bad girl by the puzzled look on her face.

My teacher said to write about something that had happened to me. I wrote about the year there was a blizzard and everybody from the two-room country school – two teachers, thirty-eight pupils, and three adults who had sought refuge in the school – had to walk two miles through the snow to our house to spend the night. I remembered it because that was the day my father came home with four hundred baby chickens and it was so cold we had to keep them in the house. All over the house it was butts and feathers. All night it was cheep and shit. Cheep and shit.

Forty-two chickens were squashed in the linoleum. Three drowned in the chamber pot. One was crushed when Ed Byars put on his boots. When Mother lighted the gas oven thirteen went up like a torch. Three more were scorched so bad that Dad threw them out in the snow. Ed Byars spent the rest of his life minus the end of his nose because he preferred frost bite to the smell of singed chicken feathers.

My teacher said I didn't know the first thing about truth or beauty. I promised to go to England the first chance I got. Or at least Korea. She loaned me books that were not available in the Wilbarger County Library, books that had been written by real writers.

Real writers wrote about such things as I had never heard of. Damsels. Splendor falling on castle walls. For splendor we had to go to the Fort Worth Fat Stock Show. Since I wasn't overly familiar with damsels and splendor, I tried reading what real writers wrote about rural life. "Dear child of nature, let them rail. There is a nest in a green vale." Which was pretty mystifying to me. I remember asking Bubba Spivey, "Don't writers get chiggers like everybody else?"

I set out looking for a green vale to make a nest in and when I got there I found out what made it so green. When it comes to vales, a cow will get ahead of you every time.

I wrote a story that contained the wisdom of the world in eight poetic pages of arcane words and mysterious imagery full of towers, turrets, and spires. My teacher loved it. She had never met a symbol she didn't like.

Assured of success, I went to college to become a writer. I knew what I wanted. I wanted to reveal the false hopes, the futile dreams, the fleeting victories, the glorious visions, the hidden desires, the sudden and secret joys, that bind us into one humanity. I wanted to refine the language, to explore the avenues of communication, to stretch the limits of understanding, to probe the mysteries and futilities and glories of man, to heal his broken spirit, to restore his sense of purpose, to discover the nature of beauty and truth, and to sell it to the movies for a million dollars. After which I intended to marry a movie star and move to Paris. Or at least, Commerce.

My instructor told me the way to find truth and beauty was to write about heroes and villains, good people versus bad people. The best people I knew did bad things. The worst people I knew did good things. We weren't heroes or villains, we were just puzzled. How could I write about the people I knew when I was attending a college that did not approve of dancing. Smoking. Swearing. Drinking. Dating members of the opposite sex. Dating members of the same sex. I used to pray, "Lord, if you will just get me out of college I will never be a Christian again."

We were told to write a love story containing truth and beauty. I was petrified. I had never seen a moat or a moor. I had never known a knight or a knave. I was the only great lover I knew. The only time I came close I began nuzzling the girl's ear and lost my chewing gum in her hair. It was Bazooka bubble gum and I hadn't gotten all the sweet out of it. I spent the next hour and forty-five minutes alternating between kissing her eyes and frisking her scalp, and holding my hands over her eyes while chewing her hair. Her mother called her three times before my jaws came unstuck.

I wrote about a boy and a girl. He is true. She is innocent. They have found a nest in a green glade. They smoke a Salem. They speak of truth and beauty.

I threw the story away. I wrote about a boy and a girl. The boy is generally true. The girl is relatively innocent. They find a meadow. The sun is hot, the wind roughens their complexion. They smell of sweat and Salem cigarettes. He speaks of love with some truth. She has a puzzled look on her face.

I tore up the pages. A boy and a girl. He is a bastard. She is a bitch. They are lying in a pasture among cow dung. Scratching chigger bites. The blazing sun raises blisters on his back. He has a herpes on his lip. She has bologna breath. He whispers obscenities into her ear. He loses his gum in her hair. It is Bazooka bubble gum and still has some of the sweet in it. Her mother calls. He gnashes his teeth.

I wrote about Bud Tabor. Bud was a married man, and Sherry McIlroy's father shot him through Box 287. Ed McIlroy was the postmaster and when Bud came in to get his mail, Ed stuck a pistol in the open end of the box and shot Bud in the eye. Ed was a conscientious man and he waited until Bud opened the box and looked inside so as not to deface government property.

They never found Bud Tabor's eye. Buried him without it. They fixed him up with a glass eye for the funeral, but Sherry and Bud's wife got in an

argument over who got to keep it as a souvenir. Sherry won. Put it on a chain and wore it hanging down between her breasts. Folks used to say Bud may have gone to hell but his eye went to heaven. Some folks' idea of heaven is mighty small. Lower on one side than the other.

My instructor said it was not a love story.

Delmer Lance had some sheep but they developed an unnatural affection for an old yellow dog. They followed the dog wherever it went. No pen could hold them for long, and once on his trail, the dog couldn't shake them. In desperation the dog ran away from home, the sheep right behind him.

From time to time the dog and sheep showed up at someone's tank or feed trough, the dog looking gaunt and haunty-eyed, the sheep looking all unraveled. Elmer Spruill shot the dog. Elmer said he couldn't stand the puzzled look in the dog's eyes.

My instructor said there was no beauty, no truth, and no moral.

Lowell Byars came to the county with his wife Lou. They lived in a dugout and poor-boyed, working as long as there was light to see. There was no time for visiting neighbors, or going to church, just day after day of chopping weeds and carrying water, with nothing to eat but biscuits and gravy, and nothing to sleep on but the gritty quilts Lou's mother had given them.

The roof of the dugout caved in during a rain storm, they were dispossessed for two days by a skunk, the crops blew away in a sandstorm, but Lou stuck it out, and if she cried of loneliness or despair it was when Lowell was away from the dugout. One morning Lowell got up early as usual and said, "Get dressed, Lou, we're going to Quanah to see the Mollie Bailey show."

Lowell milked the cow, fed the mules, hitched the wagon, and when he got back to the dugout he had to fix breakfast. Lou was still brushing her hair. They drove to Quanah and watched the wagons come in, drawn by elephants. They looked in the store windows and stared at the crowd of people in town. They drank lemonade and had a supper of sardines and crackers and saw the show and it was over, time to get in the wagon and start for home.

It was a long way back to the dugout and Lowell knew he would have to get up early the next morning to make up for the work he had missed but he didn't care. The moon was bright, a thousand stars twinkled in the sky, and he had shown his wife a sight. Lowell was feeling pleased with himself.

"It ain't so terrible being married to me is it?" he asked Lou who was sitting silent and sleepless beside him. Lou began to cry. She cried all the way home. She cried all night. When he got up the next morning she stopped crying to fix his breakfast, but she wouldn't speak to him for three more days until he cut his hand heading red top maize and she had to ask how he was.

Lowell promised to take her to the Christmas dance and rather than disappoint her they drove fifteen miles in an open wagon in the face of a norther. Lou danced every set of the all-night dance. She went home with a fever, took pneumonia, and died of frivolity.

I had found a story with a moral but I also found it wasn't easy writing about people I knew. I got all puzzled. I didn't know what was beautiful, and what was foolish, and where truth lay. Was Lou Byars a silly girl unsuited for a rugged country? Was she the innocent victim of a foolish dream? Or was she a tragic heroine who knew that the quality of life was not measured by the years endured in twilight, but by the moments spent in the candle's flame?

Ideas are so neat. You can outline an idea. You can label an idea. Ideas don't bleed. They don't

Meg Langhorne, *Pa Pa Do,* 2000; mixed media. Installation, dimensions vary.

cry. They don't blame you for their unhappiness. They don't die of frivolity. But a person has many faces. And some of them are evil, and some are vain, and some are foolish, and some are beautiful, and many are secret.

It looked like for truth and beauty you had to cross Red River. All I knew about was a little place called Chillicothe. And it wasn't even the Chillicothe that was on the map. It was a little place I called Wanderer Springs, that existed only in my mind. And all I had to go by was my grandmother who died at the age of ninety the year I was born, and my father who was born in a boxcar at the end of the track. Would truth and beauty as I wrote it stand up against the reality of my grandmother? Would my father believe it? And could it happen within the territory I had staked out for myself?

I wrote the love story of Grover and Edna Turrill. When he was sixteen Grover had married Edna, at the request of both families. Grover's father gave them a milk cow, and Edna's father gave them a steer. Grover yoked them together and started to California. It was his promise to Edna.

They crossed Red River and stopped near Preston where Edna had a baby boy with no one to help her but Grover. They started again as soon as she was able to travel, Edna and the baby in the wagon, and Grover walking beside the wagon, prodding the steer and milk cow, and picking up firewood.

One day Edna placed the sleeping baby in the back of the wagon and got out to walk beside the cow. Grover found a tree stump and not knowing the baby was in the back of the wagon, he threw in the stump, killing his child. Some cowboys found them, two teenagers traveling across the prairie with a dead baby wrapped in a quilt. The cowboys buried the child.

Grover and Edna were still on their way to California when the milk cow died near Wanderer Springs. They lived in the wagon while Grover broke the land with the steer and planted a crop. Later they built a house and had two more children. When Billo was twelve he went hunting on Wanderer Creek with some older boys. They ran a coon up a dead tree, and Billo was sent up the tree to shake the coon down. A pile of brush had been washed up under the tree and the older boys set it afire so that Billo could see. The dead tree caught fire and Billo was burned so he couldn't lie down and Edna and Grover took turns holding him the four days it took him to die.

A few years later, when Polly was thirteen, she complained of a stomach ache. Polly wasn't fat but, like Edna, she was slope-shouldered, solid, and a good eater. When she was unable to eat breakfast, Grover hitched up the wagon, made a pallet in the back, and with Edna to comfort Polly, they started for the doctor in Wanderer Springs, several miles away. The wagon had no springs, the road was just a set of ruts across the prairie, and Polly whimpered the whole way although Grover drove as slowly as he dared.

When they got to Wanderer Springs, they found that Dr. Vestal had been called out of town. Over near Medicine Hill folks thought, expected to be gone all day. Polly was too sick to wait so they started for Medicine Hill, sending word ahead by Buster Bryant who volunteered to carry the message.

It was August and the sun was hot and Polly cried out at every bump, so Edna stood and held a quilt to shade her, and Grover drove the mules as fast as he dared. They met Buster Bryant who had missed Dr. Vestal somehow. The doctor was on his way to Bull Valley. Grover turned the mules toward Bull Valley with Buster racing ahead.

Dr. Vestal had left Bull Valley for Red Top. Buster rode to head off the Turrills. The mules had played out and Grover was walking beside them to lighten the load. Edna was standing with her feet spread, holding the solid little girl in her arms, trying to absorb the bumps and shocks of the wagon with her own body. Buster told them to go home. He would find Dr. Vestal and meet them there.

It was almost dark when the wagon got back home and Buster and the doctor were waiting. Edna was sitting beside Grover holding Polly who was so big she lay across both their laps. The mules stopped of their own accord and neither Grover nor Edna made a move to get down. Dr. Vestal started to the wagon but Grover said, "I don't want you to touch her. We've been praying for you all day and listening to her die. I know it ain't your fault, but I don't want to see you now."

Buster stayed with the Turrills although he didn't dare go in the house. He unhitched the mules and fed them and sat out on the porch. After a while Grover came out. He sat on the porch and stared at the dark, empty, treeless miles over which he had ridden that day, listening to the shriek of the wagon wheels and the dying cries of his last child.

After a while Edna came out also and leaned against the porch post, hugging the porch post as though it were a child, her head hanging down a little as though permanently bent from ironing clothes and chopping cotton. She waited while the last light of day faded and one by one the stars came out, watching the prairie that under moonlight had a sheen like a silent sea.

"If that cow hadn't died, we'd be in California," Grover said.

"Old Boss," Edna said, remembering the name over all the years, recalling the dreams they had shared as they traveled across the prairie in the wagon.

"God damn country," Grover said. "Washes away ever time it rains. Blows away ever time there's a wind. Hail or grasshoppers ever God damn year. Hot as hell or cold as hell. Flood or drought. Too dry to plant to too wet to plow–"

"Yeah," Edna said, nodding her head in the darkness. "But ain't it purty."

Truth in the mythical kingdom of Wanderer Springs was neither comic nor tragic, neither big nor eternal. And it was revealed through the lives of common folk who belched and fornicated, and knew moments of courage, and saw beauty in their meager lives.

But Grover Turrill gave me some problems. Some readers thought the vocabulary was offensive. I could not write about the people I knew without using the vocabulary they knew. My father did not believe a cowboy said "golly bum" when a horse ran him through a bob wire fence.

I went to see Clifford Huff. Clifford was a horseshoer and he had been kicked, bitten, or stepped on by every horse in the county. It gave him an extensive vocabulary. I asked Clifford the worst words he knew. He said they were "yes and no." He had said yes when his wife, Letty, asked him if he was playing around and he had said no when she asked him if the gun was loaded. They had been married thirty-three years when Letty shot him once through the pantry and twice up the stairs.

Words are not casual things. They are powerful. Even explosive. Words can start wars, or families. Words can wound, they can shock and offend. Words can also heal, and explain, and give hope and understanding. Words have an intrinsic worth, and there is pride and delight in using the right word. Anyone who chops cotton with an axe is a hoer.

I don't know whether or not Travis drew a line at the Alamo. Maybe that story is myth. I do know that every writer draws the line. Must draw the line. Whether he is dealing with teachers, advisors, well-wishers, editors, publishers, critics, or the public. This is my kingdom. These are my people. I know them better than anybody. They will not jump through hoops for the amusement of casual readers. They will not temper their speech for prudish ears. I may not respond the way they do, but I respect them for what they are. And that's where I draw the line.

I wrote a book about people my grandmother would have spoken to, and they used words my father would have believed. A few people heard of it. Fewer read it. My closest friends bought it. And loaned it out. After a while the book disappeared from bookstores to make room for a best seller written by a man who had never met an adverb he didn't like. It was about a lonely but beautiful housewife who falls in love with a handsome painter who is painting the windmills of Concho County for Aquatic Monthly. After three days of romantic bliss, she decides she must be true to her ironing board and he must move on to paint the fence posts of Val Verde.

But I had already turned down the next row. Writing is a lot like chopping cotton. It's a long way to the end of the row, and when you get there, there's always another row to turn down. A friend was disturbed that I was spending so much time at something so unrewarding. "There's no money in it," he said. I couldn't argue with that. There's more fame in selling used cars. There's more fun in running a gas pump. I didn't argue with him because he was right.

I just kept chopping on down the row, knowing when I got to the end of it, there would be another row to turn down. And another. And another. And as the day wore on it wouldn't get any easier. Maybe it wouldn't get any better. Perhaps no one would come out to the field to see if I was still working. I might not even hear the dinner bell. It didn't matter. He thought I was a hoer. But I am a hoe hand.

Jesse Treviño, *El Progreso,* 1976; acrylic on canvas, 48 × 66 inches.

FRANCES MARIE TREVIÑO

Homage to Jim Dine

American Painter of Hearts

There are many
compositions and theories
of color and placement
in the shaping, sculpting
and nurturing of one's heart

A Jim Dine heart
is often linear
starting and stopping
in places most expected
for a heart to begin and end

and yet there are
those theories of color
and stroke
a movement or non-movement
of brush in hand
not knowing where a line
is going
until it gets there

when I saw
a Jim Dine heart
at a museum in New York City
the color and stroke and

placement and form
held my feet still and
made my fingers shake
and that heart jumped into mine
golden, purple, and burnt orange
hearts of fire hung
on that museum wall

hearts three and four and five
feet tall
placed on that white museum wall
while my fingers shake
and my feet stand firm
and I learn

that a Jim Dine heart
those hearts of theory
and practice
and a twisted tender, breaking
that comes back together
in an imperfect line

begins and ends
perfectly and exactly
where it should

Karen Mahaffy, Untitled (You Live Such a Pretty Life), 2003; still from video.

Jesse Amado, *Song Lyrics*, 2002; digital print, variable size.

JIM LEHRER

From *A Bus of My Own*

It was Saturday night, just after midnight. I answered the ringing phone on the city desk.

A hysterical female voice cried out: "This is *Time* magazine in New York! I need help!"

Time magazine in New York! Hello, Big Time.

"I need to know John Connally's middle name," said the voice. "I'll be killed if I can't find it. We're on deadline. Please. Please!"

I held the phone away from me and yelled over to the copy desk, some twenty yards across the newsroom. "Anybody over there know John Connally's middle name?"

Hardly even looking up, one of the copy editors said: "Bowden. Spelled B-O-W-D-E-N."

I repeated that into the phone.

"Are you certain?" said the woman.

"Are you certain?" I yelled back at the copy editor.

"As if it were mine," he replied.

"I am certain," I said into the phone.

"Oh, thank you. Thank you. What is your name? What is your Social Security number?"

I gave her both.

Five days later I received a Time Inc. check in the mail for fifty dollars.

Hello, Big Time.

It was July 1959. I was a few weeks into my first newspaper job as a night rewrite man at the *Dallas Morning News.* While winding up my time at Parris Island, I had written four I-want-to-be-a-reporter letters. United Press International never answered. The Associated Press responded with a polite "We have no openings." The *Fort Worth Star-Telegram* came with a less polite "Sorry, we're not interested." It was the *News,* after my letter number four, that brought the only answer I wanted. You look good on paper, they said; come see us after your discharge.

I came two months later, they saw, and I was hired at $82.50 a week.

Sticks was right about what a newspaperman was all about. Particularly the part about death.

In ten years as a reporter in Dallas, I covered many stories about people dying. They died in plane crashes, head-on auto wrecks, tornadoes, flash floods, house fires, love triangles, hold-ups, cop-and-robber shoot-outs, loaded-gun accidents, knife fights, wife and child beatings, and assorted other violence. Some of them even died of natural causes. I saw and smelled some of their bodies and interviewed some of the people who loved them.

I learned about heroes.

I stood outside a burning two-story slum house while two firemen went through a window filled with smoke and flame, and came out carrying two tiny, silent children. I watched with the children's screaming mother and neighbors in gagging awe as these two men put their mouths on those kids' and tried and tried and tried to breathe them back to life. They pounded the little ones' chests with their fists and pleaded and finally gave up in exhaustion and tears.

I learned that even murderers, con men, sex deviates, burglars, embezzlers and bank robbers have faces and family. So do their victims. So do the police officers, deputy sheriffs, FBI agents, prosecutors, defense lawyers and judges who work the cases. So do the people who run for office, who work in district and county clerk offices, who collect taxes, who pave roads, who type letters, who teach school, who run corporations, who sue corporations, who picket, who protest, who preach, who pray.

I interviewed Elvis Presley (before he died). He came through Dallas on a sleeper train on his way from Memphis to California after being released from the army. He appeared on the rear of the train platform like he was Harry Truman or somebody running for president.

"Ah just woke up," he said to us thirty waiting reporters and female fans.

One of the reporters – not I, I swear – shouted out a question about Elvis's father's recent decision to marry a young divorcée back in Memphis.

Elvis said he didn't mind.

"Is he with you on this trip?" somebody – I, to be embarrassingly exact – hollered.

"Wahll, no. While I was in the army, the house in Memphis got kind of run-down. . . . The grass grew up tall and the patio furniture got messed up. So he's staying there to get it all fixed up."

Great moments in journalism, and I was there.

I was also there when Steve Lawrence, another singer-soldier, came through Dallas. I interviewed him between planes at Love Field. Elvis had been a truck driver in the army. Not Lawrence, Eydie Gorme's husband.

"I don't think the army gets the full benefit of a singer's abilities if they put him behind the wheel of a truck," said Lawrence in his exclusive interview with me. "The singer doesn't benefit, either."

Great moments in journalism II.

As a general-assignments reporter, I spent a lot of journalistic moments at Love Field interviewing people of prominence and purpose who arrived or passed through. At one time I was referred to as the only foreign correspondent in American journalism who never left the city limits of Dallas. If anybody with an accent came into town, I was there.

I developed a standard repertoire of questions for all visitors from all countries. How do you like America? How do you like Texas so far? (Yes, some replied that they had just arrived and it was a little early to say.) How does it differ here from your country? How close are the communists to taking over in your country? What do you want the United States to do to help you?

My favorite Love Field story involves a reporter for KLIF radio in Dallas. He and two other reporters and I were there to cover the arrival of a Cardinal from St. Louis. When first given the assignment, I thought it was Stan Musial or Enos Slaughter, but I was quickly told this Cardinal was the Catholic cardinal of St. Louis. He was coming to Dallas to make some kind of speech.

I was not Catholic and I had no idea what to ask him. How close are the communists to taking over your country? was not quite appropriate.

So I was delighted that there were other reporters there to ask questions. But in the few minutes before the cardinal's plane actually arrived, we compared notes. Nobody had an idea – a prayer, you might say – as to what to ask.

And then suddenly there he was. A big black-haired man in a black suit. An aide-de-camp priest introduced us all around, and we followed them into a small interview room.

"Well, now," said the cardinal. "Who wants to go first?" Silence.

"Don't be bashful," said the cardinal. "We must move on to our appointments in a few moments."

More silence. I could not think of a thing. I was embarrassed and mortified and all of those things. But my mind was frozen. How do you like Texas, Your Majesty? How do you address cardinals, anyhow?

The cardinal started to move toward the door.

"Your Grace," said the KLIF reporter. "I have a question."

The cardinal, obviously pleased, sat back down. "Yes, my son?" he said.

The KLIF reporter said: "How do you like being a cardinal?"

The cardinal looked stunned. But after a beat or two he smiled and said: "It is a glorious job, thank you." And he went on and on for several minutes about how he enjoyed ministering to the needs of the Catholics of St. Louis, running the

parochial schools, the hospitals and all the rest. I do not remember every detail, but I do remember that I got enough out of it to write a four-hundred-word story under the headline CARDINAL LIKES JOB.

And I immediately added, How do you like being a Yugoslav businessman (or whatever)? to my repertoire of Love Field interview questions.

My first front-page byline story was about a kid who put a pigeon egg on top of a television set. The warmth from the TV caused the egg to hatch. My memorable lead: "A 17-inch television set gave birth to a baby pigeon Saturday morning in Oak Cliff." My first "copyrighted" front-page story was based on a telephone interview with the Texas pianist Van Cliburn in New York, about his being invited to a reception in honor of the visiting leader of the Soviet Union, Nikita Khrushchev. Among my stupidest leads was the one I put on an account of a press conference held by the Duke of Edinburgh, who was in Dallas pushing British-made airliners to Braniff: "Prince Philip, husband of the Queen of England, was asked in Dallas Saturday if he wears polka-dot underwear. 'Let's leave that under wraps, shall we?' replied the prince."

My first big investigative series was about the Communist Party in Texas, followed by one on the John Birch Society and another on the civil defense operation in Dallas. The civil defense stories were the reason I went from the *Morning News* to the *Times Herald*.

It is my only Hero Lehrer story.

I worked for several weeks running down and confirming a basic fact about the civil defense operation in Dallas. It was handing out right-wing, Reds-behind-every-bush propaganda while ignoring its real job of preparing the city of Dallas and its people for nuclear attack and other inevitable calamities of that year, 1961. It had, for

instance, published an evacuation plan that called for citizens to evacuate to safe places in rural counties surrounding the city. I went through the plan in detail and called the authorities in each of the counties that had been designated to receive people from Dallas. Few of them knew anything about it, and they were most upset when I told them. None of the citizens who were to do the fleeing when sirens sounded knew about the plan, either. The whole thing was ridiculous, and my series of five stories laid it out.

But the publisher of the *Morning News* was called by some friend on the civil defense board of directors, and my series was killed. So I quit. Literally, within an hour of having been told my stories would not be published, I had cleaned out my desk and left the building.

"That's crazy," said Johnny King, the city editor. "Where are you going?"

"I don't know," I said.

And I didn't. Fortunately, I was able to get a job with the afternoon competition, the *Times Herald*.

I had made only one phone call before telling Johnny King I was quitting. That was to Kate, who had just been forced to leave her job as a junior high English teacher because she was pregnant with Jamie, our first of three daughters, and was beginning to "show" too much.

"I don't want to work here anymore," is what I said to her.

"Then don't," she said, without even a second's hesitation. "Get out of there."

So I got out of there. Kate did not say a word about where I was going to find a job. She also did not remind me that we were without savings or assets, and that with a baby coming maybe this was not the best time for the family's remaining breadwinner to become unemployed.

Kate was the Hero Lehrer I was referring to.

JO LeCOEUR

Gravity

My mother says it's not her doing –
her chair inching toward the woods,
me sliding mine to keep up with her
and the cigarette we're sharing.

Neither of us a smoker, but the laughs
come easy on Saturdays after supper
when we sit outside getting drawn in
by the woods' quiet call.

The voice tonight is Old *Nita-Uhbi*,
Bear Killer, taking her back to when
sparks danced off her like live things
fighting free of her fierce control.

I grip her arm, my breath held to align
our exhalations. Not angled away
from each other tonight, me to the city,
her to the woods where lightning bugs

flash back at us as if they too were
dragging on fire, lanterns timed to match
her signals, woods' edge gravitating
toward us, powerless against her pull.

Terry A. Ybáñez, *Altar para mis amigas*, 2007; acrylic on canvas, 48 × 60 inches.

Juan Miguel Ramos, *Shorty of Gold*, 2004; pencil on inket print, 47 x 35 inches.

DONLEY WATT

The Man Who Talked to Houses

My name is Lyman Hendry. I'm sixty-one years old and my life has come down to realizing this: from the time a boy turns thirteen not a day passes that he doesn't think of sex, and when a man reaches sixty not a day passes that he doesn't think of death.

This is not a morbid preoccupation of mine; I don't turn to the obituaries first thing every morning, but I understand now why people do. It's not so much to see if anyone you know has kicked the bucket, or to gloat over outlasting some poor bastard who dropped over at fifty-two, or feeling off the hook when a Friday's average is eighty-seven and you figure that buys you twenty-six years more – it's not that at all, although honestly I've found myself playing out each of those games. No, it's just trying to figure what this death thing is all about, thinking maybe if you can figure that out then life won't be so damned much of a puzzle.

I live alone in a two-bedroom house in the middle of a three-block dead-end street near the downtown section of this city. Nothing about the house is out of the ordinary – in the twenties this was the suburbs – and for the most part the houses for blocks around are simple stucco cottages. Young couples move in all starry-eyed and start pouring bucks into add-ons and slick kitchens and I ask them why bother, you could have a new house for the same money. But they just laugh. The rooms of the houses are small, and in my house the tile on the kitchen counter is the same green and white as that on the bathroom floor. For me that's okay, but if you're young just think of all the choices. I've lived here on this street for two-and-a-half years now, not because I particularly like it but because the rent is right and I've lost my reasons for moving. I have to live somewhere.

My neighbors have two big dogs, one a shepherd and one some shaggy north-country mixed breed who always looks hot and out of place. Through the chain link fence I see them scabbing the backyard, restless, digging here, rolling roughly there, pulling and shaking apart anything unlucky enough to fall within reach. A plastic ball or a rag doll has no chance at all. Despite an occasional night of barking I can't complain. I feel safe and don't have to worry that my neighbors will frown about the way I neglect my yard.

I'm alone a lot, most people would think I'm lonely, but I come from a string of single-child families so don't mind. It is something I'm used to, although for a few years being married changed that. I am the only child of parents who also were only children and my life followed the same pattern, my daughter Jenny being all I have. At thirty-eight she is still not a mother and has changed husbands three times in an effort, I like to think, to correct this injustice. A grandson would be nice, but for Jenny time seems to be running out. And although I try not to give it a thought anymore, sometimes I'm sad to think of the Hendrys tailing off this way.

For a lot of years Jenny and I lost contact. She was eight when her mama and I had our trouble. Doris, who was my first and only wife, took Jenny to New Orleans and they settled into a life I couldn't know, and until Jenny reached her twenties we were lost to each other. Since then, we got together once a few years back for an awkward lunch, followed by a cycle of somewhat obligatory Christmas cards. Hers with notes looped in a rush of red ink. Mine with a new return address each year.

I stayed on the move, following real estate booms from place to place. Selling condos in San Diego and LA, pushing developments in Aspen and Santa Fe, on to Denver during the oil boom. There, with times being good I put a crew together and Hendry Homes moved a few

spec houses. The building I like, all of it: the design, the excitement when you pour the slab, the smell of tar paper and pine resin. The selling afterwards I'm good at but find mostly a nuisance, wrangling over financing and carpet colors and garage door openers.

When the market dropped I slid out of Denver and across to Phoenix and ended up here in Tucson. When I sold out in Phoenix I stuck my little chunk of cash in a long-term CD and decided that was it. I always tried to shoot straight in what can be a crooked business, and fell short a few times, I'll admit, but not enough to wake me nights. I can start pulling down a little social security check in a year, so I figure I've pretty well got it made if I watch my pennies.

Real estate's just another game and I got tired of playing. But still I'm drawn to the way houses go up. Some nights I drive out north into the foothills and park in the birth of a raw subdivision and wander the streets. If no one's around I talk to the houses, yellow skeletons in the night, waiting for tomorrow. I shake my head over shortcuts taken, encourage the slabs to be solid, the frames to be patient, remind them of years still to come. Time enough for all things, I say, embarrassed then by the words that come from somewhere deep, from my mother or some solemn pulpit I don't know. Then I say it again, this time a little softer, time enough for all things, and wonder for a while if saying it aloud makes it any less a lie.

Last year Jenny called from Houston and asked would I come for a visit. Right away I said sure – I had no reason not to – but the going was harder than the agreeing to go, and I found myself inventing excuses to stay here right up to the time I stepped on the plane.

Jenny showed me around Houston, trying to guess what I'd like. Most everything had changed, but we downed oysters at Captain Benny's and took in the Astros for a double-header. We talked some, mostly about this and that. I never asked about her mother, but right up front she said, "Mama's bitter and hard to be around." I didn't give a damn about Doris and hadn't for years, but Jenny went on in a fervent sort of confessional way, like she could mend things if they came out in the open. I told her what's past is history and might as well stay buried, but that didn't slow her. Jenny's big-boned but graceful, moves like some English actress I once saw on TV. Jenny talked and paced the room and something came over me that was hard to place. At first I thought it was guilt over the divorce and the way I had at the time run out on some responsibilities. Then I saw it wasn't that at all, but the way I was seeing Jenny for the first time as a woman no longer young. Little lines threaded around her mouth and at the corners of her eyes, and the skin under her arms sagged just a little. I felt sad for her and for me too, I guess.

She smoked and paced and talked for hours, tagging her latest ex-husband Mark the Shark and saying "no more, never again into the jaws of marriage." At that she laughed until she staggered from the room, and I heard her off and on in the bathroom for the next hour. Later she folded down the sofa for herself and gave me her bedroom. I tossed all night under lace-ruffled sheets.

On Sunday she took in church, which for her was un-orthodox Eastern of some strange kind. I went along. There were black men in white robes, from Ethiopia she said, but they looked fifth ward Houston to me. I sat at the back and watched my daughter moving at ease among brass bells and incense burners, as serious as the flat-faced saints who stared down from the walls. On the way out we filed by the Miracle of Blood, peering down through a glass case that held a miniature picture of Christ on the cross. A few weeks before,

Kelly O'Connor, *Hermaphrodite Study*, 2007; collage, 11 x 17 inches.

according to the local priest, a red resinlike substance had appeared, oozing from Christ's punctured side. Even the local papers had covered it for a day or two. Later, Jenny asked me what I thought of it. I said there are some things you just can't explain and she let it go at that. But I thought that any God who busied himself with stuff like that sure must have run out of tricks, and probably went in for macrame, too.

A few months later when Jenny called and invited herself out – just for two or three days, she said – it surprised me, but I said sure, come on, and in a week or so she did. For a couple of days we saw the sights, winding our way to the top of Mount Lemmon, wandering half a day through Nogales looking at junk and tossing down tequila at Elvira's. One evening we drove out west of town and caught a sunset.

The third day she says Daddy, don't try to entertain me, just do what you always do and I'll tag along. She has a 9:07 flight back that night to Houston, which gives us all day, so I say how about the dog races? So we go for a couple of hours. I drink a few beers and lose my ten-dollar limit and we leave. This is Sunday afternoon and on the way home she acts a little miffed, not talking much. When I ask what the problem is she says something about missing church that day and feeling bad about it. I point out that it was her idea to go with me to the races, that she could have found some kind of church that would do, that Tucson is full of all kinds of churches. She says I know, I know. So we drop it.

She's restless all afternoon, like something is working on her. I figure she's anxious to get back. She flips through the Sunday paper once and then again, like she'll come upon some answer she's looking for. I clear the table and wipe it down. I sit down with my checkbook and spread out a handful of bills. I pay bills on Sundays.

Jenny tosses the paper aside and I can tell she's watching me, but I don't look up. Finally she comes over. I'm stamping envelopes. Is this all you do? she asks. Go to the dog races and eat and pay bills? Don't you have any friends or read or go to movies?

What's wrong with that? I ask. At least I can pay my bills. And what's wrong with dog races?

I don't know what's happening, why she's angry, but an old, almost forgotten pissed-off sensation creeps back in my gut, a hell-catching sort of feeling that takes me back to times with her mother. I feel myself begin to bluster up. Yeah, Jenny, I say, sweeping my arm over the bills, giving them all a little flutter, I'm afraid that what you see is pretty much the way life is. My life, at least, is a whole lot of will the water bill be $14.88 or $16.73 and will the phone bill be under $30.00. That's why I go to the dog races. I pay these bills to keep everything the same; I pay at the races hoping to make things different.

Then she starts in on the dog races like she'd been waiting for an opening. She's going on and I'm trying to follow her. She paces the room telling me how she's figured the races out, how the mechanical rabbit's out in front and how the lead dog chases it and how all the other dogs seem only to chase the lead dog, as if there isn't a front-runner rabbit there at all. Like it's all some big joke and the dogs know, and are muzzled, not to keep them from barking or biting but to keep them from laughing at all the suckers leaning on the rail. Just one big joke, she says, with a shake of her head. I watch her soft scrambled hair move from side to side.

Then I look past her and find through the window a beam of light, all pink and purple, laced across a tiny piece of mountain way off in the distance, squeezed between a roof and a tree.

Sometimes when I'm alone I sit and stare at that slice of mountain for hours. No music, the TV silent. Maybe a beer or two. Maybe more.

One minute she's staring out the window with her back to me, and then she turns and like a flash flood racing down a rocky gulch her words start flowing and they seem important, and I am quiet and still to hear what she is saying.

Do you remember when I called you from New Orleans, when I was seventeen?

I don't remember a thing, but dig around in the past trying to orient myself, where I was then, what I was doing.

You were in San Diego, she says, involved in some big project or something. I remember you sounded impatient, or important, maybe. Mama was on the extension and you made her hang up before you would talk.

Okay, I say, now it's coming back. More than twenty years ago, but yeah, it's coming back.

What was happening? she asks. Tell me what you remember.

You know, I say, that was the past, it almost seems like another life, and you were young. A long time ago.

Just tell me what you remember, she says. Jenny's pacing again and I want her to get still so I can think, but she doesn't.

Well, I say, it seems like you called. It was late I think and I could tell from the way the phone sounded you-know-who was on the extension. So I think I said, tell her to get off the line or I hang up. I may have been angry, but I had my reasons you know.

That's okay, Jenny says. I understand, but that's not the point.

Well, what the hell is the point, I say. I go to the kitchen and get a beer and stand facing her across the room.

Just tell me what happened, what you remember.

Okay, I say, this is it—in a nutshell. You were in trouble.

Pregnant, Jenny says. I was pregnant.

Okay. You were pregnant. It was some kid who worked summers on a shrimper or somewhere, a kid like you.

He was twenty.

That's still a kid in my book.

Okay, whatever you say. Then what happened?

You asked me what you should do. You and your mama had had a big fight over it and you asked me what you should do.

And what did you say?

I don't know. I can't remember exactly. I didn't want to take sides. I think you needed some money and I said I'd send it. Something like that.

Something like that, Jenny says. Yeah, it was something like that. You want to know what you said? Do you?

I drank deep from the beer. Sure. What the hell did I say?

You said, Jenny, you're young, there's plenty of time for you to have babies.

So, what else could I say? I'm not some great big daddy in the sky who knows it all. What did you want to hear?

What did I want to hear. Oh, my God, Daddy. Don't you know anything? She waits a minute and I think she will cry, but she doesn't, and when she speaks the words are all even and spaced out like studs running down a long wall. I wanted to hear you say, come to California and have your baby and it will be my grandchild and I will love you both and take care of you. That's what I wanted to hear. That's all.

I start to say that's not fair, and all the excuses, the justifications come to my mind. Your mama had custody, it was your life, what about the boy's responsibility, and on and on. But I keep quiet.

Jenny turns back to the window and her shoulders shake and then she starts sobbing, softly, quietly at first, then from deep within her comes a moan and then another one, louder and louder. From across the yard my neighbor's dogs pick up the moans and begin to howl, and soon I hear other dogs from across the street and then from all up and down the block. Finally it seems the whole world is howling.

While Jenny's packing I almost call a cab for her. I could say my ulcer is acting up or that I can't drive at night or something. But I don't.

On the way to the airport Jenny acts like nothing at all happened. She explains low impact aerobics to me, how it can give you "body confidence." She chatters on, losing me when glycogen and fats start getting together with oxygen.

When I drop her off she gives me a peck on the cheek, and I watch while she disappears up an escalator.

I drive around awhile then, glad to be alone and in a different part of the city. I circle the Night Owl Bar, checking it out, then stop back out front with the motor idling, trying to think. Finally, I pull through the drive-in window of George's Liquor next door for a pint of Old Fitz. I head north and then turn east on 22nd. The road is smooth and wide and for a few minutes I feel an old exuberance, being alone like this on an unknown road, not knowing where I'll end up.

I drive easy, letting the city thin out around me. Then up ahead I see two giant cactuses blanketed with strands of blinking white Christmas lights. I slow when I see a sign: Cactus Estates East. At the entrance the two plants flank a gleaming asphalt drive and I pull in. Loose gravel pings up under my car. A new subdivision, just getting off the ground. I know how that feels. On my right a model home glows yellow under a guard light. The subdivision is a series of cul-de-sacs that spur off the main drive, and in one I stop and turn off the engine, hoping to hear nothing, but faintly pick up the hum of I-10 in the background. I sit for a while. When the Old Fitz has smoothed the creases from the night, I decide to cruise around some more.

Back on the main drive a couple of slabs are poured, PVC sticking out of them like periscopes on a submarine. I stop and check them out. The slabs are much too close together, I think, with all this land stretching forever around. I look back west and can't see the stars for the glow from the city, but to the east the sky is filled and bright. Jenny is up there somewhere, already over New Mexico. I stare at the sky and try to make out where the brightness ends and the dullness, the murkiness, begins, try to find some absolute line where things become clear. But I can't. "Goodbye, Jenny," I say, then look around to make sure I'm alone.

The slab is rough under my feet. I talk right to it. "You're solid, good and solid," I say, "with lots of re-bar. Last a long time. What will you do?" I ask. "With all that time? With a new life, one just beginning. Is it enough to be strong? For sure you won't be running off here and there chasing God knows what all."

I laugh and take another shot of bourbon.

"But there's always the possibility of a new freeway, maybe a loop, cutting right through you. Even an earthquake. Or a fire, or even a fickle owner. Who can say?"

My voice is bolder. I hear it carry out into the dark of the desert and no longer care. "Just a crazy old man," I say, and laugh again.

I'm quiet for a few minutes and then nothing seems funny anymore. I think about dying. What nothing might be like, a bright glow, like some people near death have said, or only darkness, or maybe no sense of anything at all. For a minute

I regret I can't be young again and go back and fix at least a few things. And I picture it, being young again, twenty-eight or thirty, and the whole world stretching out before me. With a new car, maybe, and good looks, and highways leading anywhere and everywhere. Seattle this time, maybe, or Portland. A boom city anywhere, somewhere new.

To the north the Santa Catalinas rise above the desert, hovering like a bank of somber clouds. I wander away from the road, by the light of the moon picking my way through the mesquite and cactus, and stop when I find a little rise that overhangs a dry wash. With my heel I make a mark in the sand, then step off twenty paces as straight as I can. Then another mark and at a right angle measure fifteen paces, then back and parallel to the first side twenty paces more and mark the sand once again. "Plenty of room for a house," I say. I could build one right here and build it right, so that it would last. And if Jenny called I would know what to do and know the right words to say.

I slip down into the wash and gather an armful of stones, as many as I can carry. Then I scramble back up the bank, searching the sand for the marks I've made, stacking stones for the corners of my house.

CATHERINE KASPER

Things That Fall from the Sky

The neurons splinter in a brain. Electrical-chemical short circuit, and everything here deadens. Shall we attribute our restlessness to fever?

There was a moment in a museum thought precious and out of date; I will admit it had a distinctly Victorian flavor. A hall of dinosaur bones fixed in running positions. *The Spectrum of Life:*

—bacteria swimming on turquoise video screens, stuffed tiger, bear, chimpanzee, the wired reptiles and amphibians, dangling arthropods, *Birds of the World,* and that now infamous snake vertebrae—

She places green tea in a cup, and takes it outside, along with branches, a torn piece of a brown bag, a coin, a photograph of a bat. She is not afraid to like Tennyson.

The neurons begin a slow repair, stretching, then folding into exhaustion.

Her fingers understand what it is to tease song from paper. She makes a crease in the page with the edge of a ruler.

Somewhere in the western states, an enormous meteor fell to the earth with such enthusiasm it created an immense crater. Permanent is a word.

Lloyd Walsh, Untitled, 2003; oil on canvas, 42 x 48 inches.

Cruz Ortiz, *Coyote-Landia*, 2005; pencil on paper, twine, and clothespins, 40 x 40 inches.

SANDRA CISNEROS

Bien Pretty

Ya me voy,
ay te dejo en San Antonio.

– Flaco Jiménez

He wasn't pretty unless you were in love with him. Then any time you met anyone with those same monkey eyes, that burnt-sugar skin, the face wider than it was long, well, you were in for it.

His family came from Michoacán. All *chaparritos*, every one of them – short even by Mexican standards – but to me he was perfect.

I'm to blame. Flavio Munguía was just ordinary Flavio until he met me. I filled up his head with a million and one *cariñitos*. Then he was ruined forever. Walked different. Looked people in the eye when he talked. Ran his eyes across every pair of *nalgas* and *chichis* he saw. I am sorry.

Once you tell a man he's pretty, there's no taking it back. They think they're pretty all the time, and I suppose, in a way, they are. It's got to do with believing it. Just the way I used to believe I was pretty. Before Flavio Munguía wore all my prettiness away.

Don't think I haven't noticed my girlfriends back home who got the good-lookers. They all look twice their age now, old from all the *corajes* exploding inside their hearts and bellies.

Because a pretty man is like a too-fancy car or a real good stereo or a microwave oven. Late or early, sooner or later, you're just asking for it. Know what I mean?

Flavio. He wrote poems and signed them "Rogelio Velasco." And maybe I would still be in love with him if he wasn't already married to two women, one in Tampico and the other in Matamoros. Well, that's what they say.

Who knows why the universe singled me out. Lupe Arredondo, stupid art thou amongst all women. Once I was as solid as a sailor on her sea legs, the days rolling steadily beneath me, and then – Flavio Munguía arrived.

Flavio entered my life via a pink circular rolled into a tube and wedged in the front gate curlicue:

$ SPECIAL $

PROMOTION

LA CUCARACHA APACHURRADA PEST CONTROL

OVER 10 YEARS OF EXPERIENCE

If you are Tired of ROACHES and Hate them like many People do, but can't afford to pay alot of Money $$$$ to have a house Free of ROACHES ROACHES ROACHES!!! We will treat your kitchen, behind and under your refrigerator and stove, inside your cabinets and even exterminate your living room all for only $20.00. Don't be fooled by the price. Call now. 555-2049 or Beeper #555-5912. We also kill spiders, beetles, scorpions, ants, fleas, and many more insects.

!!So Don't Hesitate Call Us Now!!
You'll be glad you did call us,
Thank you very much.
Your CUCARACHAS will be DEAD
(*$5.00 extra for each additional room)

A dead cockroach lying on its back followed as illustration.

It's because of the river and the palm and pecan trees and the humidity and all that we have so many palmetto bugs, roaches so big they look Pleistocene. I'd never seen anything like them before. We don't have bugs like that in California, at least not in the Bay. But like they say, everything's bigger and better in Texas, and that holds especially true for bugs.

So I live near the river in one of those houses with wood floors varnished the color of Coca-Cola. It isn't mine. It belongs to Irasema Izaura Coronado, a famous Texas poet who carries

herself as if she is directly descended from Ixtacci-huatl or something. Her husband is an honest-to-God Huichol *curandero*, and she's no slouch either, with a Ph.D. from the Sorbonne.

A Fulbright whisked them to Nayarit for a year, and that's how I got to live here in the turquoise house on East Guenther, not exactly in the heart of the historic King William district – it's on the wrong side of South Alamo to qualify, the side where the peasantry lives – but close enough to the royal mansions that attract every hour on the hour the Pepto Bismol – pink tourist buses wearing sombreros.

I called La Cucaracha Apachurrada Pest Control the first month I house-sat Her Highness's home. I was sharing residence with:

(8) Oaxacan black pottery pieces
signed Diego Rivera monotype
upright piano
star-shaped piñata
(5) strings of red chile lights
antique Spanish shawl
St. Jacques Majeur Haitian voodoo banner
cappuccino maker
lemonwood Olinalá table
replica of the goddess Coatlicue
life-size papier-mâché skeleton signed by the
 Linares family
Frida Kahlo altar
punched tin Virgen de Guadalupe chandelier
bent-twig couch with Mexican sarape
 cushions
seventeenth-century Spanish *retablo*
tree-of-life candlestick
Santa Fe plate rack
(2) identical sets of vintage Talavera Mexican
 dishware
eye-of-God crucifix
knotty pine armoire
pie safe
death mask of Pancho Villa with mouth
 slightly open
Texana chair upholstered in cowskin with
 longhorn horns for the arms and legs
(7) Afghan throw rugs
iron bed with a mosquito net canopy

Beneath this veneer of Southwest funk, of lace and silk and porcelain, beyond the embroidered pillows that said DUERME, MI AMOR, the Egyptian cotton sheets and eyelet bedspread, the sigh of air that barely set the gauze bedroom curtains trembling, the blue garden, the pink hydrangea, the gilt-edged tea set, the abalone-handled silver, the obsidian hair combs, the sticky, cough-medicine-and-powdered-sugar scent of magnolia blossoms, there were, as well, the roaches.

I was afraid to open drawers. I never went into the kitchen after dark. They were the same Coca-Cola color as the floors, hard to spot unless they gave themselves away in panic.

The worst thing about them wasn't their size, nor the crunch they gave under a shoe, nor the yellow grease that oozed from their guts, nor the thin shells they shed translucent as popcorn hulls, nor the possibility they might be winged and fly into your hair, no.

What made them unbearable was this. The scuttling in the middle of the night. An ugly clubfoot grate like a dead thing being dragged across the floor, a louder-than-life munching during their cannibal rites, a nervous pitter, and then patter when they scurried across the Irish-linen table runners, leaving a trail of black droppings like coffee grounds, sticky feet rustling across the clean stack of typewriter paper in the desk drawer, my primed canvasses, the set of Wedgewood rose teacups, the lace

Victorian wedding dress hanging on the bedroom wall, the dried baby's breath, the white wicker vanity, the cutwork pillowcases, your blue raven hair scented with Tres Flores brilliantine.

Flavio, it's true. The house charms me now as it did then. The folk art, the tangerine-colored walls, the *urracas* at sunset. But what would you have done if you were me? I'd driven all the way from northern California to central Texas with my past pared down to what could fit inside a van. A futon. A stainless-steel wok. My grandmother's *molcajete*. A pair of flamenco shoes with crooked heels. Eleven *huipiles*. Two *rebozos—de bolita y de seda.* My Tae Kwon Do uniform. My crystals and copal. A portable boom box and all my Latin tapes—Rubén Blades, Astor Piazzolla, Gipsy Kings, Inti Illimani, Violeta Parra, Mercedes Sosa, Agustín Lara, Trio Los Panchos, Pedro Infante, Lydia Mendoza, Paco de Lucía, Lola Beltrán, Silvio Rodríguez, Celia Cruz, Juan Peña "El Lebrijano," Los Lobos, Lucha Villa, Dr. Loco and his Original Corrido Boogie Band.

Sure, I knew I was heading for trouble the day I agreed to come to Texas. But not even the *I Ching* warned me what I was in for when Flavio Munguía drove up in the pest-control van.

"*TEX-as! What* are you going to do *there?*" Beatríz Soliz asked this, a criminal defense lawyer by day, an Aztec dance instructor by night, and my closest *comadre* in all the world. Beatriz and I go back a long way. Back to the grape-boycott demonstrations in front of the Berkeley Safeway. And I mean the *first* grape strike.

"I thought I'd give Texas a year maybe. At least that. It can't be *that* bad."

"A year!!! Lupe, are you crazy? They still lynch Meskins down there. Everybody's got chain saws and gun racks and pickups and Confederate flags. *Aren't* you *scared?*"

"Girlfriend, you watch too many John Wayne movies."

To tell the truth, Texas *did* scare the hell out of me. All I knew about Texas was it was *big*. It was *hot*. And it was *bad*. Added to this was my mama's term *teja-NO-te* for *tejano*, which is sort of like "Texcessive," in a redneck kind of way. "It was one of those *teja-NO-tes* that started it," Mama would say. "You know how they are. Always looking for a fight."

I'd said yes to an art director's job at a community cultural center in San Antonio. Eduardo and I had split. For good. *C'est finis.* End of the road, buddy. *Adiós y suerte.* San Francisco is too small a town to go around dragging your three-legged heart. Café Pícaro was off limits because it was Eddie's favorite. I stopped frequenting the Café Bohème too. Missed several good openings at La Galería. Not because I was afraid of running into Eddie, but because I was terrified of confronting "*la otra.*" My nemesis, in other words. A financial consultant for Merrill Lynch. A blonde.

Eddie, who I'd supported with waitress jobs that summer we were both struggling to pay our college loans *and* the rent on that tiny apartment on Balmy—big enough when we were in love, but too small when love was scarce. Eddie, who I met the year before I started teaching at the community college, the year after he gave up community organizing and worked part-time as a paralegal. Eddie, who taught me how to salsa, who lectured me night and day about human rights in Guatemala, El Salvador, Chile, Argentina, South Africa, but never said a word about the rights of Blacks in Oakland, the kids of the Tenderloin, the women who shared his bed. Eduardo. My Eddie. *That* Eddie. With a blonde. He didn't even have the decency to pick a woman of color.

A month hadn't passed since I unpacked the van, but I'd already convinced myself San Antonio was

a mistake. I couldn't understand how any Spanish priest in his right mind decided to sit right down in the middle of nowhere and build a mission with no large body of water for miles. I'd always lived near the ocean. I felt landlocked and dusty. Light so white it left me dizzy, sun bleached as an onion.

In the Bay, whenever I got depressed, I always drove out to Ocean Beach. Just to sit. And, I don't know, something about looking at water, how it just goes and goes and goes, something about that I found very soothing. As if somehow I were connected to every ripple that was sending itself out and out until it reached another shore.

But I hadn't found anything to replace it in San Antonio. I wondered what San Antonians did.

I was putting in sixty-hour work weeks at the arts center. No time left to create art when I came home. I'd made a bad habit of crumpling into the couch after work, drinking half a Corona and eating a bag of Hawaiian potato chips for dinner. All the lights in the house blazing when I woke in the middle of the night, hair crooked as a broom, face creased into a mean origami, clothes wrinkled as the citizens of bus stations.

The day the pink circulars appeared, I woke up from one of these naps to find a bug crunching away on Hawaiian chips and another pickled inside my beer bottle. I called La Cucaracha Apachurrada the next morning.

So while you are spraying baseboards, the hose hissing, the gold pump clicking, bending into cupboards, reaching under sinks, the leather utility belt slung loose around your hips, I'm thinking. Thinking you might be the perfect Prince Popo for a painting I've had kicking around in my brain.

I'd always wanted to do an updated version of the Prince Popocatépetl/Princess Ixtaccíhuatl volcano myth, that tragic love story metamorpho-

sized from classic to kitsch calendar art, like the ones you get at Carnicería Ximénez or Tortillería la Guadalupanita. Prince Popo, half-naked Indian warrior built like Johnny Weissmuller, crouched in grief beside his sleeping princess Ixtaccíhuatl, buxom as an Indian Jayne Mansfield. And behind them, echoing their silhouettes, their namesake volcanoes.

Hell, I could do better than that. It'd be fun. And you might be just the Prince Popo I've been waiting for with that face of a sleeping Olmec, the heavy Oriental eyes, the thick lips and wide nose, that profile carved from onyx. The more I think about it, the more I like the idea.

"Would you like to work for me as a model?"

"Excuse?"

"I mean I'm an artist. I need models. Sometimes. To model, you know. For a painting. I thought. You would be good. Because you have such a wonderful. Face."

Flavio laughed. I laughed too. We both laughed. We laughed and then we laughed some more. And when we were through with our laughing, he packed up his ant traps, spray tank, steel wool, clicked and latched and locked trays, toolboxes, slammed van doors shut. Laughed and drove away.

There is everything *but* a washer and dryer at the house on East Guenther. So every Sunday morning, I stuff all my dirty clothes into pillowcases and haul them out to the van, then drive over to the Kwik Wash on South Presa. I don't mind it, really. I almost like it, because across the street is Torres Taco Haven, "This is Taco Country." I can load up five washers at a time if I get up early enough, go have a coffee and a Haven Taco— potatoes, chile, and cheese. Then a little later, throw everything in the dryer, and go back for a second cup of coffee and a Torres Special—bean,

James Smolleck, *You Spoke of the March Violets*, 2007; acrylic on paper on panel, 25.5 x 22.5 inches.

cheese, guacamole, and bacon, flour tortilla, please.

But one morning, in between the wash and dry cycles, while I ran out to reload the machines, someone had bogarted my table, the window booth next to the jukebox. I was about to get mad and say so, until I realized it was the Prince.

"Remember me? Six eighteen on Guenther."

He looked as if he couldn't remember what he was supposed to remember—then laughed that laugh, like blackbirds startled from the corn.

"Still a good joke, but I was serious. I really am a painter."

"And in reality I am a poet," he said. "*De poeta y loco todos tenemos un poco, ¿no*? But if you asked my mother she would say I'm more *loco* than *poeta*. Unfortunately, poetry only nourishes the heart and not the belly, so I work with my uncle as a bug assassin."

"Can I sit?"

"Please, please."

I ordered my second coffee and a Torres Special. A wide silence.

"What's your favorite course?"

"Art History."

"Nono nono nono nono NO," he said the way they do in Mexico—all the no's overflowing quickly quickly quickly like a fountain of champagne glasses. "*Horse*, not *course*," and whinnied.

"Oh—horse. I don't know. Mr. Ed?" Stupid. I didn't know any horses. But Flavio smiled anyway the way he always would when I talked, as if admiring my teeth. "So. What. Will you model? Yes? I'd pay you, of course."

"Do I have to take off my clothes?"

"No, no. You just sit. Or stand there, or do whatever. Just pose. I have a studio in the garage. You'll get paid just for looking like you do."

"Well, what kind of story will I have to tell if I say no?" He wrote his name for me on a paper

napkin in a tight tangle of curly black letters. "This is my uncle and aunt's number I'm giving you. I live with them."

"What's your name anyway?" I said, twisting the napkin right side up.

"Flavio. Flavio Munguía Galindo," he said, "to serve you."

Flavio's family was so poor, the best they hoped for their son was a job where he would keep his hands clean. How were they to know destiny would lead Flavio north to Corpus Christi as a dishwasher at a Luby's Cafeteria.

At least it was better than the month he'd worked as a shrimper with his cousin in Port Isabel. He still couldn't look at shrimp after that. You come home with your skin and clothes stinking of shrimp, you even start to sweat shrimp, you know. Your hands a mess from the nicks and cuts that never get a chance to heal—the salt water gets in your gloves, stinging and blistering them raw. And how working in the shrimp-processing factory is even worse—snapping those damn shrimp heads all day and the conveyor belt never ending. Your hands as soggy and swollen as ever, and your head about to split with the racket of the machinery.

Field work, he'd done that too. Cabbage, potatoes, onion. Potatoes is better than cabbage, and cabbage is better than onions. Potatoes is clean work. He liked potatoes. The fields in the spring, cool and pretty in the morning, you could think of lines of poetry as you worked, think and think and think, because they're just paying for this, right?, showing me his stubby hands, not this, touching his heart.

But onions belong to dogs and the Devil. The sacks balloon behind you in the row you're working, snipping and trimming whiskers and greens, and you gotta work fast to make any money, you use very sharp shears, see, and your fingers get nicked

time and time again, and how dirty it all makes you feel—the taste of onions and dust in your mouth, your eyes stinging, and the click, click, clicking of the shears in the fields and in your head long after you come home and have had two beers.

That's when Flavio remembered his mother's parting wish—A job where your fingernails are clean, *mi'jo*. At least that. And he headed to Corpus and the Luby's.

So when Flavio's Uncle Roland asked him to come to San Antonio and help him out with his exterminating business—You can learn a trade, a skill for life. Always gonna be bugs—Flavio accepted. Even if the poisons and insecticides gave him headaches, even if he had to crawl under houses and occasionally rinse his hair with a garden hose after accidentally discovering a cat's favorite litter spot, even if now and again he saw things he didn't want to see—a possum, a rat, a snake—at least that was better than scraping chicken-fried steak and mashed potatoes from plates, better than having to keep your hands all day in soapy water like a woman, only he used the word *vieja*, which is worse.

I sent a Polaroid of the Woolworth's across from the Alamo to Beatriz Soliz. A self-portrait of me having the Tuesday-Chili Dog-Fries-Coke-$2.99-Special at the snakey S-shaped lunch counter. Wrote on the back of a Don't-Mess-with-Texas postcard: HAPPY TO REPORT AM WORKING AGAIN. AS IN REAL WORK. NOT THE JOB THAT FEEDS MY HABIT—EATING. BUT THE THING THAT FEEDS THE SPIRIT. COME HOME RAGGEDY-ASSED, MEAN, BUT, DAMN, I'M PAINTING. EVERY OTHER SUNDAY. KICKING *NALGA* LOOKS LIKE. OR AT LEAST TRYING. *CUÍDATE*, GIRL. ABRAZOS, LUPE

So every other Sunday I dragged my butt out of bed and into the garage studio to try to make some worth of my life. Flavio always there before me, like if he was the one painting me.

What I liked best about working with Flavio were the stories. Sometimes while he was posing we'd have storytelling competitions. "Your Favorite Sadness." "The Ugliest Food You Ever Ate." "A Horrible Person." One that I remember was for the category "At Last—Justice." It was really his grandma's story, but he told it well.

My grandma Chavela was from here. San Antonio I mean to say. She had five husbands, and the second one was called Fito, for Filiberto. They had my Uncle Roland who at the time of this story was nine months old. They lived by the old farmers' market, over by Commerce and Santa Rosa, in a two-room apartment. My grandma said she had beautiful dishes, an antique cabinet, a small table, two chairs, a stove, a lantern, a cedar chest full of embroidered tablecloths and towels, and a three-piece bedroom set.

And so, one Sunday she felt like visiting her sister Eulalia, who lived on the other side of town. Her husband left a dollar and change on the table for her trolley, kissed her good-bye, and left. My grandma meant to take along a bag of sweets, because Eulalia was fond of Mexican candy—burnt-milk bars, pecan brittle, sugared pumpkin, glazed orange rind, and those pretty coconut squares dyed red, white, and green like the Mexican flag—so sweet you can never finish them.

So my grandma stopped at Mi Tierra Bakery. That's when she looks down the street, and who does she see but her husband kissing a woman. It looked as if their bodies were ironing each other's clothes, she said. My grandma waved at Fito. Fito waved at my grandma. Then my grandma walked back home with the baby, packed all her clothes, her set of beautiful dishes, her tablecloths and towels, and asked a neighbor to drive her to her sister Eulalia's. Turn here. Turn there. *What street are we on?* It doesn't matter—just do as I tell you.

The next day Fito came looking for her at Eulalia's, to explain to my grandma that the woman was just an old friend, someone he hadn't seen in a while, a long long time. Three days passed and my grandma Chavela, Eulalia, and baby Roland drove off to Cheyenne, Wyoming. They stayed there fourteen years.

Fito died in 1935 of cancer of the penis. I think it was syphilis. He used to manage a baseball team. He got hit in the crotch by a fastball.

I was explaining yin and yang. How sexual harmony put one in communion with the infinite forces of nature. The earth is yin, see, female, while heaven is male and yang. And the interaction of the two constitutes the whole shebang. You can't have one without the other. Otherwise shit is out of balance. Inhaling, exhaling. Moon, sun. Fire, water. Man, woman. All complementary forces occur in pairs.

"Ah," said Flavio, "like the *mexicano* word 'sky-earth' for the world."

"Where the hell did you learn that? The *Popul Vuh*?"

"No," Flavio said flatly. "My grandma Oralia."

I said, "This is a powerful time we're living in. We have to let go of our present way of life and search for our past, remember our destinies, so to speak. Like the *I Ching* says, returning to one's roots is returning to one's destiny."

Flavio didn't say anything, just stared at his beer for what seemed a long time. "You Americans have a strange way of thinking about time," he began. Before I could object to being lumped with the northern half of America, he went on. "You think old ages end, but that's not so. It's ridiculous to think one age has overcome another. American time is running alongside the calendar of the sun, even if your world doesn't know it."

Then, to add sting to the blow, raised his beer bottle to his lips and added, "But what do I know, right? I'm just an exterminator."

Flavio said, "I don't know anything about this Tao business, but I believe love is always eternal. Even if eternity is only five minutes."

Flavio Munguía was coming for supper. I made a wonderful paella with brown rice and tofu and a pitcher of fresh sangría. Gipsy Kings were on the tape player. I wore my Lycra mini, a pair of silver cowboy boots, and a fringed shawl across my Danskin like Carmen in that film by Carlos Saura.

Over dinner I talked about how I once had my aura massaged by an Oakland *curandera*, Afro-Brazilian dance as a means of spiritual healing, where I might find good dim sum in San Antonio, and whether a white woman had any right to claim to be an Indian shamaness. Flavio talked about how Alex El Güero from work had won a Sony boom box that morning just by being the ninth caller on 107 FM K-Suave, how his Tía Tencha makes the best tripe soup ever no lie, how before leaving Corpus he and Johnny Canales from *El Show de Johnny Canale*s had been like this until a bet over Los Bukis left them not speaking to each other, how every Thursday night he works out at a gym on Calaveras with aims to build himself a body better than Mil Mascara's, and is there an English equivalent for the term *la fulana*?

I served Jerez and played Astor Piazzolla. Flavio said he preferred "pure tango," classic and romantic like Gardel, not this cat-howling crap. He rolled back the Afghan rug, yanked me to my feet, demonstrated *la habanera, el fandango, la milonga,* and explained how each had contributed to birth *el tango*.

Then he ran outside to his truck, the backs of his thighs grazing my knees as he edged past me and the Olinalá coffee table. I felt all the hairs on my body sway as if I were an underwater plant and a current had set me in motion. Before I could steady myself he was popping a cassette into the tape player. A soft crackling. Then sugary notes rising like a blue satin banner held aloft by doves.

"*Violín, violonchelo, piano, salterio*. Music from the time of my *abuelos*. My grandma taught me the dances – *el chotis, cancán, los valses*. All part of that lost epoch," he said. "But that was long long ago, before the time all the dogs were named after Woodrow Wilson."

"Don't you know any indigenous dances?" I finally asked, "like *el baile de los viejitos*?"

Flavio rolled his eyes. That was the end of our dance lesson.

"Who dresses you?"

"Silver."

"What's that? A store or a horse?"

"Neither. Silver Galindo. My San Antonio cousin."

"What kind of name is Silver?"

"It's English," Flavio said, "for Silvestre."

I said, "What *you* are, sweetheart, is a product of American imperialism," and plucked at the alligator on his shirt.

I don't have to dress in a sarape and sombrero to be Mexican," Flavio said. "I *know* who *I* am."

I wanted to leap across the table, throw the Oaxacan black pottery pieces across the room, swing from the punched tin chandelier, fire a pistol at his Reeboks, and force him to dance. I wanted to *be* Mexican at that moment, but it was true. I was not Mexican. Instead of the volley of insults I intended, all I managed to sling was a single clay pebble that dissolved on impact –

perro. "Dog." It wasn't even the word I'd meant to hurl.

You have, how do I say it, something. Something I can't even put my finger on. Some way of moving, of not moving, that belongs to no one but Flavio Munguía. As if your body and bones always remembered you were made by a God who loved you, the one Mama talked about in her stories.

God made men by baking them in an oven, but he forgot about the first batch, and that's how Black people were born. And then he was so anxious about the next batch, he took them out of the oven too soon, so that's how White people were made. But the third batch he let cook until they were golden-golden-golden, and, honey, that's you and me.

God made you from red clay, Flavio, with his hands. This face of yours like the little clay heads they unearth in Teotihuacán. Pinched this cheekbone, then that. Used obsidian flints for the eyes, those eyes dark as the sacrificial wells they cast virgins into. Selected hair thick as cat whiskers. Thought for a long time before deciding on this nose, elegant and wide. And the mouth, ah! Everything silent and powerful and very proud kneaded into the mouth. And then he blessed you, Flavio, with skin sweet as burnt-milk candy, smooth as river water. He made you *bien* pretty even if I didn't always know it. Yes, he did.

Romelia. Forever. That's what his arm said. Forever Romelia in ink once black that had paled to blue. Romelia. Romelia. Seven thin blue letters the color of a vein. "Romelia" said his forearm where the muscle swelled into a flat stone. "Romelia" it trembled when he held me. "Romelia" by the light of the votive lamp above the bed. But when

I unbuttoned his shirt a bannered cross above his left nipple murmured "Elsa."

I'd never made love in Spanish before. I mean not with anyone whose *first* language was Spanish. There was crazy Graham, the anarchist labor organizer who'd taught me to eat jalapeños and swear like a truck mechanic, but he was Welsh and had learned his Spanish running guns to Bolivia.

And Eddie, sure. But Eddie and I were products of our American education. Anything tender always came off sounding like the subtitles to a Buñuel film.

But Flavio. When Flavio accidentally hammered his thumb, he never yelled "Ouch!" he said "*¡Ay!*" The true test of a native Spanish speaker.

¡Ay! To make love in Spanish, in a manner as intricate and devout as la Alhambra. To have a lover sigh *mi vida*, *mi preciosa*, *mi chiquitita*, and whisper things in that language crooned to babies, that language murmured by grandmothers, those words that smelled like your house, like flour tortillas, and the inside of your daddy's hat, like everyone talking in the kitchen at the same time, or sleeping with the windows open, like sneaking cashews from the crumpled quarter-pound bag Mama always hid in her lingerie drawer after she went shopping with Daddy at the Sears.

That language. That sweep of palm leaves and fringed shawls. That startled fluttering, like the heart of a goldfinch or a fan. Nothing sounded dirty or hurtful or corny. How could I think of making love in English again? English with its starched *r*'s and *g*'s. English with its crisp linen syllables. English crunchy as apples, resilient and stiff as sailcloth.

But Spanish whirred like silk, rolled and puckered and hissed. I held Flavio close to me, in the mouth of my heart, inside my wrists.

Incredible happiness. A sigh unfurled of its own accord, a groan heaved out from my chest so rusty and full of dust it frightened me. I was crying. It surprised us both.

"My soul, did I hurt you?" Flavio said in that other language.

I managed to bunch my mouth into a knot and shake my head "no" just as the next wave of sobs began. Flavio rocked me, and cooed, and rocked me. *Ya*, *ya*, *ya*. There, there, there.

I wanted to say so many things, but all I could think of was a line I'd read in the letters of Georgia O'Keeffe years ago and had forgotten until then. Flavio . . . did you ever feel like flowers?

We take my van and a beer. Flavio drives. Watching Flavio's profile, that beautiful Tarascan face of his, something that ought to be set in jade. We don't have to say anything the whole ride and it's fine, just take turns sharing the one beer, back and forth, back and forth, just looking at each other from the corner of the eye, just smiling from the corner of the mouth.

What's happened to me? Flavio was just Flavio, a man I wouldn't've looked at twice before. But now anyone who reminds me of him, any baby with that same cane-sugar skin, any moon-faced woman in line at the Handy Andy, or bag boy with tight hips carrying my groceries to the car, or child at the Kwik Wash with ears as delicate as the whorls of a sea mollusk, I find myself looking at, lingering over, appreciating. Henceforth and henceforth. Forever and ever. Ad infinitum.

When I was with Eddie, we'd be making love, and then out of nowhere I would think of the black-and-white label on the tube of titanium yellow paint. Or a plastic Mickey Mouse change purse I once had with crazy hypnotized eyes that blinked open/shut, open/shut when you wobbled it. Or a

little scar shaped like a mitten on the chin of a boy named Eliberto Briseño whom I was madly in love with all through the fifth grade.

But with Flavio it's just the opposite. I might be working on a charcoal sketch, chewing on a pinch of a kneaded rubber eraser I've absent-mindedly put in my mouth, and then suddenly I'm thinking about the thickness of Flavio's ear-lobes between my teeth. Or a wisp of violet smoke might rise from someone's cigarette at the Bar America, and remind me of that twist of sinew from wrist to elbow in Flavio's pretty arms. Or say Danny and Craig from Tienda Guadalupe Folk Art & Gifts are demonstrating how South American rain sticks work, and boom – there's Flavio's voice like the pull of the ocean when it drags everything with it back to its center – that kind of gravelly, charcoal and shell and glass rasp to it. Incredible.

Taco Haven was crowded the way it always is Sunday mornings, full of grandmothers and babies in their good clothes, boys with hair still wet from the morning bath, big husbands in tight shirts, and rowdy mamas slapping rude children to public decency.

Three security guards were vacating my window booth, and we grabbed it. Flavio ordered *chilaquiles* and I ordered breakfast tacos. We asked for quarters for the jukebox, same as always. Five songs 50 cents. I punched 132, "All My Ex's Live in Texas," George Strait; 140, "Soy Infeliz," Lola Beltrán; 233, "Polvo y Olvido," Lucha Villa; 118, "Mal Hombre," Lydia Mendoza; and number 167, "La Movidita," because I knew Flavio loved Flaco Jiménez.

Flavio was no more quiet than usual, but midway through breakfast he announced, "My life, I have to go."

"We just got here."

"No. I mean me. *I* must go. To Mexico."

"What are you talking about?"

"My mother wrote me. I have compromises to attend to."

"But you're coming back. Right?"

"Only destiny knows."

A red dog with stiff fur tottered by the curb.

"What are you trying to tell me?"

The same red color as a cocoa doormat or those wooden-handled scrub brushes you buy at the Winn's.

"I mean I have family obligations." There was a long pause.

You could tell the dog was real sick. Big bald patches. Gummy eyes that bled like grapes.

"My mother writes that my sons –"

"Sons . . . How many?"

"Four. From my first. Three from my second."

"First. Second. What? Marriages?"

"No, only one marriage. The other doesn't count since we weren't married in a church."

"Christomatic."

Really it made you sick to look at the thing, hobbling about like that in jerky steps as if it were dancing backward and had only three legs.

"But this has nothing to do with you, Lupe. Look, you love your mother *and* your father, don't you?"

The dog was eating something, jaws working in spasmodic gulps. A bean-and-cheese taco, I think.

"Loving one person doesn't take away from lov-ing another. It's that way with me with love. One has nothing to do with the other. In all seriousness and with all my heart I tell you this, Lupe."

Somebody must've felt sorry for it and tossed it a last meal, but the kind thing would've been to shoot it.

"So that's how it is."

"There is no other remedy. *La* yin *y el* yang, you know," Flavio said and meant it.

"Well, yeah," I said. And then because my Torres Special felt like it wanted to rise from my

133

James Cobb, *The Wheel of Delusion*, 2005; giclée print on paper, 43.25 x 122.25 inches.

belly – "I think you better go now. I gotta get my clothes out of the dryer before they get wrinkled."

"*Es* cool," Flavio said, sliding out of the booth and my life. "*Ay te wacho*, I guess."

I looked for my rose-quartz crystal and visualized healing energy surrounding me. I lit copal and burned sage to purify the house. I put on a tape of Amazon flutes, Tibetan gongs, and Aztec ocarinas, tried to center on my seven chakras, and thought only positive thoughts, expressions of love, compassion, forgiveness. But after forty minutes I still had an uncontrollable desire to drive over to Flavio Munguía's house with my grandmother's *molcajete* and bash in his skull.

What kills me is your silence. So certain, so solid. Not a note, nor postcard. Not a phone call, no number I could reach you at. No address I could write to. Neither yes nor no.

Just the void. The days raw and wide as this drought-blue sky. Just this nothingness. That's what hurts.

Nothing wants to break from the eyes. When you're a kid, it's easy. You take one wooden step out in the hall dark and wait. The hallways of every house we ever lived in smelling of Pine-Sol and dirty-looking no matter how many Saturdays we scrubbed it. Chipped paint and ugly nicks and craters in the walls from a century of bikes and kids' shoes and downstairs tenants. The handrail old and never beautiful, not even the day it was new, I bet. Darkness soaked in the plaster and wood when the house was divided into apartments. Dust balls and hair in the corners where the broom didn't reach. And now and then, a mouse squeaking.

How I let the sounds, dark and full of dust and hairs, out of my throat and eyes, that sound mixed with spit and coughing and hiccups and bubbles of snot. And the sea trickling out of my eyes as if I'd always carried it inside me, like a seashell waiting to be cupped to an ear.

These days we run from the sun. Cross the street quick, get under an awning. Carry an umbrella like tightrope walkers. Red-white-and-blue-flowered nylon. Beige with green and red stripes. Faded maroon with an amber handle. Bus ladies slouched and fanning themselves with a newspaper and a bandanna.

Bad news. The sky is blue again today and will be blue again tomorrow. Herd of clouds big as longhorns passing mighty and grazing low. Heat like a husband asleep beside you, like someone breathing in your ear who you just want to shove once, good and hard, and say, "Quit it."

When I was doing collages, I bought a few "powders" from Casa Preciado Religious Articles, the Mexican voodoo shop on South Laredo. I remember I'd picked Te Tengo Amarrado y Claveteado and Regresa a Mí – just for the wrapper. But I found myself hunting around for them this morning, and when I couldn't find them, making a special trip back to that store that smells of chamomile and black bananas.

The votive candles are arranged like so. Church-sanctioned powers on one aisle – San Martín de Porres, Santo Niño de Atocha, el Sagrado Corazón, La Divina Providencia, Nuestra Señora de San Juan de los Lagos. Folk powers on another – El Gran General Pancho Villa, Ajo Macho/Garlic Macho, La Santísima Muerte/Blessed Death, Bingo Luck, Law Stay Away, Court Case Double Strength. Back to back, so as not to offend maybe. I chose a Yo Puedo Más Que Tú from the pagan side and a Virgen de Guadalupe from the Christian.

Magic oils, magic perfume and soaps, votive candles, *milagritos,* holy cards, magnet car-statuettes, plaster saints with eyelashes made from human hair, San Martín Caballero good-luck horse-shoes, incense and copal, aloe vera bunched, blessed, bound with red string, and pinned above a door. Herbs stocked from floor to ceiling in labeled drawers.

AGUAGATE, ALBAHACA, ALTAMISA, ANACAHUITE, BARBAS DE ELOTE, CEDRÓN DE CASTILLO, COYOTE, CHARRASQUILLA, CHOCOLATE DE INDIO, EUCALIPTO, FLOR DE ACOCOTILLO, FLOR DE AZAHAR, FLOR DE MIMBRE, FLOR DE TILA, FLOR DE ZEMPOAL, HIERBABUENA, HORMIGA, HUISACHE, MANZANILLA, MARRUBIO, MIRTO, NOGAL, PALO AZUL, PASMO, PATA DE VACA, PIONÍA, PIRUL, RATÓN, TEPOZÁN, VÍBORA, ZAPOTE BLANCO, ZARZAMORA.

Snake, rat, ant, coyote, cow hoof. Were there actually dead animals tucked in a drawer? A skin wrapped in tissue paper, a dried ear, a paper cone of shriveled black alphabets, a bone ground to crystals in a baby-food jar. Or were they just herbs that *looked* like the animal?

These candles and *yerbas* and stuff, do they really work? The sisters Preciado pointed to a sign above their altar to Our Lady of the Remedies. VENDEMOS, NO HACEMOS RECETAS. WE SELL, WE DON'T PRESCRIBE.

I can be brave in the day, but nights are my Geth-semane. That pinch of the dog's teeth just as it nips. A mean South American itch somewhere I can't reach. The little hurricane of bathwater just before it slips inside the drain.

Seems like the world is spinning smooth without a bump or squeak except when love comes in. Then the whole machine just quits like a loud load of wash on imbalance – buzzer singing to high heaven, the danger light flashing.

Not true. The world has always turned with its trail of tin cans rattling behind it. I have always been in love with a man.

Everything's like it was. Except for this. When I look in the mirror, I'm ugly. How come I never noticed before?

I was having *sopa tarasca* at El Mirador and reading Dear Abby. A letter from "Too Late," who wrote now that his father was dead, he was sorry he had never asked his forgiveness for having hurt him, he'd never told his father "I love you."

I pushed my bowl of soup away and blew my nose with my paper napkin. *I'd* never asked Flavio forgiveness for having hurt him. And yes, I'd never said "I love you." I'd never said it, though the words rattled in my head like *urracas* in the bamboo.

For weeks I lived with those two regrets like twin grains of sand embedded in my oyster heart, until one night listening to Carlos Gardel sing, "*Life is an absurd wound,*" I realized I had it wrong, oh.

Today the Weber kettle in the backyard finally quit. Three days of thin white smoke like kite string. I'd stuffed in all of Flavio's letters and poems and photos and cards and all the sketches and studies I'd ever done of him, then lit a match. I didn't expect paper to take so long to burn, but it was a lot of layers. I had to keep poking it with a stick. I did save one poem, the last one he gave me before he left. Pretty in Spanish. But you'll have to take my word for it. In English it just sounds goofy.

The smell of paint was giving me headaches. I couldn't bring myself to look at my canvasses. I'd turn on the TV. The Galavisión channel. Told myself I was looking for old Mexican movies. María Félix, Jorge Negrete, Pedro Infante, anything, please, where somebody's singing on a horse.

After a few days I'm watching the *telenovelas.* Avoiding board meetings, rushing home from work, stopping at Torres Taco Haven on the way and buying taquitos to go. Just so I could be seated in front of the screen in time to catch *Rosa Salvaje* with Verónica Castro as the savage Rose of the title. Or Daniela Romo in *Balada por un Amor.* Or Adela Noriega in *Dulce Desafío.* I watched them all. In the name of research.

I started dreaming of these Rosas and Briandas and Luceros. And in my dreams I'm slapping the heroine to her senses, because I want them to be women who make things happen, not women who things happen to. Not loves that are *tormentosos.* Not men powerful and passionate versus women either volatile and evil, or sweet and resigned. But women. Real women. The ones I've loved all my life. *If you don't like it* lárgate, *honey.* Those women. The ones I've known everywhere except on TV, in books and magazines. *Las* girlfriends. *Las comadres.* Our mamas and *tías.* Passionate *and* powerful, tender and volatile, brave. And, above all, fierce.

"*Bien* pretty, your shawl. You didn't buy it in San Antonio?" Centeno's Mexican Supermarket. The cashier was talking to me.

"No, it's Peruvian. Think I bought it in Santa Fe. Or New York. I don't remember."

"*Que* cute. You look real *mona.*"

Plastic hair combs with fringy flowers. Purple blouse crocheted out of shiny yarn, not tucked but worn over her jeans to hide a big stomach. I know – I do the same thing.

She's my age, but looks old. Tired. Never mind the red lips, the eye makeup that just makes her look sad. Those creases from the corner of the lip to the wing of the nostril from holding in anger, or tears. Or both. She's the one ringing up my *Vanidades.* "Extraordinary Issue." "Julio Confesses He's Looking for Love." "Still Daddy's

Girl? – Liberate Yourself!" "15 Ways to Say I Love You with Your Eyes." "The Incredible Wedding of Argentine Soccer Star Maradona (It Cost 3 Million U.S. Dollars!)" "*Summer by the Sea*, a Complete Novel by Corín Tellado."

"Libertad Palomares," she said, looking at the cover.

"*Amar es Vivir,*" I answered automatically as if it were my motto. Libertad Palomares. A big Venezuelan *telenovela* star. Big on crying. Every episode she weeps like a Magdalene. Not me. I couldn't cry if my life depended on it.

"Right she works her part real good?"

"I never miss an episode." That was the truth.

"Me neither. *Si Dios quiere* I'm going to get home in time today to watch it. It's getting good."

"Looks like it's going to finish pretty soon."

"Hope not. How much is this? I might buy one too. Three-fifty! *Bien* 'spensive."

Maybe once. Or maybe never. Maybe each time someone asks, *Wanna dance?* at Club Fandango. All for a Saturday night at Hacienda Salas Party House on South Mission Road. Or Lerma's Night Spot on Zarzamora. Making eyes at Ricky's Poco Loco Club or El Taconazo Lounge. Or maybe, like in my case, in my garage making art.

Amar es Vivir. What it comes down to for that woman at Centeno's and for me. It was enough to keep us tuning in every day at six-thirty, another episode, another thrill. To relive that living when the universe ran through the blood like river water. Alive. Not the weeks spent writing grant proposals, not the forty hours standing behind a cash register shoving cans of refried beans into plastic sacks. Hell, no. This wasn't what we were put on the planet for. Not ever.

Not Lola Beltrán sobbing "*Soy infeliz*" into her four *cervezas.* But Daniela Romo singing "*Ya no. Es verdad que te adoro, pero más me adoro yo.*" I love you, honey, but I love me more.

One way or another. Even if it's only the lyrics to a stupid pop hit. We're going to right the world and live. I mean live our lives the way lives were meant to be lived. With the throat and wrists. With rage and desire, and joy and grief, and love till it hurts, maybe. But goddamn, girl. Live.

Went back to the twin volcano painting. Got a good idea and redid the whole thing. Prince Popo and Princess Ixta trade places. After all, who's to say the sleeping mountain isn't the prince, and the voyeur the princess, right? So I've done it my way. With Prince Popocatépetl lying on his back instead of the Princess. Of course, I had to make some anatomical adjustments in order to simulate the geographical silhouettes. I think I'm going to call it *El Pipi del Popo*. I kind of like it.

Everywhere I go, it's me and me. Half of me living my life, the other half watching me live it. Here it is January already. Sky wide as an ocean, shark-belly gray for days at a time, then all at once a blue so tender you can't remember how only months before the heat split you open like a pecan shell, you can't remember anything anymore.

Every sunset, I find myself rushing, cleaning the brushes, hurrying, my footsteps giving a light tap on each rung up the aluminum ladder to the garage roof.

Because *urracas* are arriving by the thousands from all directions and settling in the river trees. Trees leafless as sea anemones in this season, the birds in their branches dark and distinct as treble clefs, very crisp and noble and clean as if someone had cut them out of black paper with sharp scissors and glued them with library paste.

Urracas. Grackles. *Urracas*. Different ways of looking at the same bird. City calls them grackles, but I prefer *urracas*. That roll of the *r* making all the difference.

Urracas, then, big as crows, shiny as ravens, swooping and whooping it up like drunks at Fiesta. *Urracas* giving a sharp cry, a slippery rise up the scales, a quick stroke across a violin string. And then a splintery whistle that they loop and lasso from that box in their throat, and spit and chirrup and chook. *Chook-chook, chook-chook*.

Here and there a handful of starlings tossed across the sky. All swooping in one direction. Then another explosion of starlings very far away, like pepper. Wind rattling pecans from the trees. *Thunk*, *thunk*. Like bad kids throwing rocks at your house. The damp smell of the earth the same smell of tea boiling.

Urracas curving, descending on treetops. Wide wings against blue. Branch tips trembling when they land, quivering when they take off again. Those at the crown devoutly facing one direction toward a private Mecca.

And other charter members off and running, high high up. Some swooping in one direction and others crisscrossing. Like marching bands at halftime. This swoop never bumping into that. *Urracas* closer to earth, starlings higher up because they're smaller. Every day. Every sunset. And no one noticing except to look at the ground and say, "Who's gonna clean up this *shit*!"

All the while the sky is throbbing. Blue, violet, peach, not holding still for one second. The sun setting and setting, all the light in the world soft as nacre, a Canaletto, an apricot, an earlobe.

And every bird in the universe chittering, jabbering, clucking, chirruping, squawking, gurgling, going crazy because God-bless-it another day has ended, as if it never had yesterday and never will again tomorrow. Just because it's today, today. With no thought of the future or past. Today. Hurray. Hurray!

ROBERT BONAZZI

Maestro of Solitude

Near the Atlantic at high tide
fearful of that crashing

Rather than to kill
the hour I encounter
this moment

Full moon on electric clef
descends a resonant tone

No fixed stars only fixed ideas

Manuscript illuminated by
long commas of light

I hear our primal nocturne

Distant solitudes listen
in intimate dialogue

Being one sacred silence

Joey Fauerso, *Opening*, 2006; oil and watercolor on paper, 46 x 44 inches.

Luz María Sánchez, *riverbank*, 2006; found clothing and personal effects. Installation, dimensions vary.

ABRAHAM VERGHESE
Tizita

At the age of twenty-five I had decided that hard work, intelligence, and perseverance assured nothing at all and that only blinding good fortune – the sort that carried an average radio announcer to the White House – could alter my life's course. Hence, when I heard the Queen of Sheba's voice, and consequently, as I tripped and fell hard to the floor of Ndongo's den, I knew that my luck was already changing, for apart from skinning my palms on the concrete and wrenching the medial meniscus on my left knee and smashing my spectacles, I was intact. What, but luck, I asked myself, kept my cervical vertebrae from wedging against my spinal cord, leaving me motorless and deadened from the chin down? What labium of time, what limbus of space, what exemption from the laws of physics applied to my tumbling body saved me from disaster?

The woman's voice husky and resonant, as if produced in an oak cask and edged with steel, had been startling, unexpected – it had caused me to fall as surely as if I had been struck by a staff. "This woman," I said aloud and with the eerie intuition of one who has just stared at death, "is either Carmen McRae or the Queen of Sheba or else she has cancer of the throat."

I was on my butt. Ndongo was in his corner under the stairs, chortling over my spectacular entrance. The woman was next to him. A single candle pushed at the shadows.

This was a fire-gutted building in a row of such buildings. The cigarette lighter, which I had been using to find my way, and a steel-mesh glove – both purchases for my research project – had gone flying into the dark. I could hear the rats dragging my lighter about. The woman had been cussing him when I came tumbling down, but it wasn't the usual "Mo'fo" jive of Roxbury; I hadn't even recognized the words. Her voice came at me again, icy as the draft down the stairwell, cutting through Ndongo's cackle: "I am not Carmen McRae and I don't have cancer," the voice said. "I am the Queen of Sheba. And what kind of Negro are you?"

I was speechless and could only listen as Ndongo spoke for me. I was, Ndongo told her, a "student Negro, a student Negro doctor" trying to culture HIV virus – "bugs," as he termed it – from the needles in his shooting gallery. The way Ndongo explained it, it was a collaboration of two institutes of enlightenment: the medical school and his.

"Lady," I said, my voice emerging high-pitched and squeaky, "forgive me. But I grew up in Roxbury. I know the Queen of Sheba. The Queen of Sheba wouldn't be caught dead in this place." She lifted the candle and lit her cigarette. My heart stopped. "Oh, God," I said. Was this indeed the face of the beautiful mulatto I once knew with rusty hair and the best legs I had ever seen step out of a Camaro?

"But lady," I said, "if you are the Queen of Sheba, what happened to you? Why are you in this place abusing your body?"

My question was thoughtless. Which of us can give an accounting of our life to someone a decade younger – someone who looked up to us and saw no flaws, expected perfection, and now, ten years later, sees us falling well short of a mark that was unreasonable to begin with?

When she spoke, her voice was sad, barely a whisper. "Why am I here? Little boy, give this digger of veins twenty dollars, if you have it."

"Twenty?"

"Twenty dollars and you shall hear the story of the Queen of Sheba. Of her rise, her fall, her imprisonment – no, I won't talk about imprisonment – and you shall watch her rise again."

I counted out eighteen dollars and change and handed the money to Ndongo. I would live

on crackers and nondairy creamer from the hospital cafeteria for a week.

The rustle and jingle of money brought Ndongo to life as if I had poured water on a slug. He began to assemble his "equipment." Meanwhile, sweeping with my boot, I located my glove. The feel of something running over my ankle made me decide to abandon the lighter. I came back into the light and watched the needle enter her antecubital vein. When they were done, I used my glove to pick the needle out of Ndongo's hands and put it in my sterile cigar box, giving him a new needle. I made an entry into my log. If I did prolong the procedure, it was so that this witness to my childhood, this woman extant in my memory and now corporealized in this black hole of a basement, should know how far in life I had come.

When she spoke again, the burrs had fallen off the voice, and it had picked up a tambourlike quiver.

"In the old days, you ask anyone in Roxbury, 'Take me to the Queen of Sheba,' and no sooner than the word 'Sheba' leaves your lips, you would be looking at a yellow two-story house, the brightest yellow you'd ever see in Roxbury. That was me. Almaz, the Queen of Sheba . . ."

I knew the house. It was on a rise, set back from a dead-end road, where the brambles began. I had lived ten blocks south before my stepfather moved us to Jamaica Plain. I remembered her house had a sagging front veranda, shored up with a column of wheel hubs, and a covered deck that jutted out at the back. Behind the Queen of Sheba's, the land had sloped down steeply to a gully where a truck rested on its back, buried in sludge. As kids, we used the rear axle of the truck as a bridge across the gulch. That upside-down truck was the meeting place for the sorties Rafael Sarona, Sweet Pie Reuben, Shorty Jackson and I made from the "jungle" to the "jingle" – from

Roxbury to the white world of restaurants and galleries that ran down Boylston and back up Newbury Street.

We were all in love with the Queen of Sheba back then; we lusted for her. Shorty Jackson weaved a Medusa myth – if you stared at her too long, your dick would fall off – but we figured Shorty was trying to scare us. Love made Rafael Sarona feverish and sick, and his mother never knew why; from his sickbed, at night, he would head out to his mission of painting "Sheba-Sarona" on the roof of every T-station from Jamaica Plain to Logan. Years later, in Mattapan Hospital, when I stumbled onto a skeleton with blue-green eyes that I recognized as belonging to the graffiti maestro of my childhood, Rafael said it was the pain of that love – "the passion, man, the passion" – that drove him to drugs.

". . .There were cars all round," she continued, "as if I was a breeder of cars. On the front door, in pink letters, Ismael painted in Amharic: ALMAZ ENTERPRISES – MAY HE GIVE HEALTH TO ALL WHO ENTER. I lived there ten years. I rented the downstairs from an Iraqi Jew. I told him when I first moved in that I was Falasha – Ethiopian Jew. Every three months he would sit in my living room, look at the electrical outlets, count the appliances. 'I have plans to rent the upstairs,' he would say. 'What do you use it for, the upstairs?' he would ask. 'Go see for yourself,' I would say. Always he would ask, 'Will you come with me?' but I never did. Upstairs, Tayitu herself took care of him. Whenever he raised the rent, I paid.

"The house was a homeland – Abyssinia in the middle of Boston. Upstairs, in one room, I stored Ethiopian teff, basmati rice, long rice, *berbere,* hot peppers, cassava, plantain, saffron, sorghum, coconut oil, gingily oil – a complete African-Asian grocery, in other words. Downstairs, in a corner

room, I had a long table and benches – an eating place to serve *injera* and *wot.* I had shares in a Quick-Mart on Commonwealth Ave., and I had shares in a taxi fleet – Sheba taxis.

"Ismael, a half-Somali, was my generalissimo. Ismael grew up near Djibouti, in a mud *tukul,* on a mud floor, wearing mud brown clothes, drinking muddy water. One day I came home and he had painted the wooden floors white and the front of the house yellow. 'Why did you do this?' I asked. He got mad. 'It was the color of mud,' he said. Ismael supervised the *tej* brewing; he bought honey wholesale, poured it into battery casings under the porch, added mother brew and let it ferment. More potent and sweet *tej* you could never find, not even in Addis Ababa. Ismael kept track of how much the taxi drivers owed us, arranged for them to deliver groceries, made loans to them. And, as a side business, every few months Ismael would buy a pound of ganja – with my money, of course – from the Rastas and sell it at once to the homeboys who would sell it as loose joints up and down Blue Hill Avenue. I pretended I didn't know about it. Maybe he employed you like this?

"Lady," I said, recalling the devious man with the giraffe neck and the loping stride of a gazelle and the expression of a hyena, "he didn't employ me, he cheated me! Of forty dollars! Don't tell me about Ismael! One time . . ."

"Your clumsiness probably got you in trouble. Ismael was a good man. Maybe it was Tayitu who cheated you – God curse that woman. An Italian, many years ago in Massawa, put out her eye. Tayitu was the cook as well as other things.

"Finally, there was Getachew, a cousin of a cousin of my bodyguard. He was weak in the head – could not be a taxi driver or parking attendant – but strong and hardworking. He took care of the chickens and goats. We would buy ten baby goats from New Hampshire and raise them behind the house; some of them were like pets, coming in out of the veranda. When they became heavy, on Muskal Day – Ethiopian harvest – we would slaughter and cook them outside the house. On that day the homeland would have all of its citizens present. The police from the Roxbury and South End stations would come in their police cruisers to eat. The next day, whatever goat meat remained we sold to the Rastas.

"But child, people came and went from the house even when it was not festival day. They were served in the kitchen, sat down on the benches in the eating room, drank *tej* and paid Ismael when they left. Most were Ethiopians who had escaped across the border to Sudan. In Khartoum, they had waited for their papers from the American Embassy, waited for years and years, working meanwhile in kiosks or as office aides or servants. That's why Ethiopians don't mind the cold in Boston; every cold day reminds us how good it is to be out of Khartoum where, even with a wet cloth over your face, the hot air will burn your lungs. They arrived at my door in Roxbury like newborn lambs, everything they had tied up in bedsheets, their X-rays still in their hands. The Embassy people knew me; 'Almaz Q. Sheba, Roxbury, Boston, MA,' was on so many sponsor forms.

"The men I found work for: stock boys, then parking attendants, then cabbies, then they were on their own. The women did piecework for Tayitu, took care of the house, and helped with the cooking. There was much to be done: grind teff, make *injera,* clean chicken, make *wot,* sweep the house, and pour *tej* into picnic jugs. If they wanted to do more, and if they were . . . well, Tayitu would take care of that. See, you Negroes are always lusting after Ethiopian women, lusting

after Semites, even more than you lust after whites. You can't deny that, can you?"

I thought of Rafael Sarona dying in Mattapan of AIDS and its complications. I thought of Shorty Jackson and Sweetie Pie Reuben – where were they? Would they believe me? I remembered the scent of honey we had supposed came from the Queen herself. I could see the green, yellow, and red Sheba taxis all over the yard, the men drinking on the porch and spilling onto the pavement. From our hideout, we waited for the Queen of Sheba to pull up; we cursed the men who clustered around the red Camaro, spoiling our view. I remembered the baby goats prancing around her and how the cocks would crow. I remembered how late at night the house would be alight and teeming with Abyssinians, how suddenly, unexpectedly, her voice came down to us as she sang, accompanied only by the rhythmic hand clapping of her retinue – a voice so piercing, so riveting, that it made the hair rise on the back of our necks. It made us look at each other and wish that we had been born somewhere else other than Roxbury, preferably in the land of Ras Tafari, the land of the Queen of Sheba.

"How did I manage all this, you are thinking: How did a woman become so powerful? I can read your Nubian eyes. What? You object to the word 'Nubian'? You think you are American, but your Idi Amin nose and cantaloupe lips betray you."

Ndongo was cackling beside her. She continued.

"I managed because I understood men. I had as much ambition as the men. I never treated one man as better than any other man. I knew when they opened their mouths they were born to lie. I used them, then spat them out like stones. I did to men what they did to women. That's how I became the Queen of Sheba. Don't look so sad! You can't help being a man any more than you can

help your slave origins. I don't choose to be here filling my veins with heroin. Ndongo does not *choose* to be doing what he does. And you, little boy, scrounger of needles? Do you choose to do this? –"

I wanted to tell her all about the Epidemiology Institute – my summer project with my mentor, the world-famous Dr. Gail Gitnick – how I dreamed this study would be a lead article in the *New England Journal of Medicine*, how the accompanying editorial would sing my praises, how it would transform me from being an "extern" in a succession of rotting city hospitals – my fate ever since the U.S. Marines had airlifted me out of medical school in Grenada – to becoming an intern in the most prestigious hospital in the world. I wanted to tell her about luck and how my luck was changing.

"Of course," she continued, "you don't choose to do what you are doing. See, all life is addiction, whether it is to food or books or money or sex or work or research or to a person. We are all slaves to our addiction. In my case and Ndongo's case, it is more apparent."

"Lady!" I said, standing up, unable to take this anymore. "Don't feed me this pop psychology, and don't make the mistake of assuming you know who I am. It might interest you to know . . ."

"I want to get to Bolodia. You paid money to hear about him, so control yourself."

I sat back down.

"Bennin Brazali Bolodia. Bolodia was an intellectual – I spit on intellectuals! Intellectuals are worse than sodomists. Worse than men who want to put their organ in your mouth. Intellectuals! When Bolodia was a student in Ethiopia, he was sent by Emperor Haile Selassie to study abroad – Russia, Italy. He returned to Ethiopia an intellectual, an agronomist. *Doctore* Bolodi – at least that is what he called himself. He talked

Trish Simonite, *Blue Clock Vine Collage*, 2007; limited edition archival pigment print, 12 x 16 inches.

loudly about the revolution, the bourgeois, the imperialists; said these things in the Addis Ababa Hilton, where I used to be a singer, and in the corridors of Haile Selassie the First University. And no one was more surprised than him when the revolution came. For once he was speechless! His surprise was even greater when the Provisional Military Council threw him in jail. For being a counterrevolutionary!

"When they let him out, he escaped from Addis Ababa and joined the Eritrean Liberation Front near Asmara – see, he was Eritrean first, Ethiopian second. I don't know how much fighting he did, but I know he almost died of malaria. He was sent to Sudan to heal, to do paperwork for the ELF, and there he turned his back on the revolution, lining up – just like the rest of us – outside the American Embassy, except he called his reasons for leaving 'ideological differences.' He was brought to my house in Roxbury by one of my taxi drivers who found him starving, drunk and beaten up outside the Harvard T-station. Along the way, the taxi driver several times thought of putting his foot in Bolodia's face and kicking him out, not just because he smelled so bad, but because the Bolodia tongue would not stop. 'Eritrea,' 'liberation,' 'bourgeois,' 'oppression,' 'proletariat' – these things came out of his mouth like farts from an old man.

"After he healed – the beating took out his front tooth and one eyebrow – I got him a job at the Brigham and Women's Hospital. There was a Ghanian I knew who was cook foreman there. At first Bolodia worked very hard. He began to resemble a human. But soon, when the Ghanian tried to order him to do things, Bolodia would say, 'You African, you are talking to someone who studied agronomy in Russia. I ran a kitchen in the Vatican. Without me, the Vatican would have collapsed.' Another time when the dietary supervisor – a white, of course – was inspecting the kitchen and the Ghanian was following behind her, respectfully, saying, 'Yes, Madam, yes,' to everything, Bolodia said in a loud voice, 'You know, even though Biko is dead, Mandela will soon be free; there is no need to be walking behind her all bent over saying, Ah – yes, ah – yes. Are you an ignorant Bantu? Are you her kaffir?'

"One day Bolodia came to work drunk, dressed in a suit and bow tie, holding a paper with a long number written on it. 'Call this number! Ask them about me!' The Ghanian turned his back. All work in the kitchen stopped and people gathered around. Bolodia was yelling, 'I demand you call this number. Clear this matter up, once and for all.' 'Who am I calling?' the Ghanian asked. 'The Siberian Agronomy Institute,' Bolodia said. The Ghanian began to laugh: 'I don't care if you were a cosmonaut; all I need from you is to wash dishes.' The Hindus and Haitians were laughing, too, and this made Bolodia furious. He took a meat knife in his hand. 'Some nations are colonized by whites,' Bolodia said, 'but you Ghanian – you savage – your mind is colonized by whites.' And then Bolodia wanted to make tripe from the Ghanian bowels.

"Why did I bother to bail him out, you are wondering; why did I fall in love with this man? This is a question I often ask myself. He had made my taxi drivers think of unions. He owed me money. He had eaten on credit, drunk *tej* on credit, even slept with women on credit; I wanted to extract my money from his hide. But when I got him out of jail, he could not even walk. I let him sleep on my porch. When he got better, I told Getachew to keep guard on him, to lock him in my room when he had no work for him. I put Bolodia – Doctore Bolodia – to work, helping the woman with cooking and cleaning, Ismael with the brewing, Getachew with plucking chickens

and feeding goats. I made him assist Tayitu with looking after my infant, James. He took himself so seriously it used to make me laugh; he would never admit his fault. Going to jail, being in debt, being beaten up was always the fault of someone else. He would be squatting in front of a basin of boiling water, plucking chicken feathers and mumbling; if you went near, you could hear a speech about what was wrong with the chickens, with Roxbury, with Boston, with America, with the world. To my surprise, he was very gentle with my baby, singing to him, rocking him, calling him Mamoosh, even though I reminded him more than once that the baby's name was James. 'Where did you get the name "James"?' he would ask. 'Do you mean James Brown? Or James Dean? I, Benin Brazali Bolodia, refuse to address this child except by an Ethiopian name. I will call him Mamoosh.' It became a big joke around the house to call the baby 'James' just to irritate Bolodia. One day when I came home, I found he had shaved Mamoosh's skull so that only a tuft of hair remained at the front of his head. 'Does Mamoosh not look like an Ethiopian child now?' he asked me. If the baby did not look delighted, I would have slit Bolodia's throat. Mamoosh loved Bolodia, never wanted to leave Bolodia's shoulder. Bolodia would take him from Tayitu, saying to her, "Woman, you have a responsibility with this child, an obligation far beyond pulling out your shriveled tit for him to suck on. Let this be clear to you!' He wanted us all to believe Mamoosh could be the next Khruschev or Nixon.

"It was surprising to me – and you will appreciate this – that Bolodia resisted me. Since he had no more credit to sleep with the woman upstairs, he ignored all women. They did not exist. And he did not seem to miss his alcohol. He would read for hours and hours – sometimes aloud for Mamoosh, otherwise for himself. Bolodia would want to watch the news on the TV in my bedroom whenever I let him. It was as if the news on was a hajji calling him to Mecca. He would say to Mamoosh as they watched, 'You see! What did I tell you?!' He talked about the liberation of Eritrea to anyone – including Ethiopian nationalists. I would hear big noises and Bolodia's spectacles smashed once again, blood coming out of his nose. 'These barbaric people,' he would say when we picked him up. It was never his fault! One day I *made* Bolodia sleep with me."

The Queen of Sheba's words were causing me physical pain – to say I was jealous of Bolodia only begins to describe my torment.

"Don't look at me like that!" she said, misreading the expression on my face. "As a man you don't have a reason to sleep with a woman, do you? Why should I be different?"

"Lady, that wasn't all I was thinking," I blurted out. "I was thinking, why didn't you ask *me*? Do you know how many years I hung around your house, dreaming that you would have such a need? Wishing that I could have been born a goat so that I could nuzzle against your legs and have your hand stroke my chin?"

The Queen of Sheba just looked at me strangely and did not resume at once. Ndongo was pounding the floor in slow motion with one hand and holding his belly with the other.

"Before Bolodia slept with me, he had me sign a paper that he was no longer my vassal and that we were equals. He was so serious about this that it made me laugh. By then, I was in my thirty-seventh year. As you can imagine, I had seen many kinds of linga – and no doubt the way you are rubbing yours, you will show me your evil one soon. I had seen long ones, small ones, thick ones, upturned ones. But his member was the only one I have had that when he was bucking me, ramming me, would grow a tumor at its tip. It began in his

balls and came to a rest at the end of his phallus, like a grapefruit."

Ndongo had stopped laughing. My hands itched to confirm certain details about my own genito-urinary anatomy; instead I fingered the steel-mesh glove. The Queen of Sheba leaned forward, and Ndongo and I brought our heads closer.

"After I had sex with him, I wriggled and pulled to get him out of me, but I was stuck. We remained joined because of this. I just lay there, breathing hard on him, listening to him talk, for he never found better words than in those moments when I was waiting for his tumor to release me. Repeatedly, in this manner, using his member that was not very long, not very thick, not unduly curved, he subverted me.

"One day I found he had enrolled full-time at Northeastern University. With no papers, he managed to talk them into both admission and assistance. In no time, he was involved in student politics, ran for office and lost, of course. He came and went from my house and my bed, carrying nothing but money, clothes. Soon he had contacts everywhere – with the Farrakhan Muslims, with the Eritrean Liberation Front, Tigre Liberation Front, PLO.

"I had graduated from high school in Ethiopia and had done one year of Commercial College. In America, the object for me was survival, the making of money. I had my looks – Mussolini's blood is in me – I spoke English well, and people would listen to me where they might ignore a man. I tried singing, but it didn't work out – the ones who were supposed to help me wanted my body, not my voice. So it came about that I made my money – lots of money – by providing for my people what no one else could do. I associated more with Ethiopians in Boston than I had ever done in Ethiopia. In Addis Ababa, I socialized

with the other half-caste Italians, and we mixed with the Gujaratis, the Armenians, the Greeks. In Roxbury, I became more Ethiopian than I had ever been. Still, Bolodia pushed me on as if I had done nothing, as if the Queen of Sheba was of no consequence. 'For Mamoosh,' he would say, 'you need to be more than a seller of *tej*; you need to leave your mark on this world.' I began to read books again, prepared to go back to college. Evenings, I went with him to African film shows, 'rap' sessions, think tanks, lectures – anywhere he could preach. For me, it was a change from hanging around taxi drivers in my own house. To be around someone who was interested in life, opinionated about life, made me feel as if my life had been empty. I became more comfortable in intellectual circles; when someone said 'Malcolm,' I knew they meant Malcolm X, and when they talked about 'our brothers' – even the whites – I knew they were talking about Africa. And, for them, Bolodia was a star. He had been a guerrilla! With his scars and his missing teeth, they loved him. And every night he would fill me with revolution, tell me I was destined for great things, that Mamoosh would command interballistic missiles. Every night he would leave his subversive semen swimming in me; it would be in me all day as I read my books. If that was love, I had never been loved like that before.

"Soon I was carrying Bolodia's baby, and so we married. Bolodia said when he graduated and found work, it would be my turn to finish college, and he would support me. I enrolled in part-time classes. Nobody could believe the change in me, that I had become the consort of Bolodia. I studied hard; I wanted to succeed in America in the highest possible way – to be, as Bolodia used to say, 'Queen of the Melting Pot.' And at night I used to wait for the love and loving of this man. For Bolodia, meanwhile,

a book, an argument, a demonstration, El Salvador, South Africa – these were bigger for him than anything else. His outer revolution was getting stronger. But the inner revolution at night no longer seemed to hold me.

"One day when I was picking up his clothes, I found a scent not his own. I knew right away it was a woman's smell. But I was too proud to ask him. I began from that day to sniff all his clothes. The smell was not there every day. When it was there, it was as though he had bathed in it; it was always the same smell – a white woman's smell. From then on, whenever we visited white people, I would enter their bathrooms, sniff their towels, fish clothes out of the laundry basket.

"This went on for months until I received a call at home. The woman said, 'If you value what is yours, I suggest you visit this address in Newton.' I asked her, "Who are you? Why are you calling me?' She said, 'That woman – that bitch – almost stole my husband. I had three kids, but she was going to take him anyway. I fought to get him back. I would've killed her. I should have killed her. She is the devil, she is poison . . .' she went on and on, but I hung up.

"I got lost several times before I found the row of condominiums in Newton. It was a day in Boston as hot as Khartoum. I parked some distance away and walked up and rang the bell. When there was no answer, I used the straight razor in my handbag to let myself in – an old Khartoum trick. Inside, in a dark hallway, I found the scent I had been searching for. It was so strong that I became dizzy. I put my hands on the walls and moved forward like a blind woman. Night-lights in the hallway came on as I neared them and turned off when my shadow crossed. I sat down on the sofa in the living room and put my swollen legs on the glass table and wept. I could feel the baby kicking hard.

"When my strength came back to me, I began to notice what was around me. There was a plant – a fern – right over my head. There was another – an ivy – in the corner of the room, three more plants on the windowsill, one plant on each speaker; they were everywhere, hovering around, staring at me like silent subjects. I sensed their resentment; I sensed the inadvisability of speaking even a word in this place – like eunuchs, these plants would whisper it later to their empress. On the mantle piece in front of me was a square clock with glass sides so I could see its insides turn. Next to it, between book stands, were large, colorful books. I put my head to the side and read: *New Mexico*, *The Scenic Northwest*, *Alaska*, *The Great Barrier Reef*, and the *Kingdom of the Orient*. I lifted myself up and found the bedroom. The bed was a queen-size, very near the ground. Above it was a huge, framed poster of a male ballet dancer. I got on my knees. I thought I smelt Bolodia. I undid the sheets and exposed the mattress. I remade the bed.

"In the dresser I found panties, bras, leg warmers, headbands, and one red and one green spandex suit. I turned on the light in her walk-in cupboard and saw a person dressed in green! I almost died of fright: it was a green-black ski suit on a hanger. A pair of ski boots stood right in the doorway as if she had not had time to put them away. Behind the suit, rows of dresses – hundreds, it seemed – hung over many pairs of shoes. A bamboo basket on the floor was full of belts. I sniffed each dress, working my way deep into the cupboard. The effort made me sick, and I ran to her bathroom and threw up in the commode. The towel racks were heavy with towels and washcloths folded into triangles as if this were a hotel, every towel with the letter *M* on it. A basket on top of the commode held tiny shampoo bottles, lotions, conditioners taken from some of the

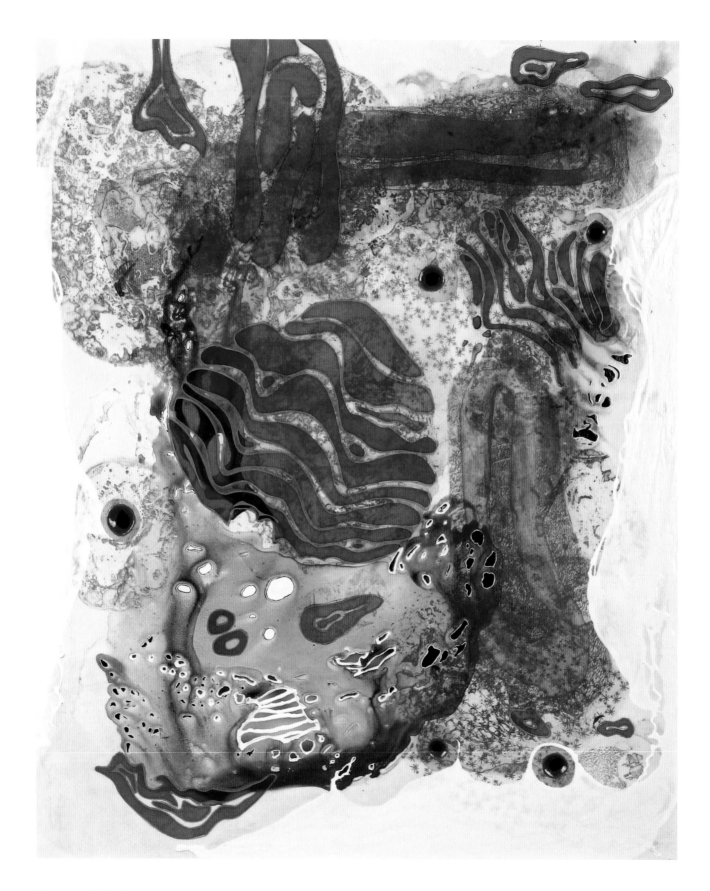

Margaret Craig, *Void Red Reaction*, 2003; mixed media, 33 x 41 inches.

places she had stayed. I picked some bottles up and read: Princes Islands, Turkey; Margo Island, Florida; Puerto Vallarta, Mexico.

"I went to the kitchen to drink water. The refrigerator was empty except for a half-full bottle of champagne and some cheese. I looked in the dishwasher for a glass – there were six champagne glasses laid carefully on their sides, the mouth of one overlapping the stem of the other. I drank water and placed the glass back in the dishwasher.

"All the time I had been in the house, the scent was never stronger than in the hallway. I found a laundry basket in a closet off the hallway, with skis and ski poles behind it. Even before I opened the laundry basket and brought the panties to my nose, I knew I had found the source."

Ndongo and I looked at each other. My heart was racing, and I wished I had peed before I came. The Queen of Sheba was speaking slowly, as if she were walking through treacle, as if during her recollection of her visit to the house she had become once again heavy with child and slowed by summer heat. She paused for so long that I burst in, "Lady, as one who loved you and would never have perpetrated the sort of deceit and duplicity that you are about to describe, this tale is causing me great distress, both distension of bladder and fluttering of involuntary muscle of bowel. Kindly tell me, what happened? What did you do?"

"I waited, little boy. I waited. Twice, her phone rang. Her answering machine picked up, and I heard her voice. 'Hello!' she began, in a voice that was bright and cheery. A man left a message saying he had tickets for *Les Miserables*, and another left a message for tickets to something else. I was hungry, but there was nothing to eat. I was back to the sofa now with my feet up on the coffee table. I picked up a ski magazine from under the table. I looked at the advertisements; the suits cost hundreds of dollars and the skis cost much

more. On every page I saw white faces with red, green, and yellow sunglasses, all sharing the same smile – as if this being on the mountain, dressed as they were, the women with crowns of fur on their heads, was the most natural thing in the world. No money, no effort was required.

"I wondered about the woman of this house. Why did she hate being here? The plants and the books and the pictures seemed at home, comfortable with her absence – where was she? Everywhere I looked I saw the evidence for her escapes. It was the kind of house in which a child – finding no continuity, no calendar except an hourly one – would wither and die. For a moment, I felt sorry for Bolodia. He was probably another diversion for her, costing no more and perhaps much less than a ski trip, and of no more value than sliding down a mountain.

"When finally I heard footsteps outside, I hid in the bedroom closet. I heard them coming to the bedroom and then the unmistakable sound of Bolodia's spectacles being set down. Soon there were no more voices. I heard her strike a match, but before the incense could reach the cupboard, I could smell her. After a few minutes, I looked through the closet door. They were arranged like the champagne glasses in the dishwasher; her mouth was on his phallus, and Bolodia – father of the baby in my womb – was turned upside down, talking to her womb with his tongue, whispering to it, as though it had a nose a mouth and eyes. On and on he went, speaking to it, every word of which I could gather from her face, for she was now so distracted that she had to let go of him. She had thrown her head back and closed her eyes; she had the same smile I saw in the ski magazine – it was plain to me that it could have been anyone between her legs and she would've looked the same. But it was Bolodia – not anyone – who was drinking from her, burping once or twice in his

haste. When he was filled up – it seemed like hours – he finally inserted his rod into her.

"There in that closet, with the belts like snakes at my feet, the ski boots pressing on me, it all came back to me. How I had been the Queen of Sheba, owner of taxis, brewery, grocery, and chickens. And now I was the Nubian goat, bleating behind this spectacled shepherd, the father of the child of my womb, and here he was pumping another woman and sucking ewe juice in the name of the revolution.

"I had let this happen because he had filled me with an expectation of something grand, something spectacular – more than Mamoosh becoming president – something that would happen to me, within me, like the Resurrection or the Second Coming. And while I was waiting, waiting, following, watching the spit fly off his lips as he quoted Malcolm X, Che, Gandhi, I should have known – I knew – deep down it could not happen.

"For the first time I understood who was the proletariat. The proletariat was me, the proletariat had always been me, and now I needed to act for the proletariat. I had my straight razor in my hand.

"But I had to wait for the moment when I saw her eyes bulge, the moment when I knew she was feeling the tumor that had been mine for so long. It was agony for me to wait. Once she screamed, 'Bolodia! I love you! Fill me up!' and I almost laughed aloud. I thought of the men on the answering machine. How many times with how many men she had used those very words – surely she did not go alone. Were these code words used by her tribe? This woman loved everything: champagne, ballet, skiing, Victor Hugo, the Great Northwest, and now she loved my Bolodia.

"I began to sing in my softest voice. They could not see me though I could see them. The music that came out of my throat seemed to hit them like a blow. I sang an old Ethiopian song, a gentle song, a sad song called 'Tizita.' In Amharic, it means 'I remember.' Every other line begins and ends with *tizita*. I saw the skin on Bolodia's balls wrinkle as if ice had landed on it. I sang louder now. They pulled at each other, gazing wild-eyed at the closet, but they were stuck; for the first time I saw fear in Bolodia's eyes. If he could have left his manhood where it was and run, he would have. But he was helpless – they were helpless – stuck in their juices, pinned in infidelity by the tip of his phallus.

"I came out of the cupboard.

"I had the intention for him: to slit his thew, slit it as if it were the stalk of henna, knowing that the seat of his power, the key to his bluster, the root of his eloquence lay between his legs. For this, I was prepared to pay any price.

"And for her I wanted only this: that she should henceforth feel at home in the haven of her own castle; that she should treasure the shelter and protection it afforded her; that she should put down roots; that she would feel less inclined to roam.

"When I was finished, I felt sweet flood my brain and spread down into my belly and through my limbs. It was as if I had cast off the manacles and broken the shackles that Bolodia put on me. Oh, I knew full well that no judge, no matter how wise, could let me go free for what I had done. And yet I did not care – the best part of my life was over the day I met Bolodia."

Only once did I see the Queen of Sheba again. It was a drizzly, October evening; the time change, with its precipitate darkness and the rapid, jerky movements of cars and pedestrians, conveyed an urgency to the matter of getting home as if somehow we had been tricked into staying late. I was exiting the Massachusetts General Hospital – yes,

by then I was an intern at the greatest hospital in the world – heading through downtown to catch the main artery home. I leaned forward at a red light to swipe the condensation off the inside of the windshield. The cobblestoned sidewalk glistened with rain and reflected light from Enzo's Deli and Bakery. Suddenly, I saw a pair of legs in black heels with open toes and fishnet stockings, then a leopard coat, and then a dazzling sight of a pair of uplifted, café-au-lait breasts, as a woman stepped out from beneath an awning to tit-flash the car in front of me and pulled back into the shadow. The light turned green, and I was past her before the face – the same face that I saw in the candlelight of Ndongo's basement – registered in my mind. I circled the block twice, but she was gone.

Now, every evening, at the start of my commute home to Gail and our new baby – yes, I married my mentor – to our cottage in Wellesley, I find myself looking at the green-and-yellow awning of Enzo's bakery. That bakery is like my touchstone: it is where I remember a ten-year-old boy from Roxbury with bug eyes and doctor dreams and an unspeakable desire to be the consort of the Queen of Sheba. I say softly to myself, "Solomon, you have been lucky, so very lucky."

TRINIDAD SANCHEZ, JR.

Why Am I So Brown?

A question Chicanitas sometimes ask
while others wonder: Why is the sky blue
or the grass so green?
Why am I so brown?

God made you brown, mi'ja
color bronce – color of your raza, your people
connecting you to your raíces, your roots
your story/historia
as you begin moving toward your future.

God made you brown, mi'ja
color bronce, beautiful/strong,
reminding you of the goodness
de tu mama, de tus abuelas, your grandmothers
y tus antepasados, your ancestors.

God made you brown, mi'ja
to wear as a crown for you are royalty – a princess,
la raza nueva, the people of the sun.
It is the color of Chicana women –
leaders/madres of Chicano warriors
luchando por la paz y la dignidad
de la justicia de la nación, Aztlán!

God wants to understand . . . brown
is not a color . . . it is: a state of being
a very human texture
alive and full of song, celebrating –
dancing to the new world
which is for everyone . . .

Finally mi'ja
God made you brown because
it is one of HER favorite celebrations!

Alex de Leon, study for *As Time Went on It Was Harder to Believe in Him*, 2004; graphite on paper, 18 x 22.5 inches.

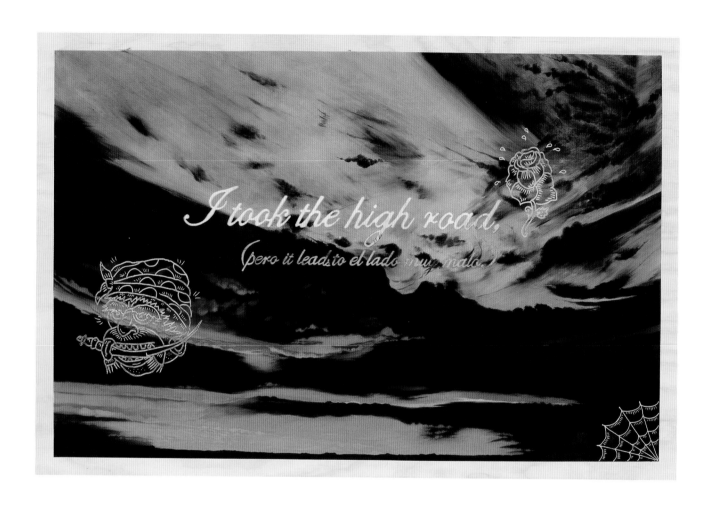

Ricky Armendariz, *"I took the high road, pero it leads to el lado muy malo . . . ,"* 2005; acrylic and polyacrylic on carved birch plywood, 48 x 78 x 1.5 inches.

RICK RIORDAN

A Small Silver Gun

"Just talk to him," my mother had insisted. Mother rarely acknowledges that I am a private investigator. She insists on introducing me as Dr. Tres Navarre, Berkeley Ph.D. She tells her friends I'm on a temporary sabbatical, that some day—when she has sufficiently cleansed my aura with essential oils—I will outgrow tequila drinking and blues music and background checks and do something really brilliant in the field of medieval literature.

And she never lines up cases for me. Especially not on her boyfriend's behalf.

But there I was on Crofton Street on a drizzly April evening. And there was Jess. And there was what was left of Jess's parents' two-story frame house—most of the walls removed and the foundation knocked away to the hole in the floorboards beneath which the body had been found.

Don't get me wrong. I like skeletal remains as much as the next guy. But right then there were other places I wanted to be. Half a mile north, the first night of Fiesta was beginning. Even from King William District you could hear the crackle of drum corps, shreds of music and the buzz of revelers converging on the narrow cobbled streets of La Villita for Night in Old San Antonio. There would be hordes of drunken college kids spilling beer down each other's tops, old rancher couples with matching potbellies and western shirts two-stepping to Bob Wills, mariachi bands shining with rhinestones and Vitalis. There would be a woman named Annie waiting at the St. Mary's Street gate, wondering where the hell I was. Annie, who had the best laugh in town and the sharpest fingernails and the blackest curls hanging over her eyes. She was not a woman I wished to keep waiting.

Jess flicked his cigarette away, making a slow red arc into the semidarkness of the overgrown backyard. "I wouldn't've asked

you, Tres. But Rachel—" He raised a hand listlessly, then dropped it, the closest he could come to apology.

"I know my mother," I assured him.

Jess looked out toward the edge of his sold-off family property, where yellow weeds and live oak roots sloped into the sluggish waters of the San Antonio River. On the opposite bank, thirty yards away, construction equipment waited impatiently, irritated at the insignificant little discovery in the insignificant little house that had momentarily held up the Blue Star bridge project.

I shined my flashlight through the ten-by-ten gap in the floorboards. The dirt beneath was scarred from the coroner's removal process, the indentations less like the impression of a skeleton than a pencil cactus—spiky and crazily geometric, not very deep at all.

"Homicide's guess is thirty years," I said. "That's about twenty-nine years, eleven months and three weeks longer than the life span of your average clue."

Jess kept his face turned toward the river, lips tight and eyes squinting, like he was enduring his own private sandstorm. I tried not to feel irritated or resentful. Honest. I wanted to see him as just another guy who was having a hard time with a problem. Not as the big idiot who was dating my mother. Maybe it would've been easier if he'd just been older—gray hair, a pipe, a few wrinkles. Anything.

But Jess looked pretty much the same as he had when we'd played varsity together at Alamo Heights sixteen years before, when all the cheerleaders had cooed about that sensitive and cuddly fullback in the second string. He had the same build, slightly babyish cheeks, thick-lashed blue eyes set a little too close together, brown hair that would've come out in curly tufts had Jess not kept it shaved close to his skull.

There was a time when he had amused me, before adulthood. Before my mother had gotten her divorce, discovered art and aromatherapy and younger men. Before her younger-man-of-choice had become Jess.

"They'll try to get something out of Pop," he said. "They've already been asking Emma some questions – who he knew back then, who he had over to the house. They wanted to know more about his work."

"Them, the IRS, the Express-News, and everybody else in town."

Jess tried to collect some anger, some indignation, but he'd spent too much of it in the last year for his father's sake. His scowl was unconvincing. His shoulders drooped with the effort of forming a response.

"He was an economist, Tres. That's all."

I nodded. There was no point in challenging him. Old Aaron Makar had been a lot of things: black marketeer, trading tycoon, capital investor, power broker to generations of city councilmen. Only in the last few years, when Makar had suffered a series of strokes and become less of a threat, less of a viable target for prosecution, had the really unpleasant stories started to surface, thrown to federal agencies by Aaron's former business partners whenever a plea bargain seemed in order. Now, many exposés later, calling Aaron Makar an economist seemed like calling a hit man a pest-control expert.

"I just don't know what I can do, Jess."

Jess rubbed the back of his neck. He stared at the drizzle like he was trying to count the drops, like he really needed an accurate number. "I want to know that Pop didn't do this."

"I understand. But that could be impossible. Even getting a positive ID on the body – the SAPD will try, but after thirty years, if it's doable at all, it could take months."

"Pop doesn't have months." The words came out so faintly I barely heard them. Jess's face told me all I needed to know about Aaron Makar's prognosis.

"Have you seen him recently?" I asked.

"A year ago."

"Before the first indictments."

Jess nodded. "Pop lost his voice with the last stroke; sometimes he can still answer with a little buzzer he operates with his thumb. Emma keeps prodding me to go. I was building up the will to go see him and not be angry. Then this happened. I was really trying."

He looked at me with those kid blue eyes, wanting me to see how sincere he was. The good son. The heavy weight of the father's sins on his shoulders.

Unh-uh, I told myself. *Careful, Navarre. No empathy. No hopeless thirty-year-old cases. Just find the polite way to say no. Get on with your Fiesta.*

I was starting to say how sorry I was when Jess had to go and mess it up. "There's something else," he said. "A man used to live with us back then. A Mexican worker. He stayed in the gardener's apartment, above the garage." Jess waved his hand toward the river. There was no garage, no evidence that there ever had been one – much less a garden. "I was only a kid, but I remember him clear enough. He was tall, scary. And I remember he left us suddenly. After he was gone there was some talk about the fights he'd gotten into with the neighborhood servants, some speculation he'd left town because he'd gotten himself in trouble. For a long time afterward my mother used to complain to Emma that this guy had stolen the good silverware when he ran off. Now I'm wondering –" Jess slid his boot along the edge of the hole. "Maybe this is why he ran."

"You told this to the police?"

Jess nodded, swallowing back the frustration. He knew as well as I did the police would spend a minimal amount of time and effort on this case. One buzz if you killed him, Mr. Makar. Two buzzes if it was a hired job. There wouldn't be any searches for retired Mexican gardeners, especially not at the instigation of the chief suspect's son.

We stood quietly, looking at the hole. After a while, out on Crofton Street, I heard the door of Jess's pickup open and then shut. His passenger had gotten impatient. A few seconds later footsteps clunked up the front stairs of the gutted building.

The old Latina woman lumbered toward us. She had a thick, round body and wore a yellow raincoat the size of a car cover. A canteen-style thermos was slung across her chest. She had two Styrofoam coffee cups in her hands, the contents of which were sloshing over her fingers. A battered green fishing hat was smushed over her head, and with the canteen and her dour expression she reminded me of a Marine drill sergeant waddling through the trenches.

"*Ay, niños,*" she called. "*Se van a enfermar si se quedan en la lluvia.*"

As she approached, she held out the coffee cups. Good-smelling steam wafted up from homemade *atole*—chocolate and vanilla and cinnamon.

Jess mumbled thanks as he took a cup. Then he said, "Tres, you remember Emma, our housekeeper?"

I nodded. "*¿Cómo está usted, señora?*"

Emma didn't smile. She handed me the other coffee cup, her fingers rough and warm and wet from spilled *atole*. She smelled strongly of lavender.

"*Más o menos el día de hoy*, Señor Tres," she sighed. "I could wait no longer—you two here with nothing warm to drink. No good standing out *en el frío, mis muchachos.*" She surveyed the old house suspiciously. She didn't like what she saw. "Ay. So many mornings at that window, *allí.*" She made pantomime gestures like washing dishes.

Jess stared into his *atole*. "Emma remembers that man."

The old woman's gaze went up, into the space that had been the second-story bedrooms. Her mouth hardened. "Herrera," she said. "Rogelio Herrera."

When she said the name her hand came up involuntarily and made a three-fingered gesture, a ward against evil. "*Qué hombre malo*, that one. He had a small silver gun."

"Herrera," I repeated. "Common enough name. A trail thirty years cold, and he was probably here illegally to begin with. I wouldn't hold my breath trying to track him down."

Jess looked me in the eye. "That mean you won't try?"

Out by the river, fireflies were starting to blink into existence. The noise from downtown had grown more audible, a consistent soft roar of people and music and traffic, peppered with occasional sirens. Jess kept giving me the sad blue stare, the weathering-a-sandstorm expression.

Aw, hell. "I will probably find nothing," I warned him. "Second most likely, I'll find that your father killed someone."

"I want to know. Whatever you find out. I can't let him die without me knowing, trying to figure out what to say—"

Emma put a protective hand on Jess's shoulder. She looked at me with heavy brown eyes. "This is no good, Señor Tres. Whether you find out more or no, it is no good for us." Then to Jess, she said, "You drink, eh? You want the raincoat?"

"No. Thank you, Emma."

She examined him critically, then nodded. "I go back to the car, then. My son José, he expects me to dinner, you remember this?"

"I'll be right there."

As she left, Jess followed her with his eyes. "I couldn't do it without her, Tres. When Pop got sick, then when Mother died."

"She's a good lady," I agreed. But I was wondering what it would've been like for the Makars not to have had Emma as the go-between, not to have had the convenient diplomat who spoke English haltingly after forty years in Texas but who understood perfectly the communication lines of their dysfunctional clan. She had held them together, however tenuously. And maybe I felt a little envious. Maybe I was thinking about all the times I could've used an Emma in my life, with my family.

"She finally got her green card," Jess murmured. "Last year. I gave her a party with her three kids and all those grandchildren. You know, the first thing in my life I remember is her smell. It used to be copal. She would tell me copal was for warding off evil. Then later, many years later, it was lavender. Lavender, to ward off sadness. She said that was much harder."

We stood there a while longer, reminiscing as if the memories were shared by drinking *atole*. "I'll try," I finally told him.

Jess nodded sleepily; then he laughed once – a weak, sour little sound. "Rachel said you would. She said to mention Herrera. She said you couldn't ever pass up a missing person, especially not a dangerous one."

Then he turned and walked toward the empty frame of the front door, leaving me staring at the dark hole where the dining table had been.

There is something offensive about a handsome medical examiner. By genetic predetermination, your basic coroner or M.E. should be albino-skinned, raw-cuticled, with blue veins and greasy pores and nervous little antisocial ticks. Anybody who deals with five to seven dead bodies a day, you would figure, has to look unappealing.

Raymond Salazar didn't fit the profile. His brown, wolfish face would've sold Tejano records by the thousands. His lab coat was open to reveal a well-pressed blue shirt, khakis, a silver belt buckle. He wore hand-tooled alligator boots. He was lean and well-muscled, his hair thick and black. He had the fixed expression of someone who had just told an inside joke for which you were on the outside.

"Tres," he said, offering me his hand. "Doggy treats this way."

"Pardon?"

His smile split open to show sharp white teeth. "Bones, *ese*. Come on."

We walked down the hallway, past a bored-looking SAPD guard, past a few empty gurneys, into a lime-green lab room where the remnants from the house on Crofton were being reconstructed.

"We got the whole thing, man," Salazar said. "The preservation was sweet."

He switched on an adjustable-arm lamp and brought it closer to the long white tabletop where the bones were laid out. They looked more like pieces of driftwood – twisted and discolored, brown and black. Only the skull had been carefully cleaned. It lay in five or six large fragments and numerous smaller ones.

"Trauma death?"

Salazar laughed. "You might could say."

He snapped on surgical gloves, dipped tweezers into a small drawer and brought out a plastic bag that contained an object about the size of a gumdrop, black and flecked with copper.

"Twenty-two slug?"

He nodded. "Lodged in the cranium. Have to wait for ballistics to be sure, but definitely small-caliber handgun, definitely close range. Ten feet

Hills Snyder, *Book of the Dead* (detail), 2005; acrylic sheet on birch support, cedar platform, 48 x 60 x 60 inches.

away, max. Plenty of entrance wound, lots of shards. One ragged hole. This little fella didn't have time for any kind of velocity – straight out of the barrel and straight into the forehead, then scramble, scramble, scramble." He waved the bullet in small circles to make his point. I thought about what Emma had said, about Rogelio Herrera's little silver gun.

"Would've been messy," I speculated.

"Not so bad. Killer rolled him up in cloth, powdered him up real good to keep down the smell – talcum mixed with some kind of yellow resin. That'll have to go to toxicology. Didn't bury him very deep. A rush job."

"Definitely a him?"

"Sure, Look at the pelvic bone. Six feet tall, I'd say, maybe one hundred eighty pounds."

"What else can you tell so far?"

Salazar plopped the bullet bag back in its drawer, snapped his tweezers a few times. "Guy had a badly broken left thigh bone at one time. Didn't heal well. That might help us ID him somewhere down the line. I'd guess he was about thirty-five at the time of death. The odontologist will tell us for sure. They're coming down tomorrow from Austin, the tooth man and the anthropologist."

"What are the odds of making an ID?"

"That depends. X-rays and dental work are like fingerprints, *ese* – won't do us much good unless we've got something to compare them to. We'd be better off if Old Man Makar got to feeling confessional, you know? You think he can drool in Morse code?"

"God, Ray. Respect."

"Yeah. Sure, man. What's your connection with this anyway? I heard some crazy rumor Makar's son is dating –"

"You're silent, Salazar. Absolutely silent."

He grinned. He picked up a femur from the table and held it perpendicular over his mouth like a giant, grotesque finger. "Shh."

When I left, he was fielding a phone call from somebody at the sheriff's office, saying something about uncollected bets on a murder victim they'd pulled out of a Jacuzzi.

Two more hot, rainy Fiesta days passed, two more nights of partial clearing – just enough for the crowds to reassemble downtown for more drinking and fighting, romance and Mexican food.

During the days, I made phone calls and met several times with my friends on the Westside, three Latino P.I.'s who do reciprocal favors for me. Our partnership is essential in a schizophrenic city where Anglos and Latinos hardly ever share information across racial lines.

During the nights, Annie kept me engaged in our full aerobic courtship. We whirled through dozens of Fiesta events downtown – had a great time square dancing with a fiftyish couple from Luling with large orange foam cowboy hats; drank until our stack of empty plastic NIOSA cups began to resemble the Leaning Tower of Pisa. After the town closed down we returned to my little apartment at 90 Queen Anne, where we stayed aerobic until three or four in the morning.

Finally on Thursday afternoon I received the information I wanted. Stiff and bleary-eyed, I made my way downtown during the afternoon traffic lull, parked by the Commerce Street bridge and headed into Chuco's Cantina.

I found Ed O'Brien at the far end of the long walnut bar, his boots hooked underneath his stool, his fingers wrapped delicately around a shot glass, holding it up like he was admiring the quality of light through the pale liquor. His belly appeared to be eating the edge of the bar. He had the largest, reddest Irish nose this side of County Cork.

"Tres Navarre," he grumbled, not looking away from his drink. "What fool son of a bitch sicced you on me this time?"

"Hey, Ed." I got onto the stool next to him, then nodded at the bartender. "Herradura Añejo. No bells or whistles."

The bartender poured me a shot of the world's finest tequila and did not insult its dignity by salting the rim or offering a lime wedge.

Ed watched as I drank it. "Expensive habit," he said. "You best find yourself another line of work."

"We've had that discussion, Ed. What can you tell me about Rogelio Herrera? He would've come across back around 1967, '68."

O'Brien made a noise like a gorilla with a hairball. "You're fooling. You want to know about a wetback from thirty years ago?"

The tequila burned pleasantly on its way down. I tapped the bar in front of Ed. "You want another?"

He shrugged. I called the bartender over, passed for me, directed a shot of Herradura into O'Brien's glass. "You're the best coyote there is, Ed. People come across the border with you, they remember it. They brag about it. The ones you pick, too, they don't tend to be your average field hand. They've got to have some special talents, something you can get a cut of once they're established in town. Some friends of mine have been asking around; they found some people who remembered this guy I'm looking for, Rogelio Herrera. Turns out they remembered he was one of yours."

Ed tipped the liquor into his mouth. Slowly he put the glass upside down on his napkin. "What makes you think I'd remember him?"

"You'd remember, Ed. From the stories I'm hearing, this one was violent, a troublemaker. He had a tendency to pick fights with the men, push himself on the ladies. But for some reason you still picked him up. You would've had a good reason. He was only in San Antonio about a year before it got too hot for him. Then he disappeared with the boss's silverware. That boss was Aaron Makar."

Ed glanced sideways at me, his eyes dark and still as well water. There could've been anything underneath – apathy, humor, intent to kill. "And you want to find him why, son?"

I told him about the skeleton under the Crofton House. "So?" he said.

"There are several possibilities. Aaron Makar might've killed someone, put him under his dining room floor, and it has nothing to do with Herrera. Or Herrera might've killed someone, hid the body, run like hell, and it's got nothing to do with Makar. Or maybe it's got something to do with both of them. I want to know why Makar hired Herrera. I don't buy that Herrera was there to weed the lawn."

Ed laughed. He looked at the bar mirror, the ceiling fan, then at me again. "You're something, Navarre. But this has got nothing to do with me."

"That property you wanted," I said. "The land in McAllen. You still interested in somebody running the deed, finding an irregularity to let you buy it out from under your cousins?"

His murky eyes suddenly gleamed. "You said you'd never work for me, son. Not in a million years, you said."

"I'm feeling generous."

Ed laughed again. "All right. Herrera was a silversmith. Makar was using him for some kind of hard-currency smuggling. I delivered Herrera across twice – paid with silver ingots both times. Last I heard, the deal was going sour somehow. So go figure. Maybe somebody found out and had to be put into long-term storage. But 'tween you and me, I can't see Herrera killing anybody. Not a man, anyway . . . he was hell on the ladies."

Ed pondered for a moment – this was a mildly unpleasant quandary to him. Then he gave up. "Property in McAllen," he mused. "I'll be in touch."

I slid off the stool and left two twenties under the shot glass. I felt only a little evil satisfaction knowing it would go on my expense bill to Jess Makar.

"One more thing," I said. "You ever know of Herrera or Makar doing business with a man with a pronounced limp in his left leg? Somebody about thirty-five years old, six feet tall, maybe one hundred eighty pounds?"

Ed examined my face carefully, a glint of suspicion in his eyes. "That a joke, son?"

"Not that I'm aware of. Why?"

Ed O'Brien grunted. "Because near as I can remember, with the limp and all, that's Rogelio Herrera you just described there."

It was the first time I'd ever gone to my mother's house with the intent to see Jess. He stood in the doorway and frowned, not sure how to read the look on my face. "We need to talk," I said.

He'd apparently just gotten home from work. He had his tie half undone and an open bottle of Lone Star in his hand. He stood aside to let me pass. "You got something?"

"This is Thursday, yes? Cleaning day?"

"What does that –" he started to ask, but I was already heading toward the master bedroom, toward the distant sound of the vacuum cleaner. Jess followed, his voice still trying to form a question.

The bedroom had been redecorated again, this time to fit Mother's African phase: moonfaced akua'ba dolls crowded the dresser along with colored beads and vials from Mother's aromatherapy kit. The bedspread on the old brass four-poster was quilted from adinkra mud cloth. She had even found a conga drum, which now served as Jess's nightstand, probably an encouragement for him to get in touch with his primal manhood.

Emma was crouched on her hands and knees, sticking the vacuum brush under the duvet. I had to call her name several times before she heard me. When she did, she started, looked back, switched off the Hoover and began the slow process of getting to her feet. "Señor Tres?" She looked behind me at Jess, then back at me. "¿*Qué es*?"

"What did he do to you, Emma?"

"¿*Mande*?"

"*En inglés*. What did Rogelio Herrera do to you?"

The old woman would've stepped farther back, farther away from me, had the bed not stopped her. The vacuum cleaner hose slipped out of her hand and slid across the edge of the mattress, clattering to the floor. She wore a dazed frown, as if a powerful, unexpected sedative had just started to kick in. Her eyes filled up.

"I have been lucky," she said. "The children born here. My oldest, Amia, is thirty-two now. She can clean instead of me, Señor Tres, take many of the other jobs. If I could have a day to leave, or perhaps two."

"What the hell are you talking about?" Jess demanded.

"Tell him, Emma."

When Emma spoke it was to my belt buckle, in a shaky but unstopping monotone, like a speech rehearsed to death. "The first time he came to me, in the kitchen, I was almost willing. When a man acts so powerful, smiling as he comes at you, no hesitation, like a husband, when there has been nothing before – it is a surprise, eh? I could not speak. I fought only a little. It was only afterward when I cried."

"Wait a minute." Jess held up one hand. "The gardener–"

"Herrera raped her," I said.

For a moment the heaviness of Emma's face seemed to melt just a little, as if hearing the words was a relief. It was possible to imagine her younger, to sculpt away the heavy wrinkles and fat from her face, the years of cleaning fluid and flour and butter and tile grime that had molded her puffy, veined hands.

Tears ran down the base of her nose. "The second time, Rogelio was drinking–something had gone wrong, a fight with a man over a woman. He had brought the woman home, to that apartment over the garage, but when she left, cursing him, he came to find me.

"He put the small gun on the table, and–and when I fought, he threatened my child. My Amia. He hit me, and the look in his eyes . . . I ran around him, and he came behind me."

"You took the gun," I finished. "And you turned and shot him."

She held her hand out, looking for something. Jess moved toward her and braced her arm. "Emma," he tried to say, but his voice cracked. He swallowed, tried again. "It's all right. It'll be fine."

"I had only killed chickens before, *mi muchacho*. My father in Monterrey, he used to show me how. He was a butcher. This–it took much less than a chicken."

Jess sat next to her on the bed, arm around her shoulders now. "It was self-defense," he insisted. "It didn't need to be hidden."

Emma sniffed, shook her head. "Your papa– he found me there, on the floor, shivering, and he was not angry at me, only at Rogelio. He said good riddance, and he told me what we would do. He was a good man–he did not want me sent away. They would have, eh? Even if they had believed my word. Your father said no. He protected me."

Jess's eyes burned with something more than just sadness–some relief, maybe even some pride.

It was my cue to mention the silver smuggling, the many reasons besides the protection of his maid that Aaron Makar would not have wanted the death of his illegally imported employee advertised to the police. Probably, given the personalities of the two men, Emma had simply saved her boss some effort he would've eventually had to make himself.

"Mr. Makar cared about you, Emma," I said instead. "It was a bad idea, hiding this, but he cared about you. That yellow resin on the body– that was copal, wasn't it? You wrapped the body up and scented it with the powder you used to ward off evil."

Emma nodded. "I could not wear that smell again, Señor Tres, not after it was mixed in with the blood of that man. But it worked for many years. For many years it kept away the spirit."

"It is still working," I told Emma. "The copal is still good."

Then I kissed her brow lightly, tasted salt there, and told Jess we had work to do. We had calls to make, explanations to give about the good intentions and the total liability of Aaron Makar in covering up this incident. We had a lawyer to hire for the woman whose newly issued green card we would not let *La Migra* revoke. And Jess had a father to visit.

WENDY BARKER

If a God

comes to you
a small
fish in the night,
simply
become water.

 *

If a dove drifts
under your sheets
let him stay,
tuck his head
in a soft place,
rest, until
you are feathers.

 *

He may come
as a lizard, a slip
of a green
slither across
your wall, crevices
left from past
freezes and thaws,
as he turns
translucent, persimmon,
ablaze.

 *

Or a monkey,
who leaps
your crenelations.
Weightless
motion of silver-
brown fur uncurling
tail, and keen
eyes focused
in, beyond.

 *

When a god comes
to you as a man,
you will have no need
for questions, blossoms,
or bracelets.
Even a name.

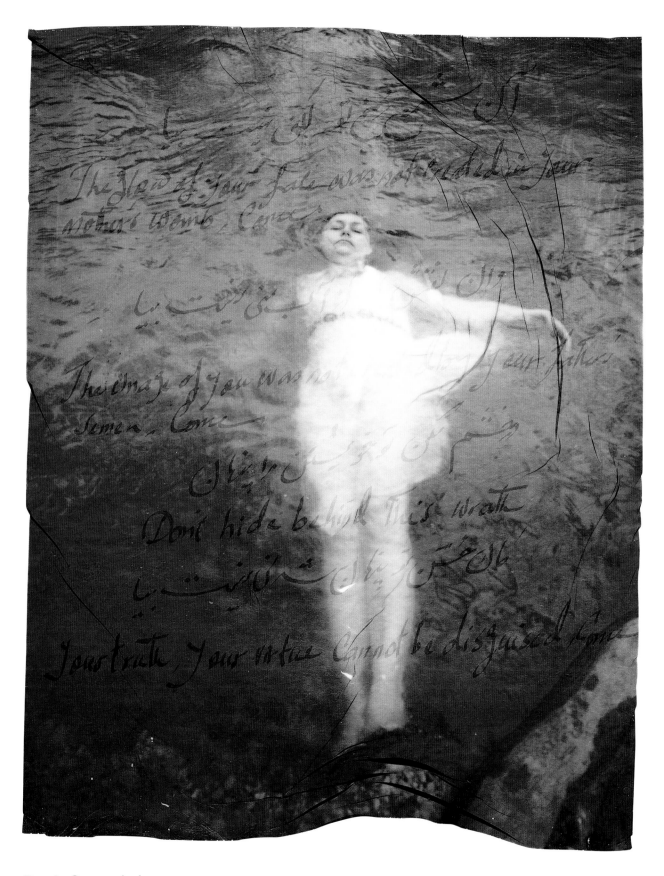

Ramin Samandari, *The Glow of Your Face*, 2007; photo, 32 x 40 inches.

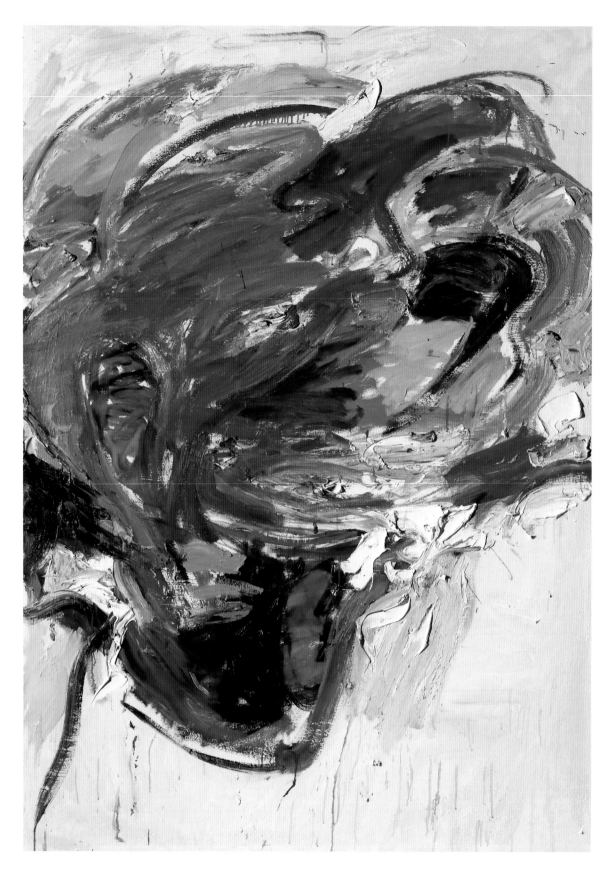

Lewis Tarver, *Blame It on My Youth*, 2006; oil on canvas, 84 x 60 inches. Collection of the University of Texas at San Antonio.

CLAUDE STANUSH

Some People Can

She had three husbands.

Then came unto Him the Sadducees, which say there is no Resurrection; and they asked Him, saying, Master, a certain woman had seven husbands, all of whom died, and last of all the woman died also. In the Resurrection, therefore, when they shall rise, whose wife shall she be?

Sam and Chester were both cads; Bertha didn't care if she ever saw them again. Solomon she had married more out of loneliness than love. But he was a kindly man and, in his own way, a wise one. He never asked her if she loved him.

And Jesus answering said unto them, Ye know not the Scriptures, neither the power of God. For when they shall rise from the dead they shall be as the angels.

Solomon was ill for almost a year before he died. Bertha nursed him like a mother. Often in the evening, when the weather was right, they would sit together in the backyard and listen to the rustling of the leaves in the tall sycamore. And they would laugh at the big, chesty mockingbird that lived in the tree and thought it belonged to him, screaming like a fishwife at the cat. Sometimes Solomon laughed so hard that tears shook from his eyes and streamed down his cheeks. Bertha wished Solomon would talk more than he did but that was the way he was and when he didn't feel like talking it was better, she had learned, to let him be. It was so peaceful, so soothing, sitting out in the yard in the cool of a summer evening that sooner or later Solomon's head would nod with the leaves and he would fall asleep, to awaken with a start and a smile at the mockingbird's loud, resounding, "Tcack, tcack, tcack, tchair, tchair, tchair."

For when they shall rise from the dead they shall be as the angels.

Once, when she was a little girl playing in the woods near her home, she saw a band of Indians riding down a trail toward her. In her fright she almost swooned. "But they can't be real Indians; they must be from some circus." Hiding behind a tree she watched, entranced, as they rode by. Led by a chief wearing a bright feathered headdress, they moved in single file so closely that the feet of their ponies seemed to belong to one body, like a giant centipede. Their faces were smeared with paint and they carried long lances which nodded with the prancing of their ponies. When they were gone, swallowed up by the brush, Bertha ran breathlessly home to tell her mother. "Circus? There's no circus in town. Child, what's the matter with you?" But she had seen them. She'd ask her teacher; Miss Clifford would know. "That's strange. There was a camp of Indians in those woods once; a long, long time ago."

"Do you believe in things you can't see?" she asked Solomon one evening. They were sitting in the yard looking at the sycamore.

"I don't know."

"Well, look at those leaves. Can you see what's making them sing and dance?"

He was silent for a moment. "Caterpillars," he said finally. "Fiddlefooted caterpillars. There's one kicking up his heels behind every leaf."

"I'm serious," she said.

"I'm serious too," he said, laughing.

Living joyfully with the husband whom thou lovest all the days of the life which He hath given thee under the sun; for that is thy portion in this life.

In August, in the fullness of summer, Solomon died. It wasn't a difficult end. He had had a restless night, then shortly before dawn he fell into a sleep, a deep sleep from which he never awakened. "God of mercy, God of grace, show the brightness of Thy face." Bertha was holding his hand and singing in a low voice as he breathed his last.

Outside, the air was clear. The sycamore stood as still as a tree in a painting, the mockingbird was silent.

Feeling Solomon's hand grow cold in hers, Bertha beckoned the doctor who sat across the room, patiently waiting. He had come about an hour before although he knew that he could do no good. Now he did no more than look at Solomon's blank, graying face.

Bertha's heart swelled up within her until she thought her ribs would snap. But she couldn't cry; the tears were too deep within her. She could only shake her head.

The doctor patted her gently on the shoulder and went into the next room where her sister Ida and Solomon's friend Albert were waiting. They, too, had come that morning at Bertha's call. Receiving the news silently, they waited for a few minutes before going into the bedroom.

The doctor stood behind them. "I'll be going now," he said, clearing his throat. "I'm very sorry about Solomon."

When the doctor had gone, Ida said to Bertha, "We're going to stay. We don't think you should be alone."

"I'm not alone," Bertha replied.

"I know," said Ida. "But Solomon's dead, Bertha. Do you want me to call the funeral home?"

Bertha didn't answer. The last time she had talked to Solomon was shortly before midnight, when he had asked her for a drink of water.

Jesus answereth, If any man walk in the day he stumbleth not, because he seeth the light of this world. But if a man walk in the night, he stumbleth, because there is no light in him. These things said He: and after that He saith unto them, Our friend Lazarus sleepeth; but I go, that I may awake him out of sleep.

Once more. Oh God, just once more!

"Bertha, I tell you Solomon's dead!"

For that which befalleth the sons of men befalleth beasts; even one thing befalleth them: as the one dieth, so dieth the other; yea, they have all one breath; so that a man hath no preeminence above a beast; for all is vanity.

"I tell you, Bertha, if the Lord ever breathes on Solomon again it will be on Resurrection Day; not now."

"You don't know what you're talking about."

"As much as you do."

"No, you don't."

"Bertha, we're all the same. You and me and Albert—and Solomon, too, when he was alive. But he's not one of us anymore."

Bertha stared out of the window. A slight breeze quickened. The sycamore leaves were quivering.

"Please leave for a while," she said. "Come back tonight."

"We'll be back shortly," Ida replied. "It's not good for you to be alone."

When they had gone, Bertha sat down again by Solomon. She looked into his face. He was resting so peacefully; why should she feel so sad?

Reaching over, she took one of his hands. It was dry and leaden but she clung to it.

There was a clock on top of the bureau. An old clock in a mahogany veneer case. Solomon had bought it at an auction. He liked it because without any noise it let you know that it was keeping time. The big minute hand moved with a sharp twitch. While Bertha waited, the big hand jogged slowly from four to ten. An airplane droned overhead.

Bertha leaned forward. "Solomon, honey," she said, "speak to me."

The hand on the old clock twitched. Several minutes passed.

This time in a more urgent tone, "Solomon, speak to me; please."

No response.

"Solomon," she demanded, "now you speak to me!"

Nothing.

Anger mingled with grief for a moment, before a smile came slowly to Bertha's face. "That's Solomon, all right," she said. "Best-hearted man in the world, but he won't be ordered about. He'll speak to me, I know he will, when he gets good and ready."

Standing up, she lifted Solomon's hand and laid it on his chest. Then she folded the other over it, the way he had often done himself when he was thinking about something.

She would wait for as long as he wanted her to.

Outside, in the stillness, a bird twittered. Bertha's heart leaped. Tchair, tchair, tchair. High notes. Tcack, tcack, tcack. Low and deep-throated, mournful-like. Tchair, tchair, tchair. High again, brilliant, exultant. Bertha's heart was lifted with the song.

"You hear him, Solomon? The mockingbird; your bird is singing. Singing for you. Tell me you hear him."

There was no answer.

Bertha was tired, exhausted, for she had been up most of the night and many nights before that. She slumped into a chair and in a few minutes, though she fought against it, her eyelids began to drop.

She was asleep, her legs sprawled outward, her hands folded like Solomon's.

The mockingbird stopped singing.

How long she slept she didn't know — when suddenly she heard a familiar voice cry out.

"Bertha. Bertha."

She was on her feet. Holding his hand again. "Yes, Solomon, what is it? I'm here. Here, right beside you."

Solomon's mouth was open. Wider than before. She was sure of it.

"You called me, Solomon! You called me! What is it you want to tell me? Are you happy? Are you sad? Tell me, so I'll know."

Her lips kept moving. She would speak the words for him if he wanted her to, if only she knew what he wanted to say. "Tell me, Solomon, tell me. But you've got to speak louder. Much louder."

The big hand on the mahogany clock danced forward but in the room there wasn't the slightest sound.

She waited. Waited. Waited for as long as she could stand it. And when she could stand it no longer she put her face into her hands and groaned. And now the tears were loosed. She wept. Wept until she could weep no more, until her body was drained of all tears and all feeling.

When Ida and Albert returned, she was sitting in the chair, her face pale and drawn though without the trace of a tear.

"Shall I call the funeral home now?" Ida asked.

Bertha didn't answer.

"I said, shall I call the funeral home?"

Bertha looked up.

"You can call them."

Her eyes lowered, and she looked down at her hands.

"Yes, you can call them. Solomon's ready to go."

OLGA SAMPLES DAVIS

Sister Girl

Sister Girl
Got it honestly . . .

 Mustard seed faith
 Wildcat spirit
 Wholesale humor
 Gift for gab.

 Had a laugh
 That brought you full circle
 Body soft and giving
 Like a newborn.

 She was
 Fighter quick
 Mother wit strong
 Woman/Child/Lady
 With a *No Trespassing* sign
 In full view.

Sister Girl got it . . .
Got it honestly
From her mother
Her mother's mother
And then some.

It was her heritage.

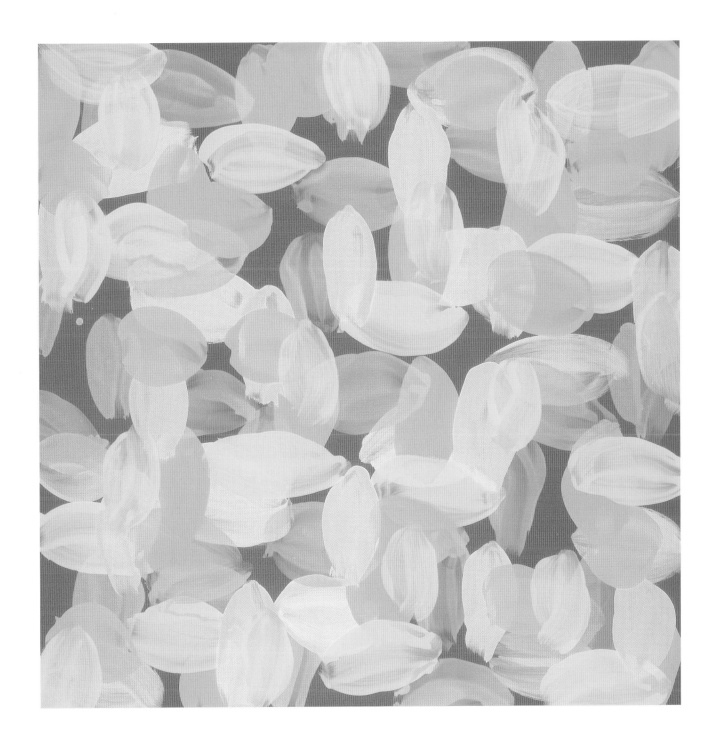

Nate Cassie, *Beulah*, 2005; enamel on panel, 30 x 30 inches.

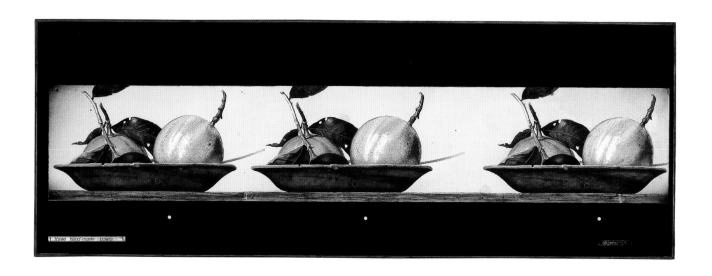

Gary Schafter, *Three Bowls*, 2006; oil on wood, 68 x 24 inches.

JACQUES BARZUN

The Search for Truths

As an historian, I am naturally, professionally, interested in truths–thousands of them–and this interest brings with it several kinds of puzzle. The first is the disentangling of the muddled reports of the past. Another is how to describe faithfully what bygone ages took to be absolute truths, now disbelieved or forgotten. A third is what test of truth to apply in each case. The last and most baffling is to frame a clear idea of what truth actually is.

In any definition of truth, reality is mentioned or implied. What is said to be true must relate to something experienced and must state that experience accurately. Moreover, the whole vast store of recorded truths is supposed to hang together, and every new one must jibe with the rest of them as well. These demands make up a tough assignment, and when one looks at any sizable portion of these claims to truth, one keeps finding a good many more to challenge than to adopt. An obvious sign of this is the amount of nonstop arguing and fighting in the world. Human beings, individually and in groups, are sure that they possess the truth about things here and hereafter, and when they see it doubted or attacked by their neighbors, they find such dissent intolerable and feel that it must be put down.

There is, of course, an obvious exception to this chaos of thought and action. If one measures by the yardstick, then this piece of string is 28½ inches long. One can measure carelessly and make an error, but as soon as it is pointed out, one agrees with the correct answer. Other measures – the meter, the calendar, the clock, the number series, or any other system that rests on common agreement and fixed standards – yield statements that are not denied by anyone in his senses who is familiar with the terms.

These conventions are endlessly useful, both in science and in practical life. But there is a host of equally immediate and important concerns for which no system and no terms have been agreed upon. It is about these interests that the battle of ideas and the bloodshed take place. This in turn tempts one to think that these contested truths are the most important of all. They have to do with religion, art, morals, education, government, and the very definition of man and his nature and his role in the universe.

A cultural historian's work brings him face to face with those passionately held ideas. At a certain time and place, millions of human beings felt sure that a divine revelation proved the existence of God, who dictated all men's beliefs and actions. The uniformity of that faith stamped it as unshakable truth. After more than a thousand years, some of the descendants of those millions began to question the revelation and all it meant. Since then, there have been many different "truths" about it, each clung to with the same fervor and confidence as before. A like diversity runs through the rest of the culture – in morals, government, and the arts.

The only sure thing is that mankind is eager for truth, lives by it, will not let it go, and turns desperate in the teeth of contradiction. That may be a noble spectacle, but it is tragic too – and depressing. If, as required, all truths must hang together consistently, it would seem that in religion, art, and the rest, truth has never reigned. Human beings begin to look like incurably misguided seekers for something that never was.

At this point, a small but remarkable group of people put on a superior grin and say: "You forget the method that clears up all doubts and delivers truth on a platter. We scientists are busy taking care of your troubles. Look at what we have done: We have gotten rid of all the follies and superstitions dreamed up about the real world in the first five thousand years of man's existence. Give us a

little more time and we will mop up all the other nonsense still in your heads and give you cast-iron truth."

This sounds delightful, but even in those disciplines where exactness and agreement appear at their highest, there is a startling mobility of views. Every day the truths of geology, cosmology, astrophysics, biology, and their sister sciences are upset. The earth is older than was thought; the dinosaurs are younger; the stars in huge galaxies have so much space they can't collide, yet they collide just the same; Mars, after being dry as dust, has liquid water; the human bones in Central Africa do not mean what they were said to mean; a new fossil shows the origin of birds to be different from the origin posited yesterday; as for the speed of light, it can be exceeded. If only the latest is true, then all earlier ideas were hardly better than superstitions.

The condition is still worse in the semi-sciences of psychology and medicine, and confusion grows as we get to the social sciences, ethics, and theology. There are "schools" in each – the telltale sign of uncertainty. The boasts of an earlier day about finding laws governing society and predicting its future have been muted for some time. In history and philosophy, some wise heads have admitted that these laws are not exact transcripts but simply documented visions, respectively, of the past and of Being as a whole. None excludes other accounts of the same particular subject.

A number of scientists have taken time to ponder these puzzles of their own making and have offered two suggestions. One is that science is not description but metaphor. It seems a poor term. A metaphor needs four parts: in "the ship plows the ocean," the ship is likened to a plow and the ocean to a field. The facts and the language of science add up to two parts, not four. Perhaps the meaning is that science is not literal but poetic, its phrasings inspired by observation and calculation. That must be why we now come across the word "charm" and others like it in theoretical physics, a tacit recognition of its suggestive, poetical character.

If so, it also means that reality is beyond our grasp, and truth along with it. Such is, in fact, the other suggested answer to the riddle, which is that there is no need for the idea of reality. From this negative it follows that we should stop being so solemnly intent on truth. Above all, we should stop fighting over tentative notions we believe in. Imagine instead that we are at a picnic, making up disposable fictions about what we see and feel. We then play with the jigsaw, but pieces are missing and others don't fit.

Where does that leave me as an historian who struggles to discover what happened in the past and to make of events and persons some intelligible patterns? First, I am not ready to throw reality into the trash can. I feel it ever present and call it by the more vivid term *experience*. It includes all my thoughts and feelings, the table-top and the electrons, light as waves and as particles, the current truths and the past superstitions. The common task, I conclude, is to place each of these within its sphere and on its level; they are incompatible only under a single-track system. One must, moreover, be ready to deal with new paradoxes and contradictions, because experience is neither fixed nor finished; it grows as we make it by our restless search for truth. Truth is a goal and a guide that cannot be dispensed with. The all-doubting skeptics only pretend to do without it.

But we must recognize that our work to attain truth succeeds only piecemeal. Where our hope of truth breaks down is at the stage of making great inferences from well-tested lesser truths.

Still, we cannot help inferring. Our love of order impels us to make theories, systems, sets of principles. We need them both for comfort and for action. A society, however pluralist, needs some beliefs in common and will not trust them unless they are labeled truths. It is there that our efforts betray us. Sooner or later, experience jabs us with an event, a feeling, or a perception that shatters the truth-value of the great inferred idea. It is like actually going to the moon or prospecting the planets with a sensor and finding that the entirely logical and satisfying inference is dead wrong. As the historian knows, the breakup of old truths is painful, often bloody, but it does not condemn the search for truth and its recurrent bafflement, which are part of man's fate. It should only strengthen tolerance and make us lessen our pretensions. Just as in the past man was defined as the rational animal and later comers said, "No – only capable of reason," so man should not be called seeker and finder of truth but fallible maker and reviser of truths.

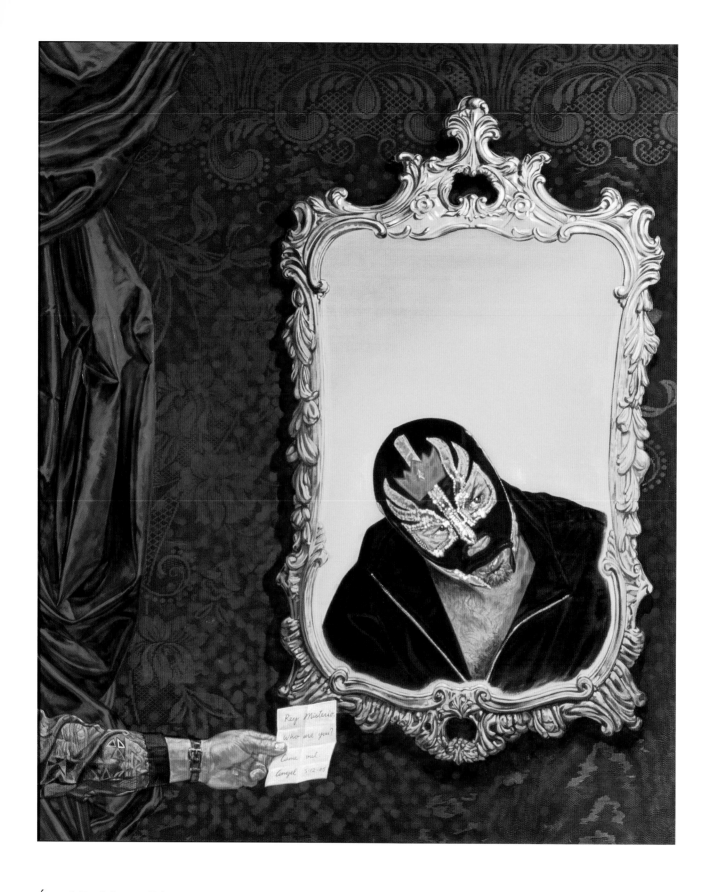

Ángel Rodríguez-Díaz, *Rey misterio . . . Who are you? . . . Come out*, 2005; acrylic and oil on canvas, 64 x 55 inches.

DAVID LISS

From *The Coffee Trader*

My name is Alonzo Rodrigo Tomas de la Alferonda, and I brought the drink called coffee to the Europeans—gave birth to its usage there, one might say. Well, perhaps I phrase that too strongly, for coffee surely would have made its murky way without my efforts. Let us say instead that I was the man-midwife who eased its passage from obscurity into glory. No, you will say, that was not me either, it was Miguel Lienzo who did that. What role, then, could Alonzo Alferonda have played in the triumph of this great fruit? More than is generally believed, I assure you. And for those who say I made nothing but mischief, that I thwarted and hindered and harmed rather than advanced, I can only say I know more than my detractors. I was there—and you, in all likelihood, were not.

My true name is Avraham, as was my father's name and his father's. All firstborn Alferonda men have secretly called their firstborn sons Avraham for as long as Jews have had secret names, and before that, when the Moors ruled Iberia, they called themselves Avraham openly. For much of my life, I was not permitted to speak my name aloud except in dark rooms, and then only in whispers. Those who would question my actions should remember that. Who would you be today, I ask you who judge me harshly, if your own name was a secret whose revelation could cost your life and the lives of your friends and family?

I was born in the Portuguese city of Lisbon to a family of Jews who were not allowed to pray as Jews. We were called New Christians, or Conversos, for our ancestors had been made to take the Catholic faith or surrender their property—and often their lives. Lest we face torture and ruin and perhaps even death, we prayed publicly as Catholics, but in shadows and

in cellars, in secret synagogues that moved from house to house, we prayed as Jews. Prayer books were rare and precious to us. In the light of day a man might measure his wealth in gold, but in the dark of those dark rooms, we measured wealth in pages and in knowledge. Few among our number could read the Hebrew of what few books we had. Few knew the right prayers for the holy days or for Shabbat.

My father knew, or at least he knew some. Having spent the first part of his childhood in the East, he had grown up among Jews unrestrained by the law from practicing their religion. He had prayer books that he lent out freely. He owned a few volumes of the Babylonian Talmud, but he knew no Aramaic and could make little sense of its pages. The Secret Jews in Lisbon came to him for instruction in the rudiments of reading the holy tongue, of the prayers for Shabbat, of fasting on fast days and feasting on feast days. He taught them to eat out-of-doors during Succoth, and of course he taught them to drink themselves to a merry stupor on Purim.

Let me be direct: my father was no holy man or sage or saint. Far from it. I admit this freely and think it no insult to his name. My father was a trickster and a cheat; in his hands, trickery and cheating were beautiful and marvelous things.

Because he was schooled in the ways of our faith—no scholar, mind you, but simply a man with an education—my father was tolerated among the Secret Jews of Lisbon in ways he might not have been otherwise, for he brought far more attention upon himself than was wise for any New Christian. Wherever merchants with a few spare coins might find themselves, my father would be there with his potions to lengthen life, improve virility, or cure any malady. He knew tricks with cards and balls and dice. He could juggle and

rope-dance and tumble. He knew how to train dogs to add and subtract simple numbers and how to train cats to dance on their hind legs.

A natural leader of men, my father attracted to him others who made their living through countless deceptive and curious entertainments. He commanded an army of cardsharps and dice cheats, fire-eaters and blade swallowers. Those who could earn a living simply by displaying the shapes with which nature had burdened them also rallied to my father's banner. Among my earliest childhood companions were dwarfs and giants, the monstrously fat and the horrifically gaunt. I played games with the snake boy and the goat girl. As I grew older I developed an unhealthy curiosity about a person my father knew who had the anatomy of both a man and a woman. For a few coins, this unfortunate would allow anyone to watch it fornicate with itself.

When I was but ten years of age my father received a late-night visit from an older boy, Miguel Lienzo, whom I recognized from synagogue worship. He was a roguish fellow, as much drawn to my father's company of tricksters and oddities as he was to my father's learning. I say he was roguish, for he loved always to defy one authority or another, and in the time I knew him in Lisbon those authorities he loved defying most were his own family and the Inquisition itself.

This Lienzo came from a line of relatively sincere New Christians. There was no shortage of these: men who, out of either genuine belief or merely a desire to avoid persecution, conformed entirely to the Christian way and shunned those of us who sought to live as Jews. Lienzo's father was a successful trader and had, in his opinion, too much to risk the ire of the Inquisition. Perhaps for this reason alone, Miguel came eagerly to our secret prayer meetings and struggled to learn what my father could teach him.

More than that, young Miguel used his father's connections with the Old Christian community to learn what he could of the Inquisition. He had a keen ear for rumor, and he delighted in providing warnings where he could. I knew of a half dozen families who had fled the night before the Inquisitors pounded on their doors—all because Lienzo had known where to lurk and listen. I believe he did these great deeds both from a desire to see justice done in the world and for the pleasure of treading where he had no business. Years later, when I saw him again in Amsterdam, he never recognized me or even remembered what he had done for my family. I have never forgotten his kindness, though some have insisted otherwise.

Miguel came to warn us after he had volunteered to help our priest scrub his private chambers in the church (he always volunteered for these thankless tasks in the hopes of gaining some intelligence) and had then chanced to hear a conversation between that wretch and an Inquisitor who had developed an interest in my father.

And so, in the dark of night, we left the only home I had known, taking many of our friends with us. We were Jew and Christian and Moor and Gypsy all, and we traveled to more cities than I can now enumerate. For years we lived in the East, and I was fortunate to spend many months in the holy city of Jerusalem. It is but a shadow of its former glory, but there were times in my unfortunate life when the memory of those days, of walking the streets of my nation's ancient capital, visiting the place where the holy Temple once stood, have sustained me when I could find meaning in nothing else. If it be the will of the Holy One, blessed be He, I shall return sometime to that sacred place and live out my remaining days there.

In our travels we also traversed Europe, and we were in London when my father died of a brain

fever. I was then five-and-twenty, grown to a man but not a man of my father's disposition. My younger brother, Mateo, wanted to take command of the army of outcasts, and I knew he had the character to lead them. Though I had wandered for years, I was not myself a wanderer. I could perform card cheats and dice tricks, but not half so well as Mateo. I could get a dog to do nothing but show me its belly and a cat to do nothing but knead upon my lap. My father had always spoken of the importance of Jews to live as Jews and among Jews, and I recalled from a visit to Amsterdam some years earlier that in that city Jews enjoyed a degree of freedom unrivaled in the rest of Christendom.

So I crossed the North Sea and found myself embraced by the large community of Portuguese Jews who lived there. I was, at any rate, embraced at first. And that is why I write this memoir. I wish to make clear why I was unjustly exiled from a people I loved. I wish to tell the world that I am not the villain it thinks me. And I wish to set on paper the true facts regarding Miguel Lienzo and his dealings in the coffee trade, having been much blamed in that sphere, and blamed very unfairly too. It is my intention to describe my doings in Amsterdam, the conditions of my excommunication, my life in that city afterward, and precisely what role I played in Lienzo's affairs.

It is true that before I knew how to walk I could hide a card in my clothes and make the dice roll the way I wished, but I vow to practice no trickery in these pages. I will be like the Bear Man, a petulant fellow with whom I traveled for years. I will disrobe to show you nature's truth. If you like, reader, you may even pull on the fur to see that it is no deception.

BONNIE LYONS

Bon Voyage

This morning the aquamarine clouds
look like they've been dipped
in the Aegean. Soon that sea
will take you in its arms.
You'll look through air so clear
the world will seem perfectly
in focus. Rosemary breezes
will stroke you, roses and bougainvillea
foam off thick white walls.
Gnarled olive trees will teach you
how to age, and the sea will tell you
how not to.

Anne Wallace, *Dream*, still from video, 2001; video projection, sound, found objects, drawings.

Cakky Brawley, *St. Anthony/San Antonio*, 2003; welded aluminum, 15 x 12 x 7 feet.

JOSEPHINA NIGGLI

From The Avenue of Illustrious Men

Chela moved in her own world. The Professor and Manolo had taken on new aspects to her. Manolo, through his sickness and dependence upon her, had ceased to be the laughing arrogant Joaquín, and was now a child whom she loved very much, but who had to be definitely handled with a strong will. The Professor, once her child, was changed into a strange, mysterious figure, silhouetted against green jungle growth, whose short stature and quick gestures were masks of the shining cacique splendor within. And still she could not decide. The mother quality in her cried for Manolo, but the romantic ego demanded the Professor.

Chela blamed herself for her vacillating. "I must make up my mind," she kept repeating over and over. "I wish I'd never seen either of them. Dear Santa Ana, blessed patron of marriage, help me. When I am with one, I want to be with the other. When Manolo touches me, it is the Professor's hand I want to feel. When the Professor smiles at me as he passes on the street, it is Manolo's face I want to see. Please, Santa Ana, advise me, aid me."

Manolo steadily grew stronger. He handled the crutches with dexterity, and would swing himself back and forth between the patio and the bedroom with a contempt for his broken leg that kept Doña Mariliria fussing at him all day long.

The little Doctor came in to see him, and finding the bedroom empty, passed through the hall to the patio. He paused for a moment, shocked. What was Alejandro doing, wearing a dressing gown and playing cards with Chela? Then the illusion passed, and he recognized Manolo. He rubbed his eyes fretfully. Alejandro's serious illness was too much on his mind, these days. It was making him see visions.

As he moved toward the patio, Manolo bent across the narrow board and kissed Chela's hand.

Hmm, thought the little Doctor, these actors! He pursed his lips to give his words importance. "Chela, go to Porfirio's house and fetch me a wooden mallet and a chisel."

"A mallet and . . ." she caught her breath, talking fast to overcome her fear that the doctor had seen Manolo's impudence. "You are going to take off the cast!"

"But naturally. This young rooster is almost well."

Chela rushed to the hall door, where she pivoted on one toe. "We must celebrate today, Manolo. Ay, this is a grand occasion."

When she was gone, the little Doctor looked down at the actor's still face. "What is wrong? For you there is no joy."

Manolo shrugged, a defensive, mocking laughter near the surface of his eyes. "This has been an amusing time. I do not like it to end."

"Actors," said the little Doctor gravely, seating himself in Chela's vacant chair, "do not make good husbands for village girls."

Manolo's mouth twitched. "Is it written in my face then?"

"So." The little Doctor clicked his tongue. "And the village has always thought Chela would never marry."

"She has charm – kindliness – understanding. Why shouldn't she marry?"

The little Doctor lighted a cigarette and gazed over the patio walls at the eastern mountains. "You are an actor," he pointed out again. "In the States, actors, I understand, have a certain social position. But here . . ." he shrugged. "Outside of the Capital, what is an actor in Mexico?"

"I have talent," said Manolo coldly. "I could act in the Capital if I liked."

"You are how old? Thirty-five, thirty-six? If you have so much talent, why aren't you in the Capital now?"

Manolo's long hand clenched in anger. "What affair is this of yours?"

"I like Chela," said the doctor, looking at Manolo's hand. "Her father is my friend. I am naturally . . ." he broke off abruptly, reached out and caught Manolo's wrist. "Let me see your hand."

Manolo tried to twist it out of his grasp, but the little Doctor was surprisingly strong. He stared intently at the narrow hand, with the little finger that was as long as the ring finger. "A gypsy in Sonora once told me that good actors always have a long little finger. It's strange. I've never seen a hand like that except in Bob Webster and the family Castillo. The Castillos are the great family of this valley." He sighed deeply. "The son Alejandro has need of acting, poor boy." He released Manolo's wrist and relaxed in his chair. "If the hand means anything, perhaps you can act. But Chela is not for Mexico City. She belongs in Hidalgo."

Manolo was frowning. "Poor Alejandro Castillo. What do you mean by that?"

"Alejandro is not important to this conversation," said the little Doctor with precision. "Men do not look easily at Chela. And these village girls are gentle creatures. The family here has been kind to you. In a few days you will be strong enough to travel."

"You want me to go away—and alone."

"Precisely."

Manolo politely hid a small yawn. "Let us talk of Alejandro Castillo. I find the subject more interesting."

For a brief moment anger flared in the little Doctor's eyes. His voice was very low as he said, "I warn you . . ."

Chela came running through the hallways. "Porfirio had such a time finding the mallet." She giggled softly. "I think he wanted to charge me rent for the tools, but he had no nerve to ask me.

That man and his love of money!" She paused and looked at the stern hard faces. "What is wrong? What has happened?"

"The little Doctor was warning me of something," said Manolo casually. "Just what were you trying to say, Doctor?"

The little Doctor sniffed angrily, but did not answer. Instead, he took the mallet and chisel and began to carefully chip away the plaster cast from the leg. When he had gone, Chela sat down by Manolo.

"What were the two of you saying?"

"He wants me to leave the valley."

"But why?"

"It seems that I might break your heart."

"He did see you kiss my hand. I knew it!"

Manolo was not paying her much attention. "Chela, tell me something—what is wrong with Alejandro?"

"Alejandro?" She looked at him in bewilderment. "I don't . . ."

"Alejandro. My brother, Alejandro. What is wrong with him?"

"Why, nothing, Manolo. What should be wrong with him?"

"I don't know." He pounded his clenched fists together. "That little man said, 'Poor Alejandro has need of acting.' What did he mean by it?"

"Oh, that." Chela flushed slightly and started pleating her skirt in embarrassment. "It is nothing, Manolo—really. I am surprised that he knows. I thought no one knew."

He leaned forward and forced her to look at him. "What has that old man, my father, done to Alejandro?"

"Nothing, Manolo. Don't excite yourself."

"Will you tell me, for the love of God?" His eyes shone with anger, and his tone was sharp and strange. She had never believed his easy indolence capable of such rage, and it startled her. She drew back from him as he said harshly,

"When my mother died, Alejandro was all I had for remembrance. If that old man has hurt him, I'll . . ." He was silent, but his fingers twisted rapidly against each other.

"I told you. It is nothing to do with your father. I am not even sure that I know, but . . ." Chela hesitated, and then she told him of seeing Alejandro's expression when María de las Garzas passed.

Manolo bit down on his lower lip. "Alejandro, mixed up in an affair with a common river girl . . ."

"No," said Chela swiftly, "it's not that at all. You have never seen María. She is . . ." Chela paused, wondering how to convey the truth. "I can't explain it. The river girl is—but how can any woman describe her? She is beyond any description beautiful . . . warm as sunlight . . . all golden sunlight and dark blue sky. As for Evita—you have seen Evita. You know what she is like."

After a pause Manolo said wearily, "Why did Alejandro marry her? Why didn't he pack this river beauty off to Tehuantepec or Yucatán where he is a stranger?"

"The village thinks his marriage to Evita is an affair of the heart. And your father was so pleased."

"But of course—Alejandro worships our father. If it pleased that old man . . ." Manolo shook his head. "Still, I have a feeling that this scandal was not in the little Doctor's mind. It was something else he meant. But what?"

"I don't know." She was silent, and the clear children's voices sang sweetly about them. Manolo hit the arm of his chair with his fist. "Damn those children! That Professor is making them scream on purpose to annoy me."

"Manolo! You know that's not true."

"These little men—they are quiet and clever. It is the big ones who are stupid. Blundering and stupid. Is Alejandro a big man?"

"Yes," admitted Chela reluctantly. She did not like to see Manolo so excited. It frightened her— her Indian blood which responded automatically to the dreaded anger of the Spanish overlord. "He is as tall as you, I think. He's the tallest man in the valley. Evita can stand under his arm."

"And this river girl? She is short?"

"No. I have to look up at her when I speak to her."

"Then it is Evita who is the dangerous one. In the Revolution I have seen it. The tall generals won the glory and the short generals won the battles." He began to tremble, and Chela, definitely worried, put him to bed. She wanted to send for the doctor, but Manolo fell so quickly into exhausted sleep that she hated to disturb him.

As she went about her household chores, she puzzled over Manolo. Her fine instinct had deserted her. There was something in him that she could not understand, and this frightened her. She had a feeling that whatever it was—this unknown thing—affected not only Manolo but herself, and in some strange way, the Professor. The little man of letters had not been back to the house since the night he gave her the handkerchief. He no longer walked past her window, but cut across the plaza on his way home. When she swept the sidewalk in the morning, she would see him going into the school. They always bowed to each other, but formally, as people do who often see each other but have never been introduced. He was so much in her mind, but she saw him far less than she had when he first came to the valley. Chela sighed and rubbed her hand across her eyes. If Manolo had never come back to Hidalgo, would she have learned that the Professor loved her? And he did love her, she knew that, but in a silent, hurt way, far different from Manolo's possessive attitude. Manolo took it so much for granted that she would go with him when he left. At intervals she believed it herself, but when she

Paula Owen, *Astral Chant*, 2006; acrylic on canvas, 12 x 24 inches.

tried to visualize that time, there was a blankness in her imagination. She had read a story once about a man who found a great book in which was written the future of the world, but when he turned to his own name he found only an empty page. That was the way she felt about her own future. And with a childish passion she wished that she were an old woman looking back on her life with all the problems solved.

In the late afternoon Chela slipped through the patio gate into the Street of the Three Crosses. She hesitated for a moment and then hurried up the Street of the Governors to the Church of Our Lady of the Miraculous Tear. In there she would be quiet and safe. No one would bother her. Manolo would be leaving soon, and she had to decide if she would go with him or stay with the Professor. This useless wavering in her mind had to stop. Better never to marry at all than to go with the one and turn into a second Evita from grieving for the other . . .

María of the River Road was also in the church. They looked at each other without speech. Chela thought, she is so beautiful and I so homely. How strange that we should be sisters in our love for Castillo men. Her hand came out and María grasped it; then María went away, and Chela knelt on an old, scarred *prie-dieu*, its red velvet cushion frayed and worn from the pressure of many knees, and rested her forehead against her clasped hands supported by the high back of the prayer stand. Would all these complexities finally unravel themselves? She was so tired – so tired. She fell asleep.

When she awoke, it was dark. Her body was stiff, and her knees ached with a slow steady pain. For a moment she could not locate herself in space and time. Then she realized where she was, and memory flooded through her. She pulled herself upright and staggered a little as the circulation began to move faster in her legs.

At last she was able to walk a little better, and she went into the street. Several people hurried past her toward the Street of the River. "Eh, Chela," called Sarita Calderón through the darkness, "is it not a terrible thing?"

"What has happened?" Chela caught up with the slow-moving Doña Fela.

"Do you not know, child? Poor Evita. I weep for her." Doña Fela carefully wiped her eyes with a lace-edged handkerchief. Before Chela could say anything, the old woman placidly continued with her news.

Chela drew in a deep, sobbing breath. Her first thought was not of Evita but of Manolo. Pulling her shawl closer about her head, she ran toward her own house. Doña Mariliria, a bowl of hot broth in her hands, was just coming out.

"Don Saturnino wants your father and Bob Webster to take care of all the details. That good old man up there alone in that big house – it isn't right. I wanted Nacho to stay with him, but no! Men never do things in a sensible manner." She clutched the bowl of broth tighter between her thin, transparent fingers.

"There is probably no food in Evita's house. People never think of the thing they need most when tragedy strikes. You will have to stay with the actor." This flood of words rushed along on one thin thread of breath. Chela said nothing as her mother scuttled away in the darkness. She shut the heavy, hand-carved street doors and went into Manolo's bedroom. He was sitting in a chair near the lamp, reading a book. As she entered, he looked up and smiled at her.

"There seems to be excitement in the streets. I can hear the people hurrying past. Has another actors' troupe decided to brave the dangers of Porfirio's empty bottles?"

"Manolo." Chela paused for a moment, then walked toward him and put her hand on his arm.

It was the first time that she had ever touched him of her own free will. He bent his head and kissed her fingers.

"You look so serious. As though the world had died. Is there gossip about us, perhaps? All villages enjoy gossip. In a few days you need worry no more about it. We will be gone from . . ."

"Manolo," she repeated, interrupting him. At the pain in her voice his light chatter stopped.

"What is it, Chela? What has happened?"

"I don't know how to tell you."

He glanced toward the window. "All those people hurrying past." His voice tightened. "There's been an accident."

"Yes." Chela in an unconscious gesture, lifted the shawl from her hair and allowed it to fall in deep folds over her shoulders.

"My father. Something has happened to . . ."

"No, Manolo. Not your father."

Manolo seemed to contract within himself. The book slid unheeded from his knees to the floor. His lips formed the name but there was no sound. She said quickly, "It seems Alejandro had a sickness. No one knew about it but the little Doctor – not even your father."

"What kind of a sickness?"

"A trouble of the throat. He had a hemorrhage this evening."

"Was there much pain?"

"I don't think so. Not at the end."

"So that's what the little Doctor meant. 'Poor Alejandro has need of acting.'" Manolo shut his mouth tightly to still the trembling of his lips. A small pulse beat low in his cheek. "You said he was big and strong. You told me that." It was an accusation.

"I thought he was, Manolo. Everyone thought so. This has been a terrible shock to the village."

"Yes. I feel so sorry for the village." The bitterness in him made an unreasonable anger flare in Chela for a moment. How dare he criticize Hidalgo? Then, with a twisted humor, she realized that Manolo was no outlander but a villager like herself. Surely he had as much right to criticize as she did.

Manolo was saying, "The last time I saw him he was thirteen. He waved good-bye to me from the train that was carrying him to the States to school. And now he is a man – and dead. A man I've never seen." His voice broke. Chela bent over him, but he pushed her away. She moved to the window and closed the long, heavy shutters.

He said, "I want to go to my father."

"But, Manolo, you can't! I'll go and fetch him. He'll come here."

"No. I'll go to him."

"But your leg . . ."

"During the Revolution I crawled five miles through cactus and flowering thorn with a bullet in my thigh. I am the last Castillo now. It is necessary that I go to that old man's hou –" He paused and pulled himself erect, reaching for his crutches. "It is time that I go home."

She knew better than to argue with this determination. "Wait, Manolo. My father has a horse. He keeps it stabled at the blacksmith's. I'll go and get it." She left quickly so that he could not argue with her.

It was very difficult getting him up on the horse. He wanted her to ride with him but she said no. "It is too dark. It is better that I guide the way." She slid her hand through the bridle and turned the horse up the Avenue of Illustrious Men. There were neither stars nor moon. In the excitement of the evening, Don Serapio had forgotten to light the oil lanterns on the Plaza of Independence. The darkness wrapped about them like a cloak, and the silent streets echoed the slow beat of the horse's hoofs.

Chela found the way from memory. She could see nothing. She felt suspended in space, with only an awareness of Manolo's nearness. He

seemed far away from her now – as though he had left her and gone into another world. For the last hour he had not thought of her at all except as a convenience to help him teach his father. She remembered her brief anger at his criticism of the village. And suddenly she knew why she had been angry. She knew, too, what was the strangeness in him that had been alien to her. And in the knowledge all of her problems were settled. She felt a release and a settled security. How wonderful it was to be sure – to know the answer to her difficulty. She remembered her childish wish to be an old woman looking back over life, and she smiled in the darkness. She thought: I am a woman now. This morning I was a girl, but tonight I am grown and a woman. And she remembered with gentleness that other moment when she had ceased to be a child and had become a girl – that moment when Don Nacho had told her that Joaquín Castillo had ridden away on his fine black horse to join the Revolution. Chela's hand slipped from the bridle to the velvety nose of the horse she was leading. She asked aloud, "What became of Rocinante?"

Manolo's voice floated toward her like sound from an invisible source. "She died. They always die – the brave and beautiful."

"Yes," said Chela, and did not think it strange that he should quote this most Spanish of proverbs, which sounded stupid to her New World ears. They reached Don Saturnino's house.

Manolo slid from the horse's back with a low grunt of pain and groped for her shoulder. She did not bother to tether the horse. He would find his way back to the corral, and Manolo had no more need of him this night. She unfastened the crutches from the back of the saddle and slid them under the man's arms. The great iron gates were difficult to manage, and she tore her fingers on the lock. At last they swung open. The two of them stumbled along the avenue walled by lime

and orange trees. Chela was afraid that she might guide Manolo into one of the tree trunks, but after a moment she found that he was guiding her, and the knowledge shocked her a little. This ground, so strange to her, was familiar to him with the familiarity that comes from childhood and never leaves the memory. In spite of Don Nacho's great friendship for Don Saturnino, she had never been on the estate.

When they reached the door she instinctively put out her hand to knock, but Manolo had already swung it open. He moved a little ahead of her into the red-tiled hall with the brass lamp flickering palely on the lid of a heavy carved chest. The ceiling was low, white between the great beams of dark wood that crisscrossed its surface. Carved doors led off this hall into other rooms. Chela felt lost, like a small animal trapped in a strange cavern.

Manolo was swinging his long body forward, moving the crutches with certainty toward a door at the back, where light gleamed through the cracks. He opened this door and went into a large room with a great fireplace at one end in which logs of mesquite wood were burning. Chela stared around her with wonder. She had never seen such a room. The ceiling-high windows were covered with heavy drapes of cream brocade that fell in soft pools on the floor, tiled, like the hall, in red. On the white plaster walls were paintings of many men and one woman in strange stiff clothes, but all had the long-fingered Castillo hands. The black wood of the furniture gleamed in the firelight, and the heavy chairs were piled with cushions, as though the velvet and silk were meant to soften the ascetic Spanish carving.

Don Saturnino was sunk in a corner of the long divan, his fine head with its crest of white hair drooped forward against his chest. Manolo, who now, in some mysterious transmutation, was no longer Manolo but Joaquín, sat down beside

him and laid his head on the old man's shoulder. There was no start of surprise – no crying out in exclamation and wonder. One Castillo had gone away. Another had come home.

Chela shut the door and went out of the house into the fragrant darkness – the fragrance that comes not from flowers but from the soil, and the labor of green things growing into spring. On impulse she bent and pushed her hand into the earth. She knew now that this house with its low ceilings and heavy furniture was not for her. In her world people laughed and cried as easily as the sun shone or rain fell. In this ordered Castillo pattern, the blood was thin with restraint. That was the true difference between the great families and other people. It was not a matter of having ancestors with more wealth and power. It was a blending of the blood, so that the family itself was more important than any individual. Joaquín, the rebel, was the strongest Castillo of them all. He had even changed his name so that nothing he did could reflect back upon the family. And he had returned to Hidalgo because the roots of the family were here. She had been angry at his criticism of the village because the family Castillo – first settlers of this valley – were far greater outlanders than the little Doctor, or Abel, the *árabe*, or – she whispered the name gently in her mind – the Professor. The family Castillo owned the land, but they did not belong to it.

The valley possessed the villagers. The mountains punished them with storms but protected them from the world beyond. The earth demanded their bones for fertilizer but gave back food. And the villagers felt this ownership, and it gave them a sense of security so that they did not have to be afraid of what they thought and felt. But the Castillos saw the mountains as barriers, the earth

as a servant. They looked to themselves for their own protection, and so they had to build their own defenses.

Chela moved easily through the darkness, thinking of these things. She even had a moment to feel sorry for Evita. No wonder the girl had been unhappily married to Alejandro. It was true that the Cantús were an old family – they had come to the Sabinas in the first days of the 1810 Revolution – but the Cantús had never been afraid to mix their blood with the villagers. They lacked the superiority of the pure strain. Evita, who could ride into anger or laughter as easily as any valley girl, could not understand the remote Alejandro. As for Joaquín, the wild one, he, too, had set up his barriers. Let him call himself Manolo de Fuentes or Fulano de Tal, he could never change the truth of his Castilloism.

As Chela reached the Casino corner, she saw a man standing on an upturned box, busy fastening a flickering oil lantern to its pole. She paused to watch him. What a natural thing that it should be the Professor who remembered to light the lanterns on a night of such excitement. She crossed the street. He heard her light footsteps and turned his head. She saw the amber light flicker across his face, darkening the eye sockets and emphasizing the high cheekbones. He saw the exotic mask of her face in the shadows. For a moment, to each other, there were no bodies, only the suspension of faces against the dark cloak of night. Chela timidly extended her hand toward him and the immovable instant was past. He jumped down from the box and came toward her. His palm touched hers. The fingers turned and clasped each other. The lantern swung dangerously in the wind but neither noticed it.

Linda Pace, *Red Crab, in Back Seat*, 2006; colored pencil on parchment paper, 8.5 x 11 inches.

JOHN IGO

Mitote of the Wasp Nest

If the place of birth
be a dead place

If the gathered years
be dust to the tongue

If the ancient wind
be a dry whisper

If the gray bell
be a soundless call

If the old home
be mud of ashes

If the lines of earth
be writing

Earth keeps its secret
 Let nothing be abandoned
The lines keep their secret
 Let nothing be lost

Eyes are too brief
to read long signs
 All things go to earth
 Let the earth be the meaning

Constance Lowe, Untitled, 2005; hand-sewn wool felt, 39 x 54 x 6 inches.

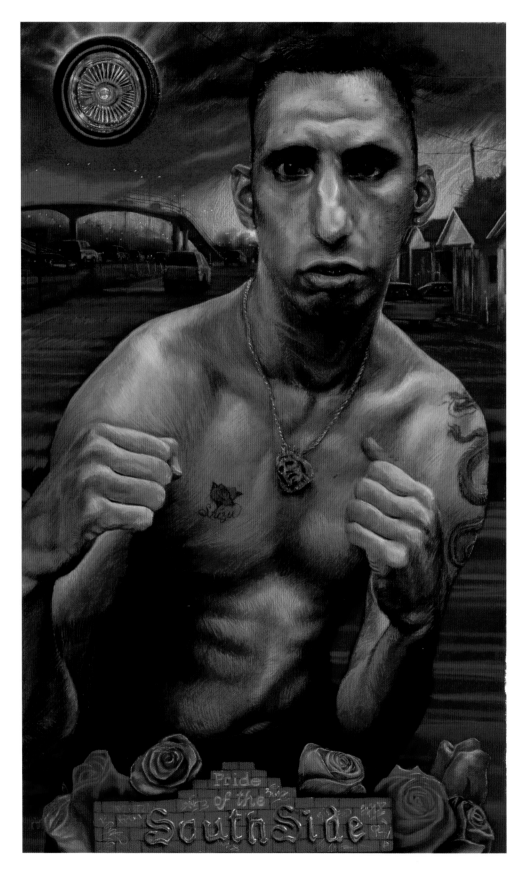

Vincent Valdez, *Pride of the Southside*, 2004; pastel and paper, 42 x 60 inches.

TOMÁS RIVERA

On the Road to Texas: Pete Fonseca

He'd only just gotten there and he already wanted to leave. He arrived one Sunday afternoon walking from the little town where we bought our food on Saturdays and where they didn't mind that we came in the afternoon all dirty from work. It was almost dark when we saw this shadow crossing the field. We'd been fooling around in the trees and when we saw him we were almost scared, but then we remembered there was more of us so we weren't so scared. He spoke to us when he got near. He wanted to know if there was any work. We told him that there was and there wasn't. There was, but there wasn't till the weeds grew. It'd been pretty dry and the weeds didn't grow and all the fields were real clean. The landowner was pretty happy about it since he didn't have to pay for weeding the onion fields. Our parents cursed the weather and prayed for rain so the weeds'd grow and we had to make like we cared too, but, really, we liked getting up late, wandering around among the trees and along the stream killing crows with our slingshots. That's why we said there was but there wasn't. There was work but not tomorrow.

"Aw, fuck it all."

We didn't mind him talking like that. I think we realized how good his words went with his body and clothes.

"There's no goddamned work no fuckin' place. Hey, can you give me something to eat? I'm fuckin' hungry. Tomorrow I'm going to Illinois. There's work there for sure . . ."

He took off his baseball cap and we saw that his hair was combed good with a pretty neat wave. He wore those pointed shoes, a little dirty, but you could tell they were expensive ones. And his pants were almost pachuco pants. He kept saying *chale* and also *nel* and *simón* and we finally decided that he was at least half pachuco. We went with him to our chicken coop. That's what we called it because it really was a turkey coop. The owner had bought ten turkey coops from a guy who sold turkeys and brought them to his farm. We lived in them, though they were pretty small for two families, but pretty sturdy. They didn't leak when it rained, but, even though we cleaned them out pretty good inside, they never really lost that stink of chicken shit.

His name was Pete Fonseca and Dad knew a friend of his pretty good. Dad said he was a big mouth since he was always talking about how he had fourteen gabardine shirts and that's why the folks called him *El Catorce Camisas.* They talked about Fourteen Shirts a while, and, when we went to eat beans with slices of Spam and hot flour tortillas, Dad invited him to eat with us. He washed his face good and his hands too, and then he combed his hair real careful, asked us for Brilliantine and combed his hair again. He liked the supper a lot and we noticed that when Mom was there he didn't use pachuco words. After supper he talked a little more and then laid down on the grass, in the shade where the light from the house wouldn't hit him. A little while later he got up and went to the outhouse and then he laid down again and fell asleep. Before we went to sleep, I heard Mom say to Dad that she didn't trust that guy.

"Me neither. He's a real con man. Gotta be careful with him. I've heard about him. Catorce Camisas is a big mouth, but I think it's him who stabbed that wetback in Colorado and they kicked him out of there or he got away from the cops. I think it's him. He also likes to smoke marijuana. I think it's him. I'm not too sure . . ."

Next morning it was raining and when we looked out the window we saw that Pete had gotten in our car. He was sitting up but it looked like he was sleeping because he wasn't moving at all. I guess the rain waked him up and that's how come he got in the car. Around nine it stopped raining so we went out and told him to come have breakfast. Mom made him some eggs and then he asked if there was any empty house or some place he could live. And when was work going to start? And how much did they pay? And how much could you get a day? And how many of us worked? Dad told him that we all worked, all five of us, and that sometimes we made almost seventy bucks a day if we worked about fourteen hours. After breakfast Dad and Pete went out and we heard him ask Dad if there were any broads on the farm. Dad answered laughing that there was only one and she was sort of a loser. La Chata, snub-nose. And they went on talking along the path that went around the huts and to the water pump.

They called her La Chata because when she was little she got sick with something like mange on her face and the nose bone had gotten infected. Then she got better but her nose stayed small. She was real pretty except for her nose and everyone spoke bad about her. They said that even when she was little she liked men a lot and everything about them. When she was fifteen she had her first kid. Everyone blamed one of her uncles but she never told who it was. Her Mom and Dad didn't even get angry. They were pretty nice. Still are. After that, she'd shack up with one guy and then another, and each one left her with at least one kid. She gave some away, her parents took care of others, but the two oldest stayed with her. They were big enough to work now. When Pete arrived, it was just two weeks after she'd lost again. Her last husband had left; he didn't even get mad at her or anything. Just left. La Chata lived in one of the biggest chicken coops with her

two sons. That's why Dad told Pete there was only one and she was sort of a loser. We figured Pete was pretty interested in what Dad said, and it seemed pretty funny since La Chata must've been about thirty-five and Pete, well, he couldn't have been more than twenty-five.

Anyhow, it turned out he was interested in what Dad said, because later, when we were fooling around near the pump, he asked us about La Chata. Where did she live, how old was she, was she any good? We were just talking about that when La Chata came down to get water and we told him that was her. We said hello to her and she said hello to us, but we noticed that she kept on looking at Pete. Like the people say, she gave him the eye. And even more when he asked her her name.

"Chavela."
"Hey, that's my mother's name."
"No kidding."
"Honest, and my grandmother's too."
"You son-of-a-bitch."
"You don't know me yet."

La Chata left the pump, and when she was pretty far away, Pete sighed and said real loud:

"Hey, mamasita, mamasota linda!"

Just to make sure she heard – he told us afterward. Because, according to him, broads like to be called that. From then on we noticed that everytime La Chata was near Pete he would always call her *mi chavelona* real loud. He said it loud so she'd hear and I think La Chata liked it because, when work started, she always chose the rows nearest Pete and, if he got ahead of her, she'd try and catch up. And then when the boss brought us water, Pete always let her drink first. Or he helped her get on and off the truck. The first Saturday

they paid us after Pete got there, he bought some fritos for La Chata's kids. That's how it began.

I liked it best when he sang her songs. Pete was going to stay and work, he'd say, until everything was over. He went to live with two other guys in an old trailer they had there. We used to go after supper to talk to them, and sometimes we'd sing. He'd go outside, turn toward La Chata's house and sing with all his might. In the fields, too, we'd just get close to her or she'd come along and Pete would let go with one of his songs. Sometimes he even sang in English: *sha bum sha bum* or *lemi go, lemi go lober,* and then in Spanish: *Ella quiso quedarse, cuando vio mi tristeza . . . Cuando te hablen de amor y de ilusiones . . .* Sometimes he'd even stop working and stand up in the row, if the boss wasn't there, and he'd sort of move his hands and his body. La Chata'd look out of the corner of her eye, like it bothered her, but she always went on taking the rows next to Pete, or meeting him, or catching up to him. About two weeks later they both started going to get water at the truck together, when the boss didn't bring it, and then they'd go behind the truck a while and then La Chata would come out fixing her blouse.

Pete would tell us everything afterward. One day he told us that, if we wanted to see something, we should hide behind the trailer that night and he'd try and get her to go in the trailer.

"You know what for . . . to give her candy . . ."

Us and the guys who lived with him hid behind the trailer that night and then after a long time we saw La Chata coming toward the trailer. Pete was waiting for her and she'd just got there and he took her hand and pulled her toward him. He put his hand up under her skirt and started kissing her. La Chata didn't say anything. Then he leaned her up against the trailer, but she got away and told him you son-of-a-bitch, not so fast. Pete was

inviting her to come into the trailer but she didn't want to and so they stayed outside. Do you love me, will you marry me, yes I will, when, right now, what about the other cat. Finally she left. We came out of the dark and he told us all about it. Then he started telling us all about other broads he'd made. Even white ones. He'd brought one from Chicago and set up his business in Austin. There, according to him, the Johns would line up at five bucks a throw. But he said that the broad he'd really loved was the first one he married, the right way, in the Church. But she'd died with the first kid.

"I sure cried for that woman, and since then nothing. This fuckin' life . . . now with this *chavelona*, I'm beginning to feel something for her . . . she's a good person, if you know what I mean."

And sometimes he'd start thinking. Then he'd say real sincere like:

"Ay, mi chavelona . . . man, she's a hot one . . . but she won't let me . . . until I marry her, she says."

Three days after we'd hid, Pete decided to get married. That's why all that week that's all he talked about. He had nothing to lose. Why, him and La Chata and the two boys could save a lot. He'd also have someone to cook his gorditas for him and his nice hot coffee, and someone to wash his clothes, and according to Pete, she could handle at least one John a night. He'd start calculating: at four dollars a throw, at least, times seven nights, that was twenty-eight dollars a week. Even if *he* couldn't work, things'd be pretty good. He also said he liked La Chata's boys. They could buy a jalopy and then Sundays they could take rides, go to a show, go fishing or to the dump

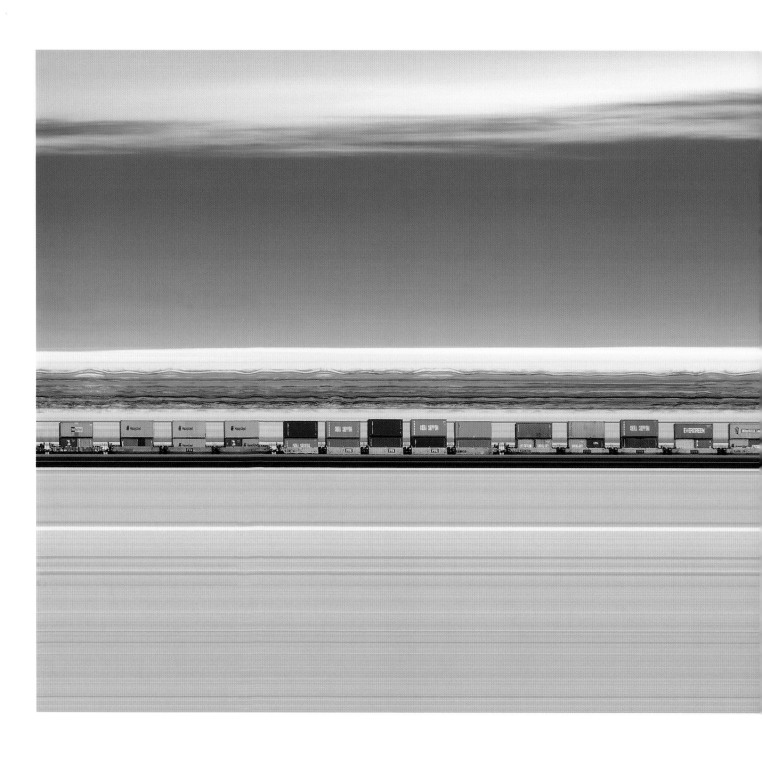

Ansen Seale, *Evergreen*, 2001; digital slitscan photograph, 24 x 56 inches.

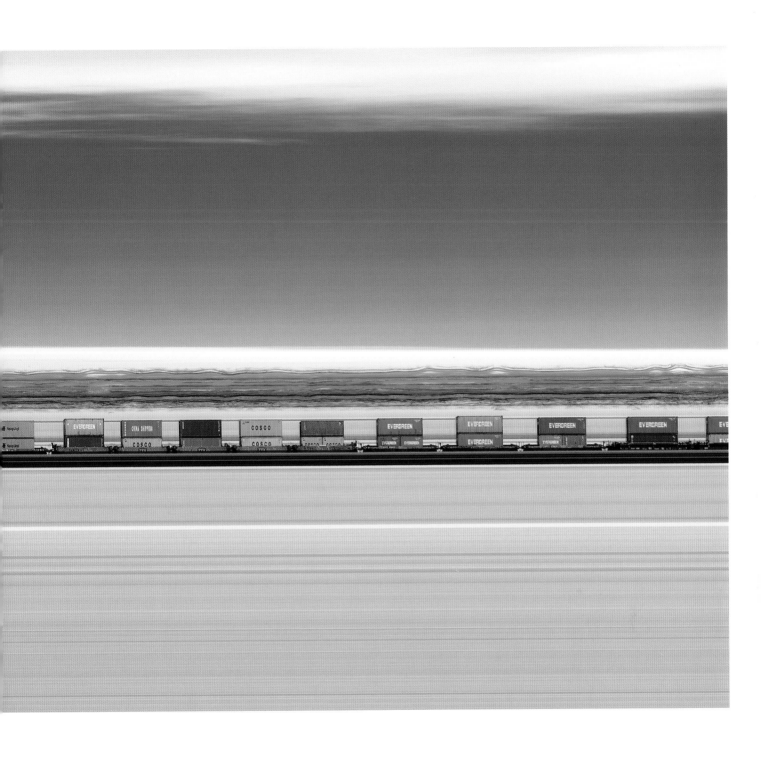

and collect copper wire to sell. In fact, he said, him marrying La Chavelona was good for all of them. And the sooner the better.

A little while later he came to talk to Dad one night. They went out on the road where no one could hear them and they talked a pretty long time. That night we heard what Dad and Mom were saying in the dark:

"Get this: he wants to marry La Chata! He wants to elope with her, but what in? So it's better to get married for real. But—get this— he's got some sickness in his blood so he doesn't want to go into town to get the papers. So what he wants is for me to go and ask La Chata's father, Don Chon, for her hand. He wants me to go right away, tomorrow . . .' Don Chon, I've come today commissioned to ask for the hand of your daughter, Isabel, in matrimony with young Pedro Fonsecca.' How's that eh? . . . How's it sound, honey? . . . Tomorrow after work, right before supper . . ."

Next day all you heard about was how they were going to ask for La Chata's hand. That day Pete and Chavela didn't even talk to each other. Pete went around all day real quiet and sort of glum, like he wanted to show us how serious he was. He didn't even tell us any jokes like he always did. And La Chata also looked real serious. She didn't laugh any all day and every now and then she'd yell at her kids to work faster. Finally the work day finished and before supper Dad washed up, parted his hair four or five times, and went straight to Don Chon's house. Pete met him in the front yard and they both knocked at the door. They went in. *It was okay—they'd asked them to come in.* About half an hour later they all came out of the house laughing. *They'd agreed.* Pete was hugging La

Chata real tight. Pretty soon they went into Chavela's house and when it got dark they closed the doors and pulled down the shade on the windows, too. That night Dad told us about ten times what had happened when he went to ask for her hand.

"Man, I just spoke real diplomatic and he couldn't say no . . ."

Next day it rained. It was Saturday and that was when we really celebrated the wedding. Almost everyone got drunk. There was a little dancing. Some guys got into fights but pretty soon every- thing calmed down.

They were real happy. There started to be more and more work. Pete, La Chata and the boys always had work. They bought a car. Sundays they'd go driving a lot. They went to Mason City to visit some of La Chata's relatives. She was sort of strutting around real proud. The boys were cleaner now than ever. Pete bought a lot of clothes and was also pretty clean. They worked together, they helped each other, they took real good care of each other, they even sang together in the fields. We all really liked to see them because sometimes they'd even kiss in the fields. They'd go up and down the rows holding hands . . . *Here come the young lovers.* Saturday they'd go shop- ping, and go into some little bar and have a couple after buying the groceries. They'd come back to the farm and sometimes even go to a show at night. They really had it good.

"Who would of said that that son-of-a-gun would marry La Chata and do her so right? It looks like he really loves her a lot. Always calling her *mi chavelona.* And can you beat how much he loves those kids? I tell you he's got a good heart. But who was to say that he

did? Boy, he looks like a real pachuco. He really loves her, and he doesn't act at all high and mighty. And she sure takes better care of him than the other guy she had before, don't you think? And the kids, all he does is play with them. They like him a lot too. And you gotta say this about him, he's a real hard worker. And La Chata, too, she works just as hard. Boy, they're gonna pick up a pretty penny, no? . . . La Chata finally has it pretty good . . . Man, I don't know why you're so mistrusting, honey . . ."

Six weeks after the wedding the potato picking ended. There were only a couple of days more work. We figured by Tuesday everything would be over and so we fixed up the car that weekend since our heads were already in Texas. Monday I remember we got up early and Dad, like always, beat us to the outhouse. But I don't even think he got there because he came right back with the news that Pete had left the farm.

"But what do you mean, Dad?"
"Yeah, he left. He took the car and all the money they'd saved between him and La Chata and the boys. He left her without a cent. He took everything they'd made . . . What did I tell you? . . . He left . . . What did I tell you?"

La Chata didn't go to work that day. In the fields that's all people talked about. They told the boss about it but he just shook his head, they said. La Chata's folks were good and mad, but I guess we weren't too much. I guess because nothing had happened to us.

Next day work ended. We didn't see La Chata again that year. We came to Texas and a couple of months later, during Christmas, Dad talked to Don Chon who'd just come down from Iowa. Dad asked him about Pete and he said he didn't know, that he heard he'd been cut up in a bar in Minnesota and was going around saying the cops had taken all his money and the car, and that the boss had told the cops after all, and they'd caught him in Albert Lea. Anyhow, no one had given any money to Don Chon or La Chata. All we remembered was how he'd only just gotten there and he already wanted to leave. Anyhow, Pete made his little pile. That all happened around '48. I think La Chata is dead now, but her kids must be grown men. I remember that Pete appeared out of nowhere, like the devil himself – bad, then he turned good, then went bad again. I guess that's why we thought he was a shadow when we first saw him.

Ethel Shipton, *Tiles*, 2004; wood and vinyl, 3 x 3 feet.

NAOMI SHIHAB NYE

The Words under the Words

for Sitti Khadra, north of Jerusalem

My grandmother's hands recognize grapes,
the damp shine of a goat's new skin.
When I was sick they followed me,
I woke from the long fever to find them
covering my head like cool prayers.

My grandmother's days are made of bread,
a round pat-pat and the slow baking.
She waits by the oven watching a strange car
circle the streets. Maybe it holds her son,
lost to America. More often, tourists,
who kneel and weep at mysterious shrines.
She knows how often mail arrives,
how rarely there is a letter.
When one comes, she announces it, a miracle,
listening to it read again and again
in the dim evening light.

My grandmother's voice says
nothing can surprise her.
Take her the shotgun wound and the crippled
 baby.
She knows the spaces we travel through,
the messages we cannot send – our voices are
 short
and would get lost on the journey.
Farewell to the husband's coat,
the ones she has loved and nourished,
who fly from her like seeds into a deep sky.
They will plant themselves. We will all die.

My grandmother's eyes say Allah is everywhere,
 even in death.
When she speaks of the orchard
and the new olive press,
when she tells the stories of Joha
and his foolish wisdoms,
He is her first thought, what she really thinks of is
 His name.

"Answer, if you hear the words under the words –
otherwise it is just a world
with a lot of rough edges,
difficult to get through, and our pockets
full of stones."

Chuck Ramirez, *Scott*, 2004; photo, c. 60 x 48 inches.

Enigma

He keeps the heavy doors of his old-fashioned piñata shop locked up tight since he's usually in the attic working. You have to ring a bell if you want to shop here. By then you're semicommitted, buying party favors even if you have no party in mind. Tomorrow I turn forty and today Mr. Beto, who has always seemed old, seems distinctively older. Did some wind blow through in the night? His face has grown thinner, more gently defined, his skin softly tissue-like. He's becoming his favorite substance. He's switching on lights for us, muttering, "It's here, it's all here."

Party favors loop down the walls. Plastic babies, Mexican finger traps, sparklers, poppers, whistles. Mountains of confetti for stuffing *cascarón* eggshells at Easter. Madison stares up at the crowds of piñatas dangling from the ceiling. "Does he really make all these?" he whispers to me, and Mr. Beto grumbles, "I do." He's married to tissue. He's snipped it into a million strips.

Once I climbed with him into the attic, the flamboyant topple of half-finished Batmen, turquoise sailing ships, chipmunks and brides, to ask him serious piñata questions. I used to interview men who ran feed stores and built toothpick dispensers. My newspaper columns appeared between ads for fertilizer and cut-rate bras. I wasn't nervous with Mr. Beto in the attic; it seemed doubtful he would wrestle me to the floor, though neighborhood legend says he has a secret room of X-rated piñatas somewhere. I've never seen it.

He told me how long it took and how much thinking it took and the sun coming in through a tiny slit of window lit up sheaves of paper along the walls. I wanted to buy just the uncut paper, plain and sheer and tropical fruit–colored, and made the mistake of saying so. It seemed to hurt him. After that I thought of him living here alone with all these faces.

Today Madison's dragging a huge pink rabbit around. Mr. Beto growls, "Put it back where you found it." How people stuff these with candy and smash them still eludes me. I can't do it. I leave them hanging till they grow dusty webs between their toes. Madison's fingering a giant birthday cake, smiling. A fish, and a policeman. Mr. Beto could supply every party between here and Saltillo till the end of the world.

My eyes fall onto a single standing girl done in odd shades of gray and brown with the word ENIGMA planted on her chest in blocky white letters. Who's this?

I carry her by the string in her head to Mr. Beto where he sits.

Two little gray braids poke out on either side of the string. She's not smiling. She looks uncharacteristically gloomy for a piñata. Does she represent a robot? A character in a cartoon?

He's waving his graceful fingers, looking for a word with sudden urgency.

"She's like *mystery,* you know? Like something you can't answer even when it stands right next to you? Like *puzzle.*"

"Yes, yes, I know what the *word* means, but who *is* she? Is she a character from a story or did you make her up?"

He pauses. Looks as if he's deciding whether to tell the truth. "I just thought of her."

He stares at the floor. She costs eight dollars. He peers up curiously when I say I thought of her too.

It takes a long time to decide not to buy her. It seems philosophical. I could hang her over the breakfast table tomorrow when forty comes to claim me. Or I could think of her in the dark shop down the street from my house, waiting, waiting. I could visit her later when it's so hot we almost die.

Regis Shephard, *Fog of War*, 2006; India ink and marker, 24 x 32 inches.

ABOUT THE WRITERS

Wendy Barker is Poet-in-Residence at the University of Texas at San Antonio. She is the author of *Poems from Paradise*, *Winter Chickens and Other Poems*, *Let the Ice Speak*, *Way of Whiteness*, which won the Violet Crown Award, and *Lunacy of Light: Emily Dickinson and the Experience of Metaphor*, as well as coeditor of *The House Is Made of Poetry: The Art of Ruth Stone*. In collaboration with Saranindranath Tagore, she published *Rabindranath Tagore: Final Poems*, which received the Sourette Diehl Fraser Award for Literary Translation from the Texas Institute of Letters. She has received a National Endowment of the Arts Fellowship, a Rockefeller Residency Fellowship, a Fulbright Fellowship, the Gemini Ink Award of Literary Excellence, and the *American Scholar* Mary Elinore Smith Poetry Prize.

Jacques Barzun has lived in San Antonio since 2000. His books include *Classic, Romantic, and Modern*; *Darwin, Marx, Wagner*; *Berlioz and the Romantic Century*; *Science: The Glorious Entertainment*; *A Stroll with William James*; and *Begin Here: The Forgotten Conditions of Teaching and Learning*. His latest work, *From Dawn to Decadence: 500 Years of Western Cultural Life, 1500 to the Present*, was a National Book Award finalist. He received the Gold Medal for Criticism from the American Academy of Arts and Letters, of which he was twice president, and the Presidential Medal of Freedom.

Robert Bonazzi, who is John Howard Griffin's authorized biographer, wrote *Man in the Mirror: John Howard Griffin and the Story of Black Like Me*. He is also the author of a novella, *The Musical Erotic*, and the poetry collections *Maestro of Solitude*, *Living the Borrowed Life*, *Fictive Music: Prose Poems 1975–1977*, and *Perpetual Texts*. He was the publisher of Latitudes Press from 1966 to 2000. He writes a poetry column for the *San Antonio Express-News*.

Catherine Bowman lived in San Antonio for many years. She is Ruth Lilly Professor of Poetry and director of the Creative Writing Program at Indiana University. Her collections of poems include *Rock Farm*, *Notarikon*, and *1-800-HOT-RIBS*, which won the Peregrine Smith Poetry Prize and the Kate Frost Tufts Discovery Award. She is the editor of *Word of Mouth: Poems Featured on NPR's "All Things Considered."* She has received the Dobie Paisano Fellowship, a New York Foundation for the Arts Fellowship in Poetry, and two Yaddo Fellowships.

Jay Brandon has published short stories in various anthologies, a history of San Antonio's legal profession, and fourteen mystery novels, including *Sliver Moon*, *Executive Privilege*, *After-Image*, *Defiance County*, *Local Rules*, *Loose among the Lambs*, *Fade the Heat*, and *Deadbolt*. Steven Spielberg, Bill Cosby, and Burt Reynolds have each optioned one of his books.

Marie Brenner was born and raised in San Antonio. She started her career as a contributing editor of *New York* magazine and was the American League's first female baseball columnist at the *Boston Herald*. She was a staff writer for *The New Yorker* and is a writer-at-large for *Vanity Fair*. Her books include *Great Dames: What I Learned from Older Women*, *House of Dreams: The Binghams of Louisville*, *Intimate Distance*, *Going Hollywood*, and *Tell Me Everything*. She has won six Front Page Awards from the Newswomen's Club of New York.

Jenny Browne is an assistant professor of creative writing at Trinity University. She has worked as a poet-in-residence in schools and

community centers through the Texas Commission on the Arts and Gemini Ink's Writers in Communities Program. A recipient of fellowships in both poetry and creative nonfiction from the Writers League of Texas, she was a University of Texas James Michener Fellow in Poetry. She is the author of the poetry collections *Glass*, *At Once*, and *The Second Reason*, and the editor of *Provide and Protect: Writers on Planned and Unplanned Parenthood*.

Norma Elia Cantú is a professor of English at the University of Texas at San Antonio. She is the editor of the book series Rio Grande/Rio Bravo: Borderlands Culture and Tradition and Flor y Ciencia: Chicanas in Mathematics, Science, and Engineering, as well as coeditor of *Chicana Traditions: Continuity and Change* and *Telling to Live: Latina Feminist Testimonios*. Her creative autobioethnography, *Canícula: Snapshots of a Girlhood en la Frontera*, won the Premio Aztlán. Cantú has received two Fulbright-Hays Fellowships to Spain.

Jacinto Jesús Cardona teaches English at Incarnate Word High School and creative writing for the Upward Bound Program at Trinity University. He has been honored by the Ford Salute to Education and has received the Trinity University Prize for Excellence in Teaching and a National Endowment of the Humanities grant. His poetry collection is titled *Pan Dulce*.

Oscar Casares lived in San Antonio from 2001 to 2002. In 2003 he published the story collection *Brownsville*, which was named a Notable Book by the American Library Association. He has received a Dobie Paisano Fellowship and grants from the National Endowment for the Arts and the James A. Michener/Copernicus Society of America. He is an assistant professor of English at the University of Texas at Austin.

Rosemary Catacalos is the executive director of Gemini Ink. She is the author of the chapbook *As Long as It Takes* and the poetry collection *Again*

for the First Time, which received the Texas Institute of Letters Prize in Poetry. A recipient of a Dobie Paisano Fellowship and a Stegner Fellowship, she has been director of the Guadalupe Cultural Arts Center literature program and the Poetry Center and American Archives at San Francisco State University. Catacalos was also a fellow at Stanford University's Institute for Women and Gender Studies.

Sandra Cisneros lives in San Antonio. She is the author of the poetry collections *Loose Woman*, *My Wicked, Wicked Ways*, and *Bad Boys* and the children's book *Hairs/Pelitos*. Her works of fiction include *Caramelo*; *Woman Hollering Creek and Other Stories*, which won the Quality Paperback Book Club New Voices Award, the PEN Center West Award, the Anisfield-Wolf Book Award, and the Lannan Foundation Literary Award; and *The House on Mango Street*, which won the Before Columbus Foundation's American Book Award. Among her honors are a MacArthur Foundation Fellowship, the Texas Medal of the Arts, two fellowships from the National Endowment for the Arts, and a Dobie Paisano Fellowship.

Olga Samples Davis was given professor emeritus status after thirty-two years of distinguished service at St. Philip's College. A San Antonio native, she is the author of *A Time to Be Born*, and *Things My Mama Told Me: The Wisdom That Shapes Our Lives*.

Angela de Hoyos was born in Mexico but has lived in San Antonio since childhood. With her partner, Moses Sandoval, she has published other Latino writers through their press, M & A Editions, and the journals *Caracol* and *Huehuetitlan*. De Hoyos's books are *Woman, Woman*; *Arise, Chicano! and Other Poems*; *Chicano Poems: For the Barrio*; *Poems/Poemas*; and *Selected Poems/Selecciones*. She is the coeditor, with Bryce Milligan and Mary Guerrero Milligan, of *¡Floricanto Sí! A Collection of Latina Poetry* and *Daughters of the Fifth Sun: A Collection of Latino Fiction and Poetry*.

Robert Flynn, professor emeritus at Trinity University, has been a resident of San Antonio since 1963. His novels include *North to Yesterday*, which received awards from the Texas Institute of Letters and the National Cowboy Hall of Fame and was a New York Times Best Book of the Year; *In the House of the Lord*; *The Sounds of Rescue, the Signs of Hope*; *Wanderer Springs*, which received the Western Writers of America Spur Award; *The Last Klick*; *The Devils Tiger*, co-written with Dan Klepper; and *Tie-Fast Country*. He is also the author of the essay collections *Growing Up a Sullen Baptist* and *Slouching toward Zion and More Lies*. He received the Distinguished Achievement Award from the Texas Institute of Letters and a Gemini Ink Award of Literary Excellence.

Marian Haddad is the author of the chapbook *Saturn Falling Down* and the poetry collection *Somewhere between Mexico and a River Called Home*. She has taught at Our Lady of the Lake University, Northwest Vista College, and St. Mary's University.

Rolando Hinojosa-Smith has been a professor of English at the University of Texas at Austin since 1981. His books include *Estampas del valle y otras obras*, which received the Premio Quinto Sol; *Klail City y sus alrededores*, which received the Casa de las Américas Prize; *Korean Love Songs*; *Generaciones, Notas, y Brechas/ Generations, Notes, and Trails*; *Mi querido Rafa*; *Rites and Witnesses*; *The Valley*; *Partners in Crime*; *Claros varones de Belken/Fair Gentlemen of Belken County*; *This Migrant Earth*; *Los Amigos de Becky*; *The Useless Servants*; *Ask a Policeman*; and *We Happy Few*. He received the Lon Tinkle Lifetime Achievement Award from the Texas Institute of Letters and was elected to the Texas Literary Hall of Fame.

Sterling Houston (1945-2006) was born in San Antonio, where he was artistic director and writer-in-residence for Jump-Start Performance Co. Beginning in 1988, twenty of his plays pre-miered there. His plays were also produced at the Judson Poet's Theatre in New York City, the Victory Gardens Theater in Chicago, the Cleveland Public Theater, and the Phoenix Theater in Indianapolis. His books include *Four Plays by Sterling Houston* and the novella *Le Griffon*. He received grants from the Mid-American Arts Alliance, the National Endowment for the Arts, the Texas Commission on the Arts, the Rockefeller Foundation, and Art Matters, Inc., as well as a Gemini Ink Award of Literary Excellence.

John Igo taught English literature, composition, and creative writing for forty-five years at San Antonio College. He has published twelve works of poetry, including *Bozzetti of John Igo*, *Alien*, and *Mitotes of John Igo*. He has also written two textbooks and nine produced plays. He was theater critic for the *North San Antonio Times* for eighteen years. He has received the Spotlight Award from the American Association of Community Theaters, a Distinguished Alumni Award from Trinity University, a National Literature Award in Poetry from the National Society of Arts and Letters, the Living Legend award from the San Antonio Theatre Coalition, two Production Awards from Centre Stage in Austin, and an Emmy for Text Editing and Consultation of *Our Children, the Next Generation*.

Catherine Kasper is an associate professor of English at the University of Texas at San Antonio. She is the author of *Field Stone*, which received the Winnow Press First Book Award in Poetry; *Optical Projections*; *A Gradual Disappearance of Insects*; and *Blueprints of the City*. She has received an AWP Intro Award, a PEN Texas award, the Mid-American Review Fineline Award, and an Academy of American Poets Prize.

Jo LeCoeur has been a professor at the University of the Incarnate Word since 1977. Before that, she was an associate professor at Loyola University in New Orleans. Her awards include a National Defense Education Act Fellowship, a grant from the Department of Arts and Cultural Affairs, and a

grant from the San Antonio Artist Foundation. Her poetry collections are *Blue Orleans Woman* and *Chocolate Milk and Whiskey Voices*.

Jim Lehrer lived in San Antonio on and off for six years while attending Jefferson High School, from which he graduated in 1952. He worked in Dallas as a newspaper reporter and host of a PBS experimental news program. He and Robert MacNeil launched the *MacNeil/Lehrer NewsHour*, the first sixty-minute evening news program in television. Lehrer's sixteen novels include *Viva Max!* and his latest, *The Phony Marine*; two memoirs, including *A Bus of My Own*; and three plays. He has received the presidential National Humanities Medal, two Emmys, the Fred Friendly First Amendment Award, the George Foster Peabody Broadcast Award, and the William Allen White Foundation Award for Journalistic Merit. He has been inducted into the Television Hall of Fame with MacNeil, and into the Silver Circle of the Washington, D.C., chapter of the National Academy of Television Arts and Sciences.

David Liss has lived in San Antonio since 2001. He is the author of the novels *The Ethical Assassin*, *A Spectacle of Corruption*, *The Coffee Trader*, and *A Conspiracy of Paper*. His books have been national and international best-sellers, have been translated into more than two dozen languages, and have received the Edgar, Barry, and Macavity awards. He is a member of the Texas Institute of Letters.

Bonnie Lyons is a professor of English at the University of Texas at San Antonio. She has been a Fulbright professor in Greece, Spain, Italy, and Israel. She is the author of the chapbooks *Hineni* and *Meanwhile*, the poetry collection *In Other Words*, and *Henry Roth: The Man and His Work*. She is also the coeditor, with Bill Lyons, of *Passion and Craft: Conversations with Notable Writers*.

Bryce Milligan has lived in San Antonio since 1977. With Sandra Cisneros, he founded the San Antonio Inter-American Bookfair, and as director of the Guadalupe Cultural Arts Center literature program he cofounded the Latina Letters conference. Since 1995 Milligan has been the publisher of Wings Press. He is the author of five children's books and six poetry collections, including *Daysleepers and Other Poems*, *Working the Stone*, and *Alms for Oblivion: A Poem in Seven Parts*, as well as the editor or coeditor of a dozen other books, including, with Angela de Hoyos and Mary Guerrero Milligan, *¡Floricanto Sí! A Collection of Latina Poetry* and *Daughters of the Fifth Sun: A Collection of Latino Fiction and Poetry*.

Josephina Niggli (1910–1983) was born near Hidalgo, Nuevo León. After the assassination of Madero, the Niggli family fled to the United States, eventually settling in San Antonio. Niggli returned to Mexico at the age of ten, remained for five years, and returned to San Antonio to attend Incarnate Word College. Her first book of poems, *Mexican Silhouettes*, was published in Hidalgo in 1928; a larger edition was published on King William Street in San Antonio in 1931. After studying playwriting at San Antonio Little Theater, Niggli did graduate work in drama at the University of North Carolina, where she became associated with the Carolina Playmakers. She published several plays, including *The Red Velvet Goat*, *Sunday Costs Five Pesos*, *The Fair God*, *The Cry of Dolores*, *Azteca*, and *Soldadera*. *Mexican Village*, a collection of ten novelettes set in Hidalgo, became a best-seller, and MGM Studios hired Niggli to adapt it for the movie *Sombrero*.

Naomi Shihab Nye moved with her parents to San Antonio as a teenager and graduated from Robert E. Lee High School and Trinity University. For half her life she has lived in historic downtown with her husband and son, one block from the San Antonio River. Nye's novel for teens, *Going Going*, celebrates San Antonio's independent businesses. Among her other books are *I'll Ask You Three Times, Are You OK? Tales of Driving and Being Driven*, *Habibi*, *Fuel*, *A Maze Me*, *Baby Radar*,

Red Suitcase, *Never in a Hurry*, *Come with Me: Poems for a Journey*, *Words under the Words*, and seven anthologies. She has been a National Book Award finalist, a Lannan Fellow, a Guggenheim Fellow, and a Library of Congress Witter Bynner Fellow and has received four Pushcart prizes and a Gemini Ink Award of Literary Excellence. She served on the National Council of the National Endowment for the Humanities for five years.

Andrew Porter is an assistant professor of English at Trinity University. He received his M.F.A. in fiction from the University of Iowa Writers' Workshop. His collection of stories, *The Theory of Light and Matter,* won the 2007 Flannery O'Connor Award and is forthcoming in fall 2008. His fiction has appeared in the *Antioch Review*, *Story*, *Epoch*, the *Ontario Review*, *One Story*, *Prairie Schooner*, *Story Quarterly*, *Threepenny Review*, and *Other Voices*. He has received the W.K. Rose Fellowship in the Creative Arts from Vassar College and a James Michener/Paul Engle Fellowship from the James Michener/Copernicus Foundation.

Rick Riordan is the author of the Tres Navarre mystery series for adults and the Percy Jackson and the Olympians series for children. He taught English and history at public and private middle schools in the San Francisco Bay Area and in Texas for fifteen years. Saint Mary's Hall honored him with the Master Teacher Award. His adult fiction has won the Edgar, the Anthony, and the Shamus awards. *The Lightning Thief* was a New York Times Notable Book and made the paper's best-selling children's paperback list; it has been optioned for feature film to Twentieth Century Fox. *The Sea of Monsters* was a Child Magazine Best Book for Children and a *Publishers Weekly* and BookSense national best-seller.

Robert Rivard has worked for five Texas newspapers and served as a foreign correspondent in Central America and as a senior editor at *Newsweek*. He joined the *San Antonio Express-News*

in 1993 and became its editor in 1997. He has received Columbia University's Maria Moors Cabot Award and the Society of Professional Journalists' Distinguished Service Award for Foreign Correspondents, and in 2002 he was named *Editor & Publisher* magazine's Editor of the Year and the University of Texas at San Antonio's Alumnus of the Year. He is the author of *Trail of Feathers: Searching for Philip True*.

Tomás Rivera (1935–1984), the eldest son of agricultural migrant workers, was born in Crystal City. His experiences inform his creative work, which includes *The Harvest*; *Y no se lo tragó la tierra /. . . And the Earth Did Not Devour Him*, which won the Premio Quinto Sol; and *The Searchers*. Rivera held positions in various Texas institutions of higher education, including vice presidencies at the University of Texas at San Antonio and the University of Texas at El Paso, before becoming chancellor of the University of California, Riverside.

Lee Robinson teaches at the Center for Medical Humanities and Ethics at the University of Texas Health Science Center and at Trinity University. Robinson's poetry collection, *Hearsay*, won the Poets Out Loud Prize and the Violet Crown Award. She has also published a young adult novel, *Gateway*, and is a three-time winner of the S.C. Fiction Project for her short stories. A former attorney, she received the *American Bar Association Journal*'s Ross Essay Award.

Jan Jarboe Russell worked as a reporter for the *San Antonio Light* and in 1985 joined the staff of *Texas Monthly*, where she is currently a writer-at-large. She has written a nationally syndicated opinion column for the *San Antonio Express-News* and stories for the *New York Times*, *George*, *Talk*, *Good Housekeeping*, *Redbook*, and *Ladies' Home Journal*. She is the author of *Lady Bird: A Biography of Mrs. Johnson*; *San Antonio: A Cultural Tapestry*, with Mark Langford and Cathy Smith; and *Dreaming Red: Creating ArtPace*, with Linda Pace.

Trinidad Sanchez, Jr. (1943–2006) taught in the Artist in Education Program for the San Antonio Independent School District and in the Austin Writer's League Texas Literary Touring Program. His poetry collections are *Why Am I So Brown?* and *Jalapeño Blues*. He won the 1995 Albuquerque Poetry Slam Competition and moved to the National Poetry Slam the same year. Recognized for his activism on behalf of prison inmates and his involvement in social issues, he received the Rev. Dr. Martin Luther King Jr. Keep the Dream Alive Award.

John Phillip Santos, born and raised in San Antonio, comes from a family with roots in South Texas and northern Mexico going back to the seventeenth century, when the region was known as La Nueva Extremadura. Though he lived in New York City for twenty years, his writing focuses on storytelling in this part of the world. He is the author of *Songs Older Than Any Known Singer: Selected and New Poems, 1974–2006,* and a memoir, *Places Left Unfinished at the Time of Creation*, which was a finalist for the National Book Award. His other awards include the Academy of American Poets Prize at the University of Notre Dame, the Oxford Prize for Fiction, and two documentary nominations for an Emmy. The first Mexican American Rhodes Scholar, Santos has written and produced more than forty television documentaries for CBS-TV and PBS-TV.

Claude Stanush worked on the *LIFE* staff for thirteen years as a Hollywood correspondent, science writer, religion editor, chief of correspondents in Washington, D.C., and associate editor. One of his articles inspired the movie *The Lusty Men*, on which he worked as a screenwriter. He also worked as a screenwriter on *The Newton Boys*. His books include *The World in My Head*, a collection of his *San Antonio Express-News* columns; the story collections *The Balanced Rock* and *Sometimes It's New York*; and the novel *All Honest Men*, cowritten with Michelle Stanush. He has received a Dobie Paisano Fellowship and awards from the National Endowment for the Arts,

the American Association for the Advancement of Science, and the World Council of Churches.

Peter Streckfus was born in San Antonio in 1969. He attended the University of Texas at San Antonio and received a B.A. from the University of Texas at Austin and an M.F.A. from George Mason University. His first book of poems, *The Cuckoo*, was selected by Louise Glück as the winner in the Yale Series of Younger Poets competition in 2003 and was a finalist for the Academy of American Poets Walt Whitman Award. He is a member of the creative writing faculty at the University of Alabama in Tuscaloosa.

Carmen Tafolla is a native of San Antonio's West Side. She is the author of five poetry collections, including *Sonnets to Human Beings*, *Sonnets and Salsa*, and *Curandera*; the children's books *My House Is Your House/Mi casa es su casa* and *Baby Coyote and the Old Woman/El Coyotito y la viejita*; seven television screenplays; and one nonfiction book. She has performed her dramatic one-woman show throughout the United States and in London, Madrid, Granada, Canada, Germany, Mexico, and Norway. She is a recipient of the Art of Peace award.

Frances Marie Treviño is the author of *Mama and Other Tragedies*; *The Laughter of Doves*, which won the 2000 Premio Poesía Tejana; and *Cayetana*. She was a National Endowment for the Humanities fellow in 1999 and is the recipient of a grant from the Alfredo Cisneros del Moral Foundation. From 1999 to 2002 she was a member of the performance group Women of Ill-Repute, Refute! She teaches courses in British literature in the San Antonio Independent School District and in American literature at San Antonio College.

David Ray Vance is an assistant professor of English at the University of Texas at San Antonio. He received his Ph.D. in poetry from the University of Houston and is coeditor of *American Letters & Commentary*. His collection,

Vitreous, won the 2005 Del Sol Press Poetry Prize and was on the Poetry Foundation's poetry best-seller list.

Abraham Verghese is senior associate chair and professor of theory and practice of medicine at Stanford University. He lived in Texas for sixteen years, the last five in San Antonio. He is the author of *My Own Country*, which was a finalist for the National Book Critics Circle Award and was made into a movie, and *The Tennis Partner*, which was a New York Times Notable Book.

Evangelina Vigil-Piñón, a native of San Antonio, is the author of the children's book *Marina's Muumuu/El muumuu de Marina* and the poetry collections *Nade y nade*, *The Computer Is Down*, and *Thirty an' Seen a Lot*, which won the American Book Award. Vigil-Piñón also edited the first anthology of U.S. Latina literature, *Woman of Her Word: Hispanic Women Write*, served as poetry editor of the *Americas Review*, and translated Tomás Rivera's *Y no se lo tragó la tierra /. . . And the Earth Did Not Devour Him*. She received a National Endowment for the Arts Fellowship and is a public affairs director and producer with a network television station in Houston.

Donley Watt has lived the past ten years in San Antonio. His books include *Can You Get There from Here?*, winner of the Texas Institute of Letters Stephen F. Turner Award for the best first work of fiction; *The Journey of Hector Rabinal*, a finalist for the Western Writers of America Spur Award; *Reynolds*; *Dancing with Lyndon*; and *Haley, Texas 1959: Two Novellas*.

Jerald Winakur has practiced internal and geriatric medicine in San Antonio for thirty years. He is an associate faculty member at the Center for Medical Humanities and Ethics at the University of Texas Health Science Center and also teaches at the University of Texas at San Antonio and Trinity University. His *Washington Post* op-ed piece, "What Are We Going to Do with Dad?" was nationally syndicated. A memoir-manifesto about his life as a geriatrician, a commentary on aging in America, and the trials and joys of being the son of an old, old man is forthcoming from Hyperion.

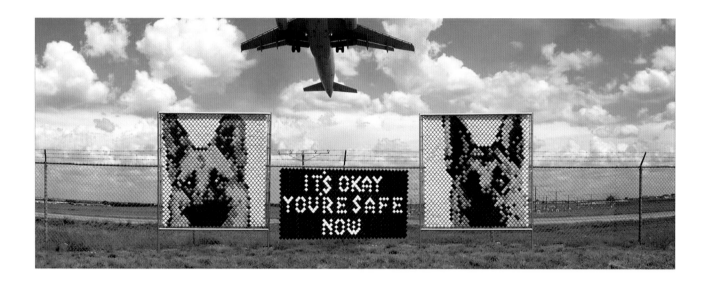

Gary Sweeney, *It's Okay, You're Safe Now*, 2005; chain link, plastic cups. Outdoor installation.

ABOUT THE ARTISTS

Jennifer Agricola works in a variety of media, including drawing, sculpture, and installation. Most recently she has exhibited her work at the Joan Grona Gallery and Sala Diaz in San Antonio; the Dallas Center for Contemporary Art; and the IF Gallery in Prague. She received her B.F.A. from Ohio University and her M.F.A. from the University of Texas at San Antonio.

Stuart Allen is a visual artist working primarily in photography, sculpture, and installation. His work addresses fundamental issues of perception such as light, space, gravity, and time. He lives and works in San Antonio. For more information visit www.stuartallen.info.

Jesse Amado, a San Antonio native, lives and works in New York City. He earned his M.F.A. from the University of Texas at San Antonio. His work has been exhibited nationally and internationally, and he has received grants and residencies from Artpace San Antonio, in 1995; the City Gallery of Kwangju, South Korea, in 1997; the Fabric Workshop, Philadelphia, in 1990; and a National Endowment for the Arts Fellowship in 1991.

Bernice B. Appelin-Williams is a Texas-born multimedia artist, educator, and arts and community activist whose work has been exhibited nationally. She says her work is often a query of "one's perceptions of the social order . . . whatever that is."

Ricky Armendariz was born and raised in the border town of El Paso. He attended the University of Texas at El Paso and the University of Texas at San Antonio, where he earned his B.F.A. He earned an M.F.A. from the University of Colorado at Boulder in 1999. He is an assistant professor of art at the University of Texas at San Antonio.

Ron Binks earned a B.F.A. from the Rhode Island School of Design and an M.F.A. from Yale University. He spent two years in Berlin as a Fulbright Fellow and is a recipient of the Rome Prize in painting from the American Academy in Rome. He is a professor of art at the University of Texas at San Antonio.

Cakky Brawley, a metal sculptor, has been involved with several large-scale, public art projects in San Antonio. City commissions include the Henry B. Gonzalez Convention Center Grotto, the Stinson Airport expansion, and the Labor Street Pocket Park. She received a B.F.A. from Texas Tech University and an M.F.A. from Indiana University. She teaches sculpture and ceramics at Palo Alto College.

Rolando Briseño's work is included in the Brooklyn Museum, the Museo del Barrio in New York City, the Corcoran Gallery, the San Antonio Museum of Art, the Museum of Contemporary Art in San Juan, Puerto Rico, MexicArte Museum, and the Jack S. Blanton Museum in Austin, as well as the University of Texas at Austin, the University of Texas at San Antonio, Arizona State University, and the University of Puerto Rico, Rio Piedras. He has public art works at Houston's George Bush Intercontinental Airport, Trinity University in San Antonio, the Austin Convention Center, Cypress Hills Library in Brooklyn, and the North White Plains railroad station in New York.

Andréa Caillouet was born and raised in New Orleans, Louisiana. She has lived and worked in San Antonio since earning her M.F.A. at the University of Texas at San Antonio in 1999. The current focus of her work involves expanding site-specific installation and public art into the realm

of intervention. "I am searching for the moments, openings, and pauses where art can intervene with and exist in daily life–a message left in a library book, a gift in the pocket of a Salvation Army coat."

Nate Cassie has lived and worked in San Antonio since 1993. His work has been shown at the Corcoran Gallery, the City Museum in Querétaro, Mexico, and other national and international venues. He is a past fellow in Artpace San Antonio's International Artist-in-Residence Program in San Antonio and the National Foundation for the Advancement of the Arts' FIVA residency program in Miami.

Danville Chadbourne was born in Bryan, Texas. He received a B.F.A. from Sam Houston State University and an M.F.A. from Texas Tech University, and he has lived in San Antonio since 1979. He taught studio art and art history for seventeen years and now devotes himself full time to his art. His work has been exhibited extensively around the state and nationally. He has had more than fifty solo exhibitions, and his work is in numerous private and public collections.

James Cobb worked for five years as a mail artist under the name Nunzio Mifune before transitioning into fifteen years of gallery shows as a painter in oils. Forays into music have led to the production of two CDs as Six-Fing Thing and five CDs with Pseudo Buddha. He primarily works digitally and teaches courses in new media at Our Lady of the Lake University in San Antonio.

Paula Cox received her B.A. in art from the University of Arkansas in 1975. Originally from Odessa, she raised her children in Leakey and now lives part of the time in San Antonio. She began relief printmaking eight years ago. The Tower-Life Building is her favorite landmark site.

Margaret Craig is chair of the Painting, Drawing, and Printmaking Department at the Southwest School of Art and Craft. She received a degree

in biology secondary education, which has influenced her imagery, as well as a B.S. and an M.A. in art from the University of Wisconsin–Madison. She received an M.F.A. in printmaking from the University of Texas at San Antonio. She shows nationally and internationally and is included in public and private collections.

Alex de Leon was born in Edinburg, Texas, and raised in San Antonio. After graduating from the Kansas City Art Institute in 1983, he established himself as a professional printer in San Antonio. He has most recently concentrated his efforts in ceramics and painting, and his latest pieces combine sculpture and video.

Joey Fauerso was born in San Antonio. She received her M.F.A. from the University of Wisconsin–Madison in 2001. She has exhibited her work throughout Texas, as well as nationally and internationally, and lives and works in San Antonio.

Bill FitzGibbons has received over thirty-two public art commissions in five countries and was selected to represent the United States at the lorence Biennale in December 2007. He has been a Fulbright Scholar at the Hungarian Art Academy in Budapest and is on the board of the International Sculpture Center. He has been the executive director of Blue Star Contemporary Art Center since 2002.

Janet Lennie Flohr was born in São Paulo, Brazil, and has lived in San Antonio since 1971. She received her M.F.A. from the University of Texas at San Antonio in 1990. In 1993 she and partner Gary Nichols founded Hare and Hound Press, a collaborative fine art printing studio in San Antonio. Flohr was a member of the art faculty at Trinity University from 1996 to 2000.

Larry Graeber was raised in Austin, where his educational studies included architecture, painting, sculpture, and printmaking. He moved

to San Antonio in the 1970s and had his first exhibition of work, titled Works from a Small Duplex, at the McNay Art Museum in 1974. He switched focus from public sculpture to painting in the early 1990s. His work has evolved through figural concerns into nonobjective ones, and he currently divides his attention between painting and small-scale sculpture.

Jessica Halonen has exhibited at the Museum of Fine Arts Houston, the Austin Museum of Art, and the Dallas Center for Contemporary Art. Halonen received her M.F.A. in painting at Washington University in St. Louis. She was a Core Fellow at the Glassell School of Art in the Museum of Fine Arts Houston and an artist-in-residence at the MacDowell Colony in New Hampshire.

Mark Hogensen lives and works in San Antonio and teaches at Palo Alto College. He received his B.F.A. from Oregon State University and his M.F.A. from the University of Texas at San Antonio. His paintings and drawings "overflow with ambiguous spatial references that manipulate and alter perceptions. When his colorful palette and oddly familiar shapes collide, the results serve both humor and the contemplation of gravity."

Marilyn Lanfear says: "The human figure is the focal point of all my work. I have spent many years drawing and painting and forming the figure, all the while looking carefully at the source. Today I can imagine the figure without looking."

Meg Langhorne lives and works at the edge of the Hill Country in Helotes. As a regular volunteer for Wildlife Rescue and Rehabilitation, she retrieves trapped or wounded animals from the sometimes hellish experience they find in their clashes with suburbia. There on that line between urban sprawl and the woods, Langhorne merges art-making with her passion for the natural world.

Ken Little came to San Antonio in 1988 to join the Department of Art faculty at the University of Texas at San Antonio. Since that time he has been a strong advocate for the arts in San Antonio as an artist, educator, and founder of Blue Moon Studios and the Rrose Amarillo Exhibition Space. *Burn* is typical of the work in mixed media sculpture for which he is nationally recognized.

Constance Lowe has lived and worked in San Antonio since 1991. Her drawings, constructions, and installations have been exhibited at Artpace San Antonio; the Phoenix Art Museum; Trinity College, Hartford, Connecticut; Thomas Barry Fine Arts, Minneapolis; I Space, Chicago; and the Forum for Contemporary Art, St. Louis. She is an associate professor at the University of Texas at San Antonio.

Karen Mahaffy earned her M.F.A. from the University of Texas at San Antonio in 1996. She has exhibited in the McNay Art Museum, the San Antonio Museum of Art, Sala Diaz, and Blue Star Contemporary Art Center in San Antonio; and at Locust Street Projects in Miami, the Dallas Center for Contemporary Art, and Smack Mellon in Brooklyn. She is chair of the Fine and Performing Arts Department at Palo Alto College.

Scott Martin is a fine-art photographer whose work has been exhibited nationally and is included in many private and public collections. He holds a degree in digital photographic imaging from Evergreen State College, is an Adobe Certified Expert, serves on the board of the Texas Photographic Society, and owns Onsight, a digital photography consulting and training business.

César A. Martínez was born and raised in Laredo, Texas. He lives and works in San Antonio. He's "still from Laredo after all these years."

Alberto Mijangos (1925–2007) began as a figurative artist, painting abstractions in the late 1960s. Influenced by abstract expressionists known for building layer upon layer of paint,

Mijangos developed his own process of layering, using a variety of materials. Characteristic of his paintings of the 1980s is a T-shirt or cross motif that has metaphoric associations with the sweat and toil of the laborer as well as with spirituality. Of *Surrounded by Sound*, Mijangos said: "Look at my paintings, feel the silence that embraces red. Harmony exists there. Without silence, continuity is broken. Sound evokes invisible components that create a magical awareness of the soul."

Franco Mondini-Ruiz holds a J.D. from St. Mary's University in San Antonio. He has exhibited at Artpace San Antonio, at Kiasma in Helsinki, and in the 2000 Whitney Biennial. He lives and works in San Antonio.

Michael Nye is working on his third photographic and audio documentary, *About Hunger*. He is married to poet Naomi Shihab Nye and has one son, Madison.

Kelly O'Connor, who was born and raised in San Antonio, began her studies at San Antonio College. She received her B.F.A. from the University of Texas at Austin. Her work was recently featured in the 2007 Texas Biennial.

Cruz Ortiz lives and works in San Antonio. In 2005 he was an International Artist-in-Residence at Artpace San Antonio. His work is exhibited in the United States and Europe.

Paula Owen, who has been president of the Southwest School of Art and Craft since 1996, holds an M.F.A. in painting and printmaking from Virginia Commonwealth University. Her work is in public and private collections throughout the United States and in Japan. She is a frequent contributor to art periodicals and is the coeditor of *Objects and Meaning: New Perspectives on Art and Craft*.

Linda Pace (1945–2007), a San Antonio native, was both an artist and an art patron. She earned a degree in fine arts from Trinity University and

maintained an active career as an artist. In 1995 she founded Artpace San Antonio, whose residencies, exhibitions, and education programs nurture the creative expression of emerging and established artists. Her work has been featured in exhibitions throughout Texas, including the 2007 Texas Biennial.

Victor Pagona is chair of the Photography Department at the Southwest School of Art and Craft. He earned a B.F.A. in photography and an M.A. in history from the University of Wisconsin and an M.F.A. in photography and sculpture from the University of South Carolina. He has shown work regionally, nationally, and internationally.

Katie Pell has lived in San Antonio since 1995. Her work "describes the excruciating negotiations needed when confronting sexism, class, and racism." She has organized the Automatic Downtown Studio Tour and participated in the Artpace International Residency Program.

Chuck Ramirez is an artist and designer. His large-scale photographic portraits of banal objects are "humorous yet poignant metaphors for the transient nature of consumer culture and the frailty of life." He resides in the Baja King William neighborhood of San Antonio with his three cats.

Juan Miguel Ramos teaches art and is a working musician, in addition to pursuing his art career. Since 2001 he has been awarded residencies at Artpace San Antonio, the Dallas Museum of Art, and the Holter Museum of Art in Helena, Montana. Ramos's work was chosen for the Altoids Curiously Strong Collection in 2005 and included in the 2004 San Juan Triennial, Puerto Rico.

Kate Ritson is a professor of art at Trinity University. She received her B.F.A. from the New York State College of Ceramics at Alfred and her M.F.A. from Rutgers University. Her work can be found in numerous private and public collections, including the San Antonio

Museum of Art, the McNay Art Museum, the Nora Eccles Harrison Museum of Art in Utah, and the Virginia Center for Creative Arts.

Dario Robleto was born and raised in San Antonio, where he currently works. He has shown nationally and internationally, including at the Whitney Museum of American Art, the Contemporary Arts Museum Houston, and the Frac Languedoc-Roussillon, Montpelier, France. He attended the University of Texas at El Paso and received his B.F.A. from the University of Texas at San Antonio.

Ángel Rodríguez-Díaz's work was most recently featured in the national exhibition Retratos: 2000 Years of Latin American Portraits, organized by the San Antonio Museum of Art, the National Portrait Gallery in Washington, and El Museo del Barrio in New York City.

Diana Rodríguez Gíl lives and works in San Antonio. She has an M.F.A. from the University of Texas at San Antonio and is an art instructor in the Edgewood Independent School District. Her work has been exhibited at the Blue Star Contemporary Art Center, the University of Texas at San Antonio Downtown Campus, and Paragon Cable in San Antonio.

Alex Rubio, who grew up on San Antonio's West Side, was recruited by the Community Cultural Arts Organization as a youth arts crew leader for their mural program, and thus began his training in large-scale drawing and painting, mural composition, community outreach, and youth arts education. Rubio has spent over twenty years working in *muralismo*. In addition, he has instructed and coordinated community-based programs for the Bexar County Detention Center, the City of San Antonio Urban Smarts Project, SAY Sí, the Guadalupe Cultural Arts Center, and San Anto Cultural Arts.

Ramin Samandari emigrated from Iran to the United States in 1978 and makes his home in San Antonio. Working with photographic and digital imaging processes, he investigates the human form in relation to other forms, space, and the intangible forces of time, place, and history. He has taught at the Southwest School of Art and Craft and operates the Magical Realism Studio.

Luz María Sánchez is a Mexican-born sound and visual artist. Her work has been exhibited in major sound and music festivals, as well as in galleries and museums in Europe and America. She was an International Artist-in-Residence at Artpace San Antonio in 2006. In her doctoral studies Sánchez has focused on the role of sound in art, particularly the radio plays of Samuel Beckett, linking them to the radiophonic art that emerged in the mid-twentieth century.

Chris Sauter lives and works in San Antonio, where he earned his M.F.A. in 1996 from the University of Texas at San Antonio. He exhibits nationally and internationally; recent solo exhibitions have been at Elizabeth Dee, New York City; Galerie Valerie Cueto, Paris; Susanne Vielmetter, Los Angeles Projects; and Finesilver in Houston. Group exhibitions include EVA, Limerick, Ireland; Musee d'Art Moderne Saint-Etienne, France; and the Drawing Center, New York City.

Gary Schafter moved to San Antonio in 1982. Since completing his M.F.A. at the University Texas at San Antonio, he has been working as a professional artist.

Mark Schlesinger graduated from the State University of New York at Binghamton and participated in the Independent Study Program at the Whitney Museum of American Art. He lived and painted in New York City until 1999, when he moved to San Antonio. He has exhibited in solo and group shows nationally and internationally and had a survey show, Paintings New York–Texas 1993–2003, at the Westfaelischer Kunstverein in Münster, Germany.

Ansen Seale lives and works in San Antonio. His work has been exhibited in museums and galleries and is in the collections of corporations, institutions, and private collectors. He uses an invention of his own, a digital panoramic camera that he believes records a hidden reality. It captures only a small vertical slit of any scene over and over in rapid succession, in effect swapping the horizontal dimension of the photo for the dimension of time. The apparent "distortions" in the images all happen in-camera as the image is being recorded, using no Photoshop manipulation.

Regis Shephard received a B.F.A. in painting from Texas Tech University and an M.F.A. in drawing from the University of Texas at San Antonio. He is an associate professor and chair of the Fine Arts Department at St. Philip's College in San Antonio. He has exhibited his work at the Blue Star Contemporary Art Center, the University of Texas at San Antonio Satellite Space, the University of Texas at San Antonio Gallery, the Southwest School of Art and Craft, the McNay Art Museum, and the Carver Cultural Center. He has also exhibited at the Fine Arts Gallery in Lubbock, the Longview Museum of Art, the Dallas Center for Contemporary Art, and the African American Museum of Art in Dallas.

Ethel Shipton has lived and worked in San Antonio since 1996. Her work has appeared in solo and group exhibitions at Artpace San Antonio, Cactus Bra Gallery, Sala Diaz, the McNay Art Museum, Blue Star Contemporary Art Center, the Dallas Center for Contemporary Art, and other venues.

Trish Simonite has exhibited her photographs in solo and group shows from Texas to Thailand. She photographs with conventional and digital cameras, and her subjects are still life and landscapes. Simonite received an M.F.A. from the University of Texas at San Antonio. She is an associate professor at Trinity University and vice-president of the Texas Photographic Society.

James Smolleck was born and raised in San Antonio. He received his B.F.A. from the University of Texas at San Antonio. He and his wife, Tracie, have a daughter, Ruby. When not spending time with his family, Smolleck can be found creating paintings of an esoteric nature.

Hills Snyder, who wrote the ballad "Song 44" and a piece about artist Alejandro Cesarco titled "Page 33," is known to have used a .22 in his 1970 serigraph, *Art Shooter*. It is widely believed that he was born in Lubbock, Texas, though some say it was on a mountaintop in Tennessee.

Penelope Speier graduated from the University of Texas at Austin in 1966 with a B.S.F.A. in art history. Throughout the years she has applied her interest in the arts by developing a rich history of community involvement as both an artist and an advocate for the arts in education. Speier has worked on her paintings and collages in studios in Italy, Japan, and Mexico. She lives in New Braunfels.

Henry Stein studied at the Art Students League of New York and holds a B.F.A. from the University of Texas at San Antonio. He exhibits nationally and internationally, and his work is in many corporate and private collections. He is the recipient of a National Endowment for the Arts/Mid-America Arts Alliance Fellowship in Sculpture.

Gary Sweeney is originally from Southern California. His text-based, humor-driven art deals with a variety of subjects, from Americana kitsch and family driving vacations to biting political satire. He was the first fine artist to use plastic advertising cups (Put-in-Cups) to create his large installation pieces.

Lewis Tarver has been practicing law in San Antonio for fifty-five years–a shameless interference with his painting. Jazz has inspired, informed, accompanied, and entitled his painting. His art education, spasmodic by choice, was by

Charles Umlauf at the University of Texas at Austin and Reginald Rowe and Charles Field. He also studied at the San Antonio Art Institute.

Robert Tiemann's works can be found in private and public collections from Italy to Japan and New York to California. A graduate of the University of Texas and the University of Southern California, he has taught art for many years, primarily at Trinity University but also at Harvard University, the University of Texas at San Antonio, the University of Southern California, Melbourne High School in Florida, and Alamo Heights High School in San Antonio.

Jesse Treviño has earned an international reputation by painting the people, landmarks, and culture of San Antonio's West Side, where he grew up with his eleven brothers and sisters. He earned an A.A. from San Antonio Junior College, a B.A. in art from Our Lady of the Lake University, and an M.F.A. in painting from the University of Texas at San Antonio. In 1987 he was honored with the National Hispanic Heritage Award for Artist of the Year. Two of his paintings are in the collection of the Smithsonian American Art Museum.

Vincent Valdez was born and raised on San Antonio's South Side. He studied at the International Fine Arts School and earned a B.F.A. from the Rhode Island School of Design. His solo exhibition Stations, which debuted at the McNay Art Museum in 2004, has traveled throughout the country, and other work has been exhibited internationally. In 2005 Valdez was a recipient of the Skowhegan School of Painting and Sculpture residency in Maine.

Anita Valencia has studied at the San Antonio Art Institute, the Tamarind Institute of Lithography, and the University of Texas at San Antonio, where she received a B.A. in humanities. Her public art commissions include work at the Southwest Blood and Tissue Center, the University of Texas at San Antonio Downtown Campus, and the Henry B. Gonzalez Convention Center.

Kathy Vargas, a San Antonio native, has had one-person shows at Sala Uno in Rome and Galería Juan Martin in Mexico City, and a retrospective at the McNay Art Museum. Her work has appeared in group shows at the Corcoran Gallery and the Moscow Museum of Modern Art, among other venues, and is in the collections of the Smithsonian's American Art Museum, the Mexican Museum in San Francisco, the Toledo Art Museum, the Museum of Fine Arts Houston, the Sprint Collection, and the Southwestern Bell Collection. Her awards include a National Endowment for the Arts/Mid-America Arts Alliance Regional Fellowship and an Artpace San Antonio residency. The Texas Commission on the Arts named her the Texas Two-Dimensional Artist of the Year in 2005. She is an associate professor of art, chair of the Art Department, and director of the Semmes Gallery at the University of the Incarnate Word.

Anne Wallace often incorporates community perspectives on history and the environment into her site-specific multimedia projects. An important subtext is the relationship between cultural diversity and biodiversity. Wallace was one of the first recipients of a grant from the Artist Foundation of San Antonio, for a short film developing her sound and video work.

Lloyd Walsh lives and works in San Antonio. He received his B.F.A. in photography from the University of Texas at San Antonio in 1989. In 1992 he received his M.F.A. in painting and drawing from the California College of Arts and Craft in Oakland. He has had recent exhibitions in San Francisco, Santa Monica, Houston, Chicago, and Paris.

Bettie Ward says: "I am the cowgirl daughter of an old world rancher who taught me to get back up on my horse as soon as I hit the ground. My art tells stories about transitions, romances and their consequences, human sensations, the earth as home, cycles of existence, social issues including war and homeless living, and nature as it relates

to man. I listen to the voice of the work, becoming its creator and its true love all at the same time."

Liz Ward lives and works in Castroville, Texas, where she has resided since joining the art faculty at Trinity University in 1999. Often inspired by the landscape and natural history of South Texas, her paintings, works on paper, and installations have been exhibited in the region and beyond. Her work is represented in numerous public and private collections, notably the Whitney Museum of American Art, the Museum of Fine Arts Houston, and the Austin Museum of Art.

Terry A. Ybáñez has taught in public schools for nineteen years. She currently teaches art at Brackenridge High School in San Antonio. She has illustrated two children's books, *Hairs/Pelitos*, by Sandra Cisneros, and *The Christmas Tree/El árbol de Navidad*, by Alma Flor Ada. Her work has been exhibited in San Antonio, Dallas, Austin, Laredo, San Francisco, Paris, Kuwait, and Mexico.

Robert Ziebell is a lens-based artist who resides in central Texas. His work has been featured in *Grand Street*, *Adbusters*, *Dwell*, and *Texas Monthly's 25th Anniversary 100 Best Photos* and has been exhibited throughout Texas, including at the Contemporary Arts Museum Houston, the Museum of Fine Arts Houston, the Dallas Museum of Art, the Austin Museum of Art, and the Blaffer Gallery at the University of Houston.

PERMISSIONS

Wendy Barker, "If a God" from *Poems from Paradise*. Copyright © 2005 by Wendy Barker. Reprinted with the permission of the author.

Jacques Barzun, "Imagination of the Real." Reprinted with the permission of the author.

Robert Bonazzi, "Maestro of Solitude" from *Maestro of Solitude*. Copyright © 2007 by Robert Bonazzi. Reprinted with the permission of Wings: A Literary Press.

Catherine Bowman, "Deathwatch Beetle" from *1-800-HOT-RIBS* (Salt Lake City: Gibbs Smith Publishers, 1993). Copyright © 1993 by Catherine Bowman. Reprinted with the permission of the author.

Jay Brandon, "The Grip" from *Guilty as Charged: A Mystery Writers of America Anthology*, edited by Scott Turow (New York: Pocket Books, 1996). Reprinted with the permission of the author.

Marie Brenner, excerpt from "Thelma Brenner" from *Great Dames: What I Learned from Older Women*. Copyright © 2000 by Marie Brenner. Reprinted with the permission of the author and Crown Publishers, a division of Random House, Inc.

Jenny Browne, "Native Grasses" from *At Once*. Copyright © 2003 by Jenny Browne. Reprinted with the permission of the author and the University of Tampa Press.

Norma Elia Cantú, "Mexican Citizen" from *Canicula: Snapshots of a Girlhood en la Frontera*. Copyright © 1995 by Norma Elia Cantú. Reprinted with the permission of the University of New Mexico Press.

Jacinto Jesús Cardona, "Back in '57" from *Pan Dulce* (San Antonio: Chili Verde Press, 1998). Copyright © 1998 by Jacinto Jesús Cardona. Reprinted with the permission of the author.

Oscar Casares, "RG" from *Brownsville*. Copyright © 2003 by Oscar Casares. Reprinted with the permission of Little, Brown and Company.

Rosemary Catacalos, "From Home" from *Again for the First Time* (Santa Fe, New Mexico: Tooth of Time Books, 1984). Copyright © 1984 by Rosemary Catacalos. Reprinted with the permission of the author.

Sandra Cisneros, "*Bien* Pretty" from *Woman Hollering Creek and Other Stories*. Copyright © 1991 by Sandra Cisneros. Reprinted with the permission of Susan Bergholz Literary Services, New York, New York, and Lamy, New Mexico. All rights reserved.

Nan Cuba, excerpt from *Body and Bread*. Copyright © by Nan Cuba. Reprinted with the permission of the author.

Olga Samples Davis, "Sister Girl" from *A Time to Be Born* (San Antonio: Pecan Grove Press, 1991). Copyright © 1991 by Olga Samples Davis. Reprinted with the permission of the author.

Angela de Hoyos, "La Vie: I Never Said It Was Simple" from *¡Floricanto Sí! A Collection of Latina Poetry*, edited by Bryce Milligan, Mary Guerrero Milligan, and Angela de Hoyos (New York: Penguin Books, 1998). Copyright © 1998 by Angela de Hoyos. Reprinted with the permission of Arte Público Press.

Robert Flynn, "Truth and Beauty" from *Growing Up a Sullen Baptist and Other Lies*. Copyright © 1986, 1996 by Robert Flynn. Reprinted with the permission of the author and the University of North Texas Press.

Marian Haddad, "Resurrection" from *Somewhere between Mexico and a River Called Home* (San Antonio, Texas: Pecan Grove Press, 2004). Copyright © 2004 by Marian Haddad. Reprinted with the permission of the author.

Rolando Hinojosa-Smith, "Rafe Buenrostro: Delineations for a First Portrait with Sketches and Photographs" from *The Valley*. Copyright © 1983 by Bilingual Press/Editorial Bilingüe. Reprinted with the permission of Bilingual Press/Editorial Bilingüe.

Sterling Houston, excerpt from *The Secret Oral Teachings of the Sacred Walking Blues*. Reprinted with the permission of the author.

John Igo, "Mitote of the Wasp Nest" from *The Mitotes of John Igo*. Copyright © 1989 by John Igo. Reprinted with the permission of the author.

Catherine Kasper, "Things That Fall from the Sky" from *Field Stone* (Austin, Texas: Winnow Press, 2004). Copyright © 2004 by Catherine Kasper. Reprinted with the permission of the author.

Jo LeCoeur, "Gravity." Reprinted with the permission of the author.

Jim Lehrer, excerpt from "Thank You, Felix" from *A Bus of My Own* (New York: Putnam, 1992). Copyright © 1992 by Jim Lehrer. Reprinted with the permission of the author.

David Liss, "From the Factual and Revealing Memoirs of Alonzo Alferonda" from *The Coffee Trader*. Copyright © 2003 by David Liss. Reprinted with the permission of Random House, Inc.

ABOUT THE EDITORS

Nan Cuba is the coeditor of *Writers at the Lake: An Anniversary Anthology* and has published stories, poems, and reviews in *Quarterly West, Columbia: A Magazine of Poetry and Prose,* the *Harvard Review,* and the *Bloomsbury Review*. As an investigative journalist, she reported on the causes of extraordinary violence in *LIFE* and *D Magazine*. She is the founder of Gemini Ink, a nonprofit literary center, and is an assistant professor of English at Our Lady of the Lake University in San Antonio.

Riley Robinson has been the studio director for Artpace San Antonio since 1994. He has curated the exhibitions San Antonio Collects and Made By Hand: Straight to Video at the Blue Star Contemporary Art Center, and Morton Hebsgaard at Cactus Bra Space. His artwork has been exhibited in San Antonio at Sala Diaz and the Southwest School of Art and Craft, and at Testsite, Austin; the Matfest Outdoor Invitational Exhibition, Bergen, Norway; the Art Museum of Southeast Texas, Beaumont; Virginia Commonwealth University, Richmond; and Kiasma, Helsinki.